Images of Myths in Classical Antiquity

Myths inspired Greek and Roman artists to rise to the challenge of conveying flowing narratives in static form. This book describes the different ways painters, sculptors, and other artists explored and exploited the dense forest of myth. It explains how formulas were devised for certain stories; how these could be adapted, developed, and even transferred to other contexts; how one myth could be distinguished from another – or confused with it; how myths related to daily life or political propaganda; and the influence of evolving tastes.

Written in a lively and accessible style, fully illustrated with examples drawn from a wide range of media, *Images of Myths in Classical Antiquity* provides fresh and stimulating insights into the representation of myths in Greek and Roman art.

Dr. Susan Woodford teaches Greek and Roman art for the University of London and is engaged in research for the Department of Greek and Roman Antiquities at the British Museum. A former Fulbright Scholar and Woodrow Wilson Fellow, she has written extensively on classical art for learned journals and is the author of several books, including *The Parthenon, The Art of Greece and Rome, An Introduction to Greek Art,* and *The Trojan War in Ancient Art*.

IMAGES OF MYTHS IN CLASSICAL ANTIQUITY

SUSAN WOODFORD

CAMBRIDGE
UNIVERSITY PRESS

CAMBRIDGE UNIVERSITY PRESS
Cambridge, New York, Melbourne, Madrid, Cape Town, Singapore, São Paulo, Delhi

Cambridge University Press
32 Avenue of the Americas, New York, NY 10013-2473, USA

www.cambridge.org
Information on this title: www.cambridge.org/9780521782678

First published 2003
Reprinted 2007 (twice)

Printed in the United States of America

A catalog record for this publication is available from the British Library.

ISBN 978-0-521-78267-8 hardback
ISBN 978-0-521-78809-0 paperback

FOR HELEN

ὅστις δὲ πλοῦτον ἢ σθένος μᾶλλον φίλων
ἀγαθῶν πεπᾶσθαι βούλεται, κακῶς φρονεῖ.

 – Euripides, *The Madness of Herakles,* lines 1425–1426

Only a fool would prefer wealth or power to true friends.

Contents

Illustrations

Acknowledgements

A number of friends have unstintingly put their precious time and wide-ranging talents at my disposal – criticising, suggesting, correcting and encouraging. Without their generous help there would be far less clarity and many more errors. I therefore thank most warmly Lucilla Burn, Barbara Goward, Catherine Hobey, Carla Lord, Ian MacPhee, Jenny March, David Mitten, Elizabeth Pemberton, Nancy Ramage, Rowena Rosenbaum, Jocelyn Penny Small, Helen Solomon, Dyfri Williams, and my patient, constant and kind in-house editor, Peter Woodford. Such mistakes as remain are, of course, mine alone.

Thanks are also due to Jonathan Bayer for beautiful photographs from awkward and unmanageable books and other photographic tasks executed with skill and ingenuity; to Susan Bird for painstaking drawings of otherwise unintelligible vases and sarcophagi; to Deborah Blake for helpful technical advice and permission to use material from my publications for Duckworth; and finally to Olga Palagia, to whom I owe the instigation of this book, and Beatrice Rehl, to whom I owe its completion.

Note on Terminology and Spelling

PERIODS IN GREEK AND ROMAN ART

Greek

Archaic: the style of early Greek art from about the middle of the 7th century BC to the beginnning of the 5th century BC.

Classical: Greek art produced between the end of the Persian wars (490–479 BC) and the death of Alexander the Great (323 BC).

Hellenistic: the period from the death of Alexander the Great, when Greek art was further developed over the wide area that had been conquered by Alexander and was ruled by his successors to the final conquest of all the Hellenistic Kingdoms by Rome in 31 BC.

Roman

Republican: the early phase of Roman art, much influenced by the Etruscans, lasting from the 6th century BC through the 1st century BC.

Imperial: Roman art under the emperors, starting with the first emperor, Augustus (ruled from 27 BC–AD 14).

* * *

Attic is the adjective pertaining to Athens and the art produced by the Athenians.

SPELLING

The transliteration of Greek names is problematic. Many have long been familiar in Anglicised (e.g., Priam) or Latinised (e.g., Achilles, Ajax) forms. Others are now more commonly found in forms closer to the original Greek (e.g., Herakles).

Early on I abandoned any hope of being consistent in the spelling of Greek names. I have usually tried to use the form that seemed to me most familiar to an English-speaking public or the form most suitable to the context (that is, transliterating from Greek for less familiar Greek myths and using Latin spelling when the context is a Roman myth or work of art). The alternative spelling (when there is one) is given in the Glossary.

AN INTRODUCTION

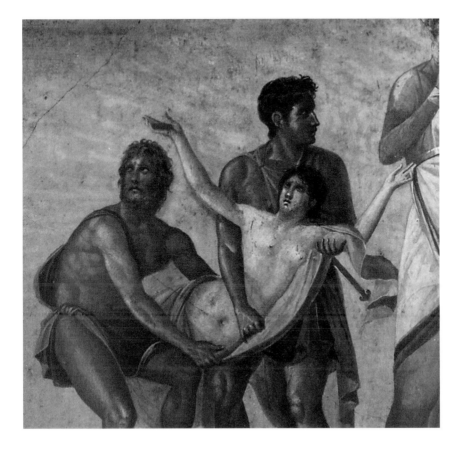

Myths and Images

Greek myths are seldom light-hearted, cheerful stories; more often they are bleak, heartless and cruel. The myth of the Trojan War is framed by two such grim episodes, both dealing with the sacrifice of an innocent young girl.

When the combined Greek forces had assembled under the leadership of the powerful king Agamemnon and were ready to sail across the Aegean Sea to attack the city of Troy, they found they were thwarted by the lack of a suitable wind. The remedy, they discovered to their horror, lay in the sacrifice of Agamemnon's virgin daughter Iphigeneia to the goddess Artemis, whom Agamemnon had offended. Once the girl was dispatched, the expedition was able to set off and in time successfully sacked the city.

After Troy had fallen and its king had been slain, one last terrible act was demanded of the victorious Greeks before they could return home: the ghost of Achilles, who had been killed in action, demanded as his prize Polyxena, a harmless maiden, daughter of Priam, the defeated Trojan king. Achilles had been a warrior of such distinction that his posthumous wishes could not easily be ignored. The girl was sacrificed and the Greeks sailed away.

Clues to Matching Myths and Images

A Roman painting (Fig. 1), preserved on a wall in Pompeii, shows a half-naked young woman held by two men. She raises her arms pathetically and lifts her eyes to heaven. A priest, standing to the right, anxiously raises one hand to his chin. In his other hand, he holds a sword. He is wreathed and prepared to perform a religious rite. The sword indicates that a sacrifice is imminent. The girl is to be the victim.

A Greek vase (Fig. 2) provides a more explicit and brutal image: a girl is actually being sacrificed. Her tightly swathed body is held by three warriors, while a fourth cuts her throat, from which blood spurts out.

How do we know who these unfortunate victims are?

The one on the vase (Fig. 2) is easy to identify: her name is written above her head. She is Polyxena; her slayer is Neoptolemos, the son of Achilles. His name is also inscribed, as are those of all the participants.

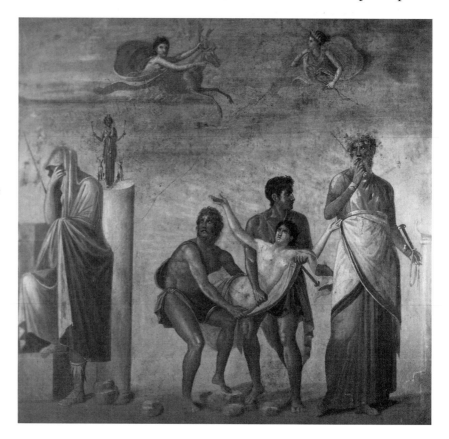

1. Iphigeneia being carried to be sacrificed. Fresco, Roman wall painting from Pompeii, AD 63–79. Museo Nazionale, Naples.

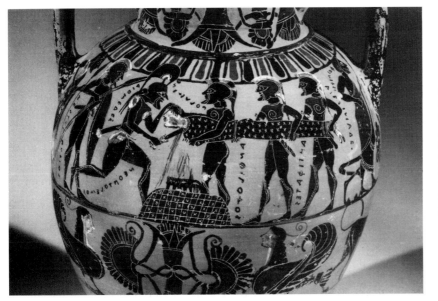

2. Polyxena being sacrificed at the tomb of Achilles. Attic black-figure amphora, c. 570–560 BC, by one of the painters of the Tyrrhenian Group. British Museum, London.

Inscriptions are a very clear and (usually) unambiguous way of specifying a story.

What about the girl in the Roman painting (Fig. 1)?

Here there are no inscriptions, but there are other clues that help to identify the story. Up in the sky to the right floats the upper part of the goddess Artemis, identifiable from the bow she carries. She summons a nymph, to the left, who emerges from the clouds holding on to a deer.

According to one version of the myth, Artemis at the last minute substituted a deer for Iphigeneia and miraculously whisked the girl away to be a temple servant in the land of the Taurians. The presence in the sky of a deer, soon to replace the maiden carried to the altar, identifies the victim. This must be Iphigeneia, for no such last-minute rescue was vouchsafed to the unfortunate Polyxena.

The deer alone is enough to identify Iphigeneia on a vase (Fig. 3) made by a Greek in South Italy. In the centre is an altar, behind which stands the man about to make the sacrifice. He holds a knife out towards the girl who slowly, solemnly approaches. Shadowing her, with its head, legs and rump just visible behind her, is a deer. Other figures surround the central scene: Artemis above and to the right, about to engineer the exchange of deer for girl. Opposite Artemis, on the left, is her brother Apollo, not a participant in this myth, but a twin often paired in images with his sister. Below and to the left, there is a young man assisting at the sacrifice and, at the far left, a woman.

3. Iphigeneia going willingly to her death. Apulian red-figure volute krater, 360–350 BC, by a painter related to the Iliupersis Painter. British Museum, London.

Iphigeneia in the Roman painting (Fig. 1) was carried protesting to the sacrifice, but on this vase (Fig. 3) she advances unprotestingly. There were, in fact, two different traditions as to how Iphigeneia met her end. According to one, she was taken by force to be sacrificed. This is most memorably recalled in Aeschylus' tragedy *Agamemnon* when the chorus recall how in order to gain a fair wind to take the troops to Troy, the girl was brutally slaughtered like an animal over the altar:

> Her prayers, her cries, her virgin youth,
> Counted for nothing.
> The warriors would have their war.
> The ritual began.
> Father, priest and king, he prayed the prayers,
> Commanded attendants to swing her up,
> Like a goat, over the altar,
> Face down . . .
> She cast piteous looks, arrows of grief,
> At the ministers of sacrifice . . .
>
> *Agamemnon*, lines 227–243 (trans. Raphael and McLeish)

According to the other tradition, Iphigeneia, at first horrified to learn the fate that awaited her, upon consideration decided to welcome it. This unexpected reversal is touchingly portrayed in Euripides' tragedy *Iphigeneia in Aulis*.

"I have pondered the thing," Iphigeneia reflects, "I am resolved to die. And I will do it gloriously. . . . The whole might of Hellas [Greece] depends on me. . . . Ten thousand men are armed with shields, ten thousand men have oars in their hands. . . . Shall my single life be a hindrance to all this? . . . If Artemis has willed to take my body, shall I, a mortal woman, thwart the goddess? It cannot be. I give my body to Hellas [Greece]. Sacrifice me, sack Troy. That will be my monument. . . ."

> *Iphigeneia in Aulis*, lines 1375–1399 (trans. Hadas and McLean)

Artists could choose which tradition they wished to illustrate. The painter of the vase in Figure 3, like Euripides, showed Iphigeneia approaching the altar with calm dignity; the Roman painter (Fig. 1) preferred the harsh tradition described by Aeschylus and so showed the terrified victim held in the firm grip of the two men carrying her.

Despite his best efforts, the Roman artist has compromised the tragic content of the scene: the priest at the right is awkward and overlarge and the girl in the centre looks artificially posed and theatrical. As a result there is little to touch the heart in this mediocre painting – except for the grief-stricken man at the far left, his cloak over his head, his face buried in his hand. The Roman painter did not invent this strikingly poignant figure himself; he took the image from a celebrated painting (now lost) that had been created centuries before by a famous Greek painter named Timanthes.

Pliny, a Roman writer of the 1st century AD, described the painting in which it first appeared, as:

> that much-praised painting of *Iphigeneia* depicted by Timanthes with the girl standing by the altar ready for death. Timanthes had represented all the onlookers as plunged in sorrow so effectively that he exhausted every possible representation of grief, and when he came to portray Agamemnon [her distraught father], he had to conceal his face in his cloak, for he had reserved no adequate expression to show his suffering.
>
> Adapted from Pliny the Elder *Natural History* 35, 73

Timanthes knew what he was about better than Pliny realised. By concealing Agamemnon's face, he liberated us to imagine a grief more overwhelming than any that could be portrayed.

Timanthes depicted Iphigeneia quietly accepting her fate (as on the vase in Fig. 3 and in Euripides' tragedy); the fame of his painting rested primarily on the emotional impact produced by his expressive

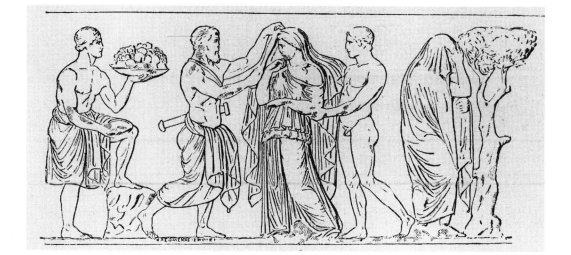

4. Iphigeneia about to be sacrificed. Drawing of a Roman marble altar decorated with reliefs possibly derived from a lost painting by the 4th-century BC Greek painter Timanthes. 1st century BC. Uffizi, Florence.

characterisation of Agamemnon, heart-broken father of the innocent victim, turning away from the ghastly action that he himself had been obliged to instigate.

The Roman painter appreciated the power of this invention. In composing his picture (Fig. 1), he freely drew on two different traditions. He chose to show Iphigeneia being forcibly carried to a violent death (as presented by Aeschylus), but, perhaps aware of his own limited ability to convey subtle feelings, he cleverly added Timanthes' creation, the evocative image of the veiled Agamemnon.

A Roman cylindrical altar decorated with reliefs (drawn in Fig. 4) shows a girl solemnly facing a man who cuts off a lock of her hair. Before an animal was sacrificed, its forelock was cut off and placed on the altar. This ritual action performed on the girl, as it would be for an animal sacrifice, makes clear what is about to happen. There is no deer, no image of Artemis. Does the girl's apparently willing compliance identify her as Iphigeneia?

No, she could be Polyxena, for there were two traditions about her sacrifice, too. Whereas the Greek vase in Figure 2 shows Polyxena being carried forcibly to the altar, other images present her as fully compliant, as does Euripides' tragedy *Hecuba*.

The clue in this instance comes from further round to the right, where the veiled, averted figure of Agamemnon stands. Timanthes' invention is enough to identify the scene. Agamemnon's grief can only be for his own daughter – the fate of a Trojan princess would hardly move him. Nor could the veiled figure be Polyxena's father, Priam, since he was already dead when Polyxena was sacrificed.

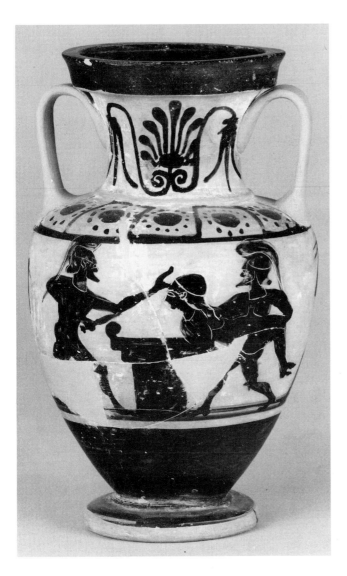

5. Warriors about to sacrifice a girl (Iphigeneia ? Polyxena ?). Etrusco-Campanian black-figure amphora, 470–450 BC. British Museum, London.

It looks as if once one knows the myths of Iphigeneia and Polyxena, images of girls about to be sacrificed can fairly easily be distinguished from one another. The presence of a deer or the goddess Artemis, the image of the veiled Agamemnon, the inscription of names, the surviving description of a lost image – such clues help to determine which unfortunate princess is intended.

But what about the painting on an Etruscan vase (Fig. 5) which just shows a girl being carried to an altar by a warrior where another warrior holding a sword awaits her? There are no clues to identify the girl. The fact is, we do not know. The scene may even represent a story that has not come down to us.

The Mutability of Myths

Decoding images and relating them to myths is often more complicated than it seems at first. The myths themselves were seldom fixed in any way; they always remained flexible and were often rethought.

Long before they were written down, Greek myths were told and retold to eager listeners – little children at home or groups of adults at public festivals or private parties. In the telling the myths were changed, modified, improved and elaborated. Small incidents were enlarged, new episodes introduced, local variants incorporated and different (even contradictory) interpretations offered. We have seen that by the end of the 5th century BC there already existed two versions of how Iphigeneia and Polyxena met their deaths.

Some myths eventually acquired a generally accepted form, but even those incorporated into the two revered Homeric epics, the *Iliad* and the *Odyssey*, could still be treated freely by other storytellers, poets or playwrights.

This rich tradition was just as available to artists who worked with images as to those who worked with words. Though we may be tempted to think of portrayals of myths as illustrations of texts, it is actually more likely that artists drew inspiration independently from the same fund of stories that writers used. They probably thought of themselves as creating visual equivalents of those stories without reference to any particular literary works.

Myths in Images

From the 7th century BC on, the Greeks portrayed myths in a vast array of media. They depicted them in the decorations on their temples, in monumental wall paintings (now mostly lost), and even in gold jewellery, but most prolifically on painted pottery, a modest luxury produced in abundance until near the end of the 4th century BC.

The Romans, as they gradually conquered the Greek cities in South Italy and Sicily and finally Greece itself, became increasingly captivated by Greek culture and began to depict Greek myths painted on the walls of their homes and public buildings, carved on sarcophagi (elaborate marble coffins), laid in mosaics on floors, even ornamenting expensive glassware or composed into gigantic sculptural

groups. However, turning words into images is not a simple proce-
dure. The chapters that follow explore various aspects of how artists in
classical antiquity managed to evoke so many myths so successfully in
visual form.

To begin with, artists had to find ways to make stories recognisable,
so that people would know who was being represented and what was
going on. Then they had to decide how to encapsulate a myth, which
a storyteller might take hours to narrate, in a static image. They also
had to choose whether to focus on the climax of the story, to hint at the
outcome or to suggest the cause, to concentrate on a few pivotal figures
or events, or to sketch in the broad context in which the story was set.

Once these crucial decisions had been made, work could begin and
artists could start building images. They did not always have to invent a
new scene from scratch; they could sometimes adapt an established im-
age. If certain formulas had already been given visual form (aggressive
pursuits, amorous encounters, murderous attacks), these types could be
modified to depict different myths. Artists could express their personal
interpretations by adding, changing or deleting certain elements. Even
quite subtle innovations could be striking if placed against a conven-
tional background.

Images evolved as myths evolved. Artists could be inspired by new
poems or plays to create new images and by new interpretations of
traditional tales to modify old ones. Sometimes they themselves in-
vented images of considerable power and originality which provided
unexpected insights into the meaning of a myth or the relationships
between mythological characters.

An image of a myth could gain immediacy and emotional richness
when it was shown as though taking place in settings familiar to the
people of the time so that heroes could appear to behave like ordinary
people and ordinary people like heroes. A mythological disguise might
occasionally be used to make a political point: historical personages
and real events could be made to carry propagandistic messages when
artists set them in the realm of myth.

There were constant challenges. Images had to be so constructed
that they could be fitted into awkward spaces (long thin ribbons, tall
rectangles, or even triangles or circles); ways had to be found to reveal
things that could not actually be seen (a series of transformations, a
powerful emotion or a concealed threat); means had to be devised to
avoid confusing one myth with another or confusing it with something
that was not a myth at all.

Greek and Roman artists ingeniously solved many problems to create hundreds of images of myths that we can readily interpret or patiently decode. Sometimes, however, being human, they made mistakes, muddled names, confused motifs or conflated formulas. Aided by experience and scholarship we can often make sense of such images and occasionally even understand the causes of confusion. But some images continue to baffle all attempts at interpretation. Artists engaged on expensive projects could be expected to be careful and conscientious – yet some of the most celebrated works continue to defy agreement on what exactly they represent. Two such cases are discussed in Chapter 17. The puzzle we must solve is whether the artists have omitted essential clues or we have simply failed to find them.

PART TWO

TRANSFORMING WORDS INTO IMAGES

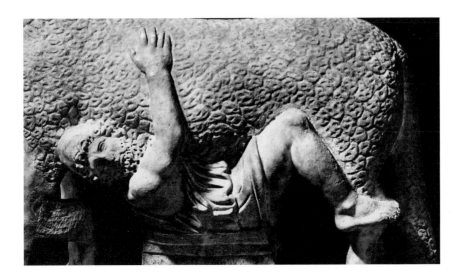

Making Myths Recognisable

People living in ancient Greece and Rome knew many myths. Some they heard while still children sitting at their mother's knee, some they learned from teachers as they grew older, some they listened to in public recitations at religious festivals or saw enacted in the theatre; only a very few did they read in books, and those not much before the end of the 5th century BC. Storytelling was largely an oral affair and each teller was free to vary and embellish the basic story as he or she saw fit.

But telling a story in words is very different from conveying it through images. Words can make clear at once who is doing what to whom and why. Images do not. Artists had to find other ways to ensure that their audience knew which myth they were illustrating and what characters were participating – in short, that the message they sent would be correctly received. Five main devices were employed to this end.

Labelling by Inscription

The simplest and most obvious method was to use inscriptions. Just as a verbal storyteller could begin by naming his subject and thus avoid confusion, so an artist could inscribe his work. We have already seen how inscriptions could clarify the subject on a Greek vase (Fig. 2) where

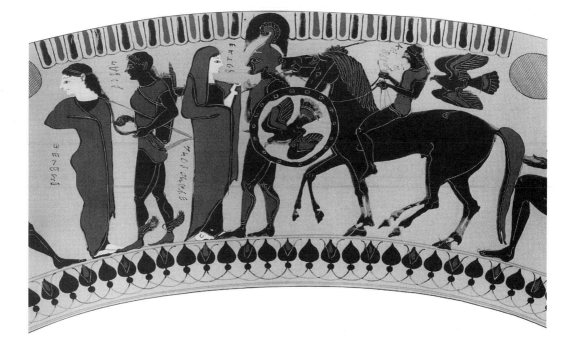

6. Hector and Andromache; Helen and Paris. Chalcidian black-figure krater, c. 540–530 BC, by the Inscription Painter. Martin von Wagner Museum, Würzburg.

the tragic victim of a human sacrifice could be identified as Polyxena because her name was written beside her.

The use of inscriptions could also lend poignancy to an otherwise uninteresting image, for instance, a Greek vase (Fig. 6) which shows a quiet scene, two couples to the left, a horseman with a second horse to the right. The vase is decorated in what is called the black-figure technique, the same technique as was used for the Polyxena vase (Fig. 2) and for Figure 5. The figures were painted on the unfired vase with a slip that turned black in the course of a three-stage firing process. Internal markings – eyes, hair, clothing, the manes of the horses, the feathers on the bird's wings, the legs of the youth sitting on the horse and other similar details – were incised into the wet slip. White slip made of a slightly different clay was often added, particularly for the flesh of women or to decorate something like a dress, a piece of armour or a shield. It did not adhere as well as the slip that turned black and has often flaked off. A purplish-red slip was also sometimes used to vary the otherwise austere colour scheme.

At first glance not much seems to be happening in Figure 6, but the fact that the artist has labelled the two men and the two women calls to mind one of the most moving books in the *Iliad*, Homer's epic poem dealing with the Trojan War. Greeks and Trojans, Homer recounted,

daily fought brutally outside the city walls, but occasionally the Trojans could dart inside to seize a brief moment with their families.

Hector, the Trojans' champion, is one of the most appealing heroes in the *Iliad*: a brave warrior, a tender husband and a loving father. In book 6 of the *Iliad*, Homer tells how he breaks off from the fighting in order to go into the city and ask his mother to make an offering to the goddess Athena. While there, he takes the opportunity to meet his wife, Andromache. He finds her standing on the walls anxiously looking out over the field of battle, and with her is their little son. Though they are full of foreboding, the love between Hector and Andromache is touchingly revealed.

On the vase (Fig. 6) Hector is shown in the very centre, armed with shield and spear and wearing a crested helmet. His name is written in front of him. He stands face to face with Andromache (her name inscribed behind her). The vase painter has caught something of the mood of trust and mutual affection portrayed in the Homeric epic. He conveys it by the way the two look directly into one another's eyes and the way Andromache, though modestly veiled, holds her cloak open to receive her husband.

In another book of the *Iliad* the Trojan prince Paris, younger brother of Hector, also takes a breather from the fighting. He wants to see Helen, the beautiful queen whom he abducted from Greece. Helen was the actual cause of the war, for the Greeks' whole purpose in besieging Troy was to recover her. Helen was at first charmed by Paris, but after years of living in Troy, she tired of him and began to long for her old home. The vase painter (Fig. 6) shows Paris (his name inscribed in front of him) holding a bow and eagerly addressing her, but Helen (at the far left, her name written behind her) wraps herself in her cloak and turns her head away from him. The contrasting relationships of the two couples, so vividly expressed in the poetry of the epic, is sensitively captured by the painter of the vase. But if we did not have the names inscribed, it would hardly be possible to relate the image to its probable Homeric inspiration.

The youth to the right, riding one horse and holding another, has the name Kebriones inscribed beside him. Kebriones was one of Hector's brothers, who, according to the *Iliad*, acted as his charioteer in an emergency. His presence here holding a spare horse ready for Hector hints at the war with its grim fighting which forms the background to this brief encounter of armed men with their besieged womenfolk.

Inscriptions are specific and (usually) unmistakable, but if they are unavailable, a second way of identifying particular figures is by means of attributes – special equipment carried or worn by individual gods or heroes.

Identification through Attributes

The hero Herakles was immensely popular and appears in countless images. Sometimes he is shown as young and beardless, at other times

7. Weary Herakles (Hercules Farnese). Roman marble copy (or adaptation) of a Greek statue made by Lysippos in the 4th century BC. Museo Nazionale, Naples.

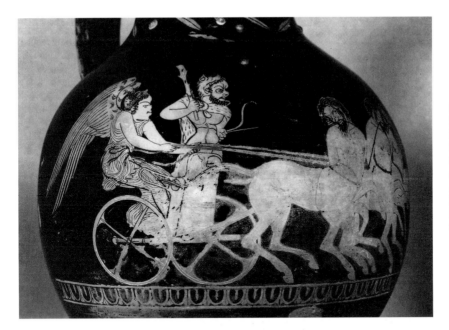

8. Herakles riding in a chariot driven by Nike and drawn by centaurs. Attic red-figure oinochoe, c. 410–400 BC, by the Nikias Painter, Louvre, Paris. Copyright R. M. N.

as mature and bearded, but almost always he is shown with a lion skin and a club. Occasionally he also carries or uses a bow.

A huge and powerful statue (Fig. 7), which once decorated an impressive Roman imperial bath complex, depicts the weary hero leaning on his characteristic club, over which he has draped his lion skin. The Romans much admired Greek sculpture and often had copies made of particularly celebrated works. The Greek works were usually made of bronze and have since disappeared. Roman copies were frequently made of marble, and many of them have lasted better. The original model for this statue was probably a bronze made by the famous 4th-century BC sculptor Lysippos. He sympathetically showed the muscular hero in a very human light, tired out by his seemingly endless labours. Herakles' right hand is behind his back, and in it he holds the golden apples of the Hesperides. Obtaining these apples was the last of the many gruelling tasks imposed on the hero, and the toll it has taken on him is indicated by his obvious exhaustion.

Herakles was admired, but he could also be the butt of jokes. Comic portrayals of the hero exist in literature and also in art. On a Greek vase of the 5th century BC (Fig. 8) he is caricatured as a fierce-looking brute, but nevertheless he is still easily recognisable, as he is wearing his lion skin, carrying his club and is even equipped with his bow. He stands in a chariot driven by Nike, the goddess of victory,

recognisable by her wings and long robe, but here also teasingly mocked, caricatured as a snub-nosed urchin driving a chariot pulled by a team of grumpy centaurs, mythical creatures that are part man and part horse.

This vase is painted in the red-figure technique, as was Figure 3. Whereas the black-figure technique was in vogue in the 6th century BC, red-figure developed about 530 BC and was favoured in the 5th and 4th centuries BC despite the fact that it was in some ways more awkward for the vase painter. Instead of painting the figures in slip that turned black, the painter left the figures in the natural reddish colour of the clay and blacked in the background instead. He therefore had to think about his image indirectly, that is, to remember that the figures were the part of the vase that he was *not* painting. But there were compensations: instead of having to incise internal markings with a sharp tool, he could now draw them in black with a fluid brush. This made for a whole new range of possibilities and led to the development of much more naturalistic images.

Characterisation by Means of a Strangely Formed Adversary

A third way of specifying a myth is by portraying a hero confronting a unique and peculiar adversary. Almost any sort of unnatural creature can serve, whether a many-bodied snake, a human-headed bird or a bull-headed man.

Only one bull-headed man is known to mythology, the unfortunate Minotaur. The product of mismating between the queen of Crete and a very attractive bull, he was considered something of a disgrace to the royal family and so was sequestered in the centre of a labyrinth designed, according to the myth, especially to accommodate him. His uncouth appetite for girls and boys from Athens eventually led to his demise, as the youthful hero Theseus once accompanied the doomed young people who were intended as Minotaur fodder and killed the beast instead.

On a Greek black-figure cup (Fig. 9) the impending end of the Minotaur is illustrated as Theseus, to the left, holds the monster by one horn and prepares to run him through with his sword. The Minotaur, with his bull's head and hairy body indicated by many small incisions, looks more frightened than frightening, grasping Theseus' sword with

9. Theseus and the Minotaur. Attic black-figure cup, c. 550–540 BC, signed by Archikles and Glaukytes. Antikensammlungen, Munich.

one hand in an effort to turn the blow aside, but at the same time prudently trying to escape.

As the Minotaur is unique in his form and is known to have been dispatched by Theseus, the names that are inscribed around the figures are not necessary for the understanding of the story, but the letters do serve to fill up spaces which might otherwise seem rather empty.

Clues Provided by Normal Elements Abnormally Combined

A fourth way to ensure that a myth is unmistakable is to portray a strikingly unusual situation. The elements need not in themselves be anything other than everyday, but the way they are put together must have something special about it. Thus sheep are perfectly familiar animals and men may have nothing odd about them, but to see a man *riding* a sheep is enough to give a hint that a myth is being represented, and to see a man riding *upside-down* beneath a sheep, as on Figure 10, makes it clear that something quite out of the ordinary is going on.

The man in this case is Odysseus, the long-suffering hero of Homer's *Odyssey*. He might be recognised by his traveller's hat (a *pilos*), which became something of a trademark, but his situation is actually very much more revealing. The reason for his peculiar position is the following.

When Odysseus and his companions strayed into the cave of the gigantic, one-eyed Cyclops Polyphemus, the cave was empty. They waited. When the huge owner returned with his flocks and meticulously closed the mouth of the cave with an enormous boulder, too large and too heavy

for any men to move, they began to be alarmed. Now they were trapped in the cave. Their alarm increased when the Cyclops discovered them and found them interesting – not just to talk to, but also to eat. He devoured two men before bed, and two more the next morning. He then took his flocks out to pasture, but secured the mouth of the cave with the enormous boulder, preventing the remainder of the men from escaping. Odysseus feared that the Cyclops' newly discovered taste for men's flesh was becoming something of a habit and tried to think up some way he could escape and save what was left of his companions. This did not prove easy. The main problem was the boulder at the mouth of the cave. The men could not move it themselves; only the huge Cyclops could shift it. Thus if Polyphemus were killed, the men would never manage to get out. Odysseus finally decided that the best thing would be to intoxicate the monster and then poke out his eye (the Cyclops had, after all, only one) and hope that eventually, even when blind, the Cyclops would remove the boulder himself to let his flocks out.

All went according to plan, but when the enraged and blinded Cyclops finally did move the boulder to let the hungry sheep out to pasture, he was understandably reluctant to allow the men who had injured him go free. He sat by the entrance of the cave running his fingers over the backs of the sheep and in between them to ensure that no men could escape. Odysseus had thought of that. He tied each man up *under* the bellies of three sheep grouped together and finally himself clung on under the belly of the biggest ram. And that, of course, is what is represented in the Roman statue (Fig. 10).

The image is extraordinarily unconvincing. Odysseus' back rests on a block of stone beneath him. This was necessary because in a marble statue the weight of the sheep's belly and Odysseus beneath it could not possibly be supported on the four slender legs of the sheep. Marble has little tensile strength and heavy horizontal elements need substantial vertical supports.

Odysseus' escape could, however, have been quite elegantly repre- sented in three-dimensional form by a statue made of bronze. Bronze has great tensile strength, and so even slight supports are often suffi- cient to hold up quite complex and extended forms. A bronze sheep could easily stand on its four legs, even with a figure of Odysseus cling- ing to its belly, without needing further support. It is possible that an image in bronze inspired this clumsy adaptation suitable for execution in marble.

10. Odysseus escaping from Polyphemus' cave. Roman marble statue, 1st century AD. Palazzo Doria Pamfili, Rome. Photo Alinari.

When it was new, the marble statue was painted. This must have made it much livelier, clearly distinguishing man from sheep, clothing from naked flesh, and disguising the supporting block by coating it in a dark colour so that it would look as if Odysseus was actually clinging on to the sheep unsupported by anything below him. One can understand the temptation to create such a statue, as this single image concisely and unmistakably conveys the myth. Vase painters often produced variations on this theme, either depicting Odysseus in isolation (as here) or a whole series of men under sheep, occasionally escaping under the unseeing eye of the Cyclops.

Clarification through Context within a Mythological Cycle

Finally, a fifth way of ensuring that the illustration of a myth is unambiguous is by showing it in a context that makes its identity clear. For instance, both Herakles and Theseus had violent encounters with a monstrous bull, and both were portrayed capturing it. Sometimes it is difficult to tell which hero is intended, especially if there are no inscriptions or distinguishing attributes. The problem is solved, however, if the bull episode is represented in the context of other deeds of one or other of the heroes.

11. The deeds of
Theseus. Attic
red-figure cup,
c. 440–430 BC, by
the Codrus Painter.
British Museum,
London.

Theseus, whose bold slaying of the Minotaur we saw in Figure 9, also performed a number of other heroic deeds (Fig. 11). Though the son of an Athenian king, Theseus was born and grew up in the Peloponnese. When he reached maturity he went to Athens to meet his father. At the time most people made the journey from the Peloponnese to Athens by sea, as the land route was infested with bandits and wild animals. Theseus, however, to prove himself a hero and worthy to be acknowledged as the son of his royal father, chose to follow the land route and to clear it of the troublesome hazards.

The centre of the red-figure cup (Fig. 11) shows Theseus' later triumph over the Minotaur, as he drags the dead body of the monster out of the labyrinth in which it had been confined. Circling round the centre are shown the various cruel men and beasts that confronted Theseus and the methods he used to defeat them. Whenever possible he inflicted their own crimes on the perpetrators. Thus (at the top) he wrestles with Kerkyon, whose practice had been to wrestle strangers to death. Next, reading clockwise, (at two o'clock) he adjusts Procrustes' anatomy to fit his bed more neatly by lopping off superfluous limbs with an axe; this had been Procrustes' own wicked procedure. Then (at four o'clock) he sends Skiron tumbling down a cliff to be devoured by

a turtle below; Skiron had previously required all travellers to wash his feet and then kicked them over the cliff – a tasty morsel for the turtle. Next (at eight o'clock, skipping six o'clock for the moment) he attaches Sinis to a tree temporarily bent over for the purpose, just as Sinis used to do to passersby; and finally (at ten o'clock) he kills the sow that had been attacking people and damaging crops in the neighbourhood of Krommyon.

After he reached Athens, Theseus volunteered to capture the bull that was devastating the area around Marathon (inserted at six o'clock), and for this act he employed a club, one rather thinner than that habitually used by Herakles, but still an attribute that might cause confusion between the heroes, were it not that this deed of Theseus' is firmly set within the context of his other deeds.

The ever-popular Herakles (Figs. 7 and 8) was also involved in numerous adventures. Twelve of them were assembled to decorate the twelve metopes (rectangular panels in the Doric order of architecture, see Fig. 66) over the porches of the Temple of Zeus at Olympia (Fig. 12). The first six of these labours took place in the northern Peloponnese, near Olympia itself. These required Herakles to kill the lion of Nemea, which was invulnerable to weapons (1); dispatch the many-headed hydra of Lerna, which had the awkward habit of growing two heads to replace any one that was severed (2); to kill, or at least drive away, the aggressive and savage birds that haunted Lake Stymphalus (3); to capture the Kerynitian hind that he had to chase for a full year (5); to bring the Erymanthian boar alive to Eurystheus (the king who ordered Herakles to perform these twelve labours) (7); and finally to clean out the filthy Augean stables in a single day (12). The next four labours took Herakles to the four corners of the world, to the south to capture the Cretan bull (4), to the east to obtain the Amazon's girdle (6), to the north to capture some man-eating horses (8), and to the west to rustle the cattle owned by triple-bodied Geryon (9). Finally, the last two labours took Herakles beyond the confines of mortality – to bring Cerberus, the guard dog of the Underworld, to Eurystheus (11), and to obtain the golden apples of immortality, the apples of the Hesperides (10) (cf. Fig. 7).

This group of labours, supposedly all ordered by King Eurystheus, eventually became canonic, appearing together in literature and as a set on Roman sarcophagi and mosaics. Before they were assembled at Olympia these adventures had very different histories. Some of them appeared early (like the hydra), others later – the labour of the Augean

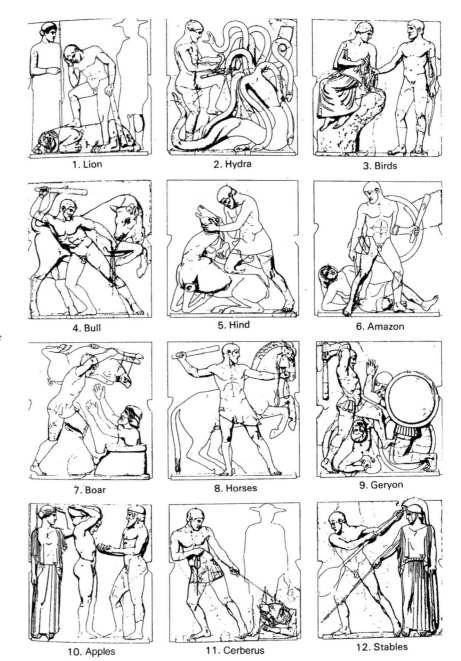

12. The labours
of Herakles.
Reconstruction
drawing of the
metopes over the
porches of the
Temple of Zeus
at Olympia,
465–457 BC.

1. Lion

2. Hydra

3. Birds

4. Bull

5. Hind

6. Amazon

7. Boar

8. Horses

9. Geryon

10. Apples

11. Cerberus

12. Stables

stables makes its first preserved appearance here on the metopes at Olympia. Some were more popular than others, the killing of the Nemean lion being the most popular of all (see also Figs. 13, 14, and 15). As the lion was invulnerable, swords, arrows and spears had no effect on it. In the end Herakles, after a terrible struggle, strangled it with his bare hands and then skinned it with its own claws, which could cut through anything, even its otherwise invulnerable hide. Herakles thenceforth either carried or wore the lion's skin.

Some of Herakles' opponents are sufficiently distinctive to make them instantly recognisable, for instance the many-headed snake-like hydra and the triple-bodied Geryon. Others are frequently shown in a conventional schema – for instance, Herakles holding the boar aloft and threatening Eurystheus, who cowers in a large storage jar which he hopes will afford him protection, or Herakles kneeling on the back of the hind. Some have little that is distinctive about them but can be recognised because they are part of a series of illustrations of Herakles' labours. Thus although both Herakles and Theseus captured a bull (Figs. 11 and 12), no one but Theseus could be represented on Figure 11 in the context of those other unmistakably Thesean deeds, while it is certain that Herakles is the hero on the Olympia metopes. Distinguishing two heroes who both use a club and are both involved with capturing a bull is however not always so easy.

All the clues and devices enumerated in this chapter are helpful, but none can be relied on absolutely, as we shall see.

THREE

——————

Choosing a Moment

The story of a myth unfolds in time; an image is static. How does an artist decide what moment to illustrate?

Illustrating the Climax of the Story

The most dramatic moment captures the height of the action, the climax of the story. Thus most artists chose to show Herakles actually killing the Nemean lion, Odysseus actually blinding Polyphemus or Ajax actually committing suicide.

Herakles' first labour – slaying the Nemean lion – was an immensely popular subject with vase painters. Hundreds of examples survive. Because its hide was impervious to all weapons, Herakles was forced to strangle the lion with his bare hands. Most vase painters chose to show him doing just that.

Two main types of images were favoured in the 6th and 5th centuries BC. One showed both Herakles and the lion crouching, almost sprawled on the ground (Fig. 13), the other showed them both standing (Fig. 14).

On a red-figure vase (Fig. 13) Herakles kneels as he grapples with the beast, forcing down the head and forepaws of the lion. Herakles uses both hands to prise open the lion's mouth; the lion braces himself with one hind paw on the ground and uses the other to claw at Herakles' head. The moment is a tense one, as man and beast are locked in combat.

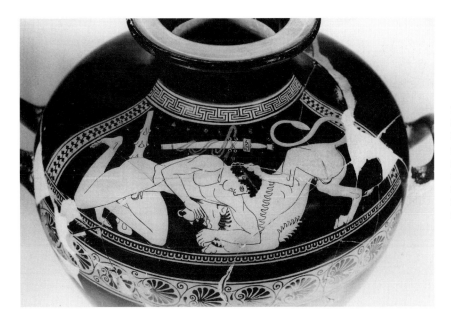

13. Herakles strangling the Nemean lion. Attic red-figure hydria shoulder, c. 500 BC, by the Kleophrades Painter. Villa Giulia, Rome.

Knowing the myth means knowing that Herakles will emerge the victor, but the artist emphasises the intensity of the struggle. Herakles' useless club rests against the corner of the frame to the left; his sword (not his most characteristic attribute but one he is often equipped with) hangs horizontally above him, filling up what would otherwise be a blank space. The two contestants on this vase lie spread out across the whole of the available space.

On a black-figure vase (Fig. 14) both Herakles and the lion are shown standing, the lion perched on one hind paw, while the other claws Herakles' thigh. Herakles has put one arm around the lion's neck and with his hand holds the beast's jaws open. With the other hand he grasps one of the lion's front paws. The lion's other front paw has gone around Herakles' back and claws his shoulder. Thus the two combatants appear to be embracing one another.

To the right of the central group stands Athena, the warrior goddess. She can be recognised by the fact that although she wears a woman's long skirt, she is armed, carrying spear and shield and wearing a helmet. She had much sympathy for young heroes and is often shown standing by them, usually offering moral support rather than providing any physical aid.

To the left of the central group stands Iolaos, Herakles' nephew and his companion in many of his labours. Iolaos looks on anxiously (balancing the caring Athena in his placement). He holds Herakles'

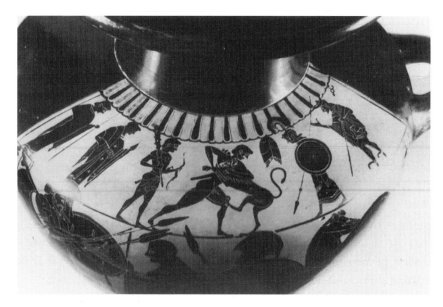

14. Herakles strangling the Nemean lion. Attic black-figure hydria shoulder, c. 520 BC, in the manner of the Antimenes Painter. Iris & B. Gerald Cantor Center for Visual Arts at Stanford University; Hazel D. Hansen Fund.

club and bow while Herakles is otherwise engaged. It is easy to see in this instance how the possession of Herakles' attributes does not automatically make someone into Herakles; later we shall see how even possessing Herakles' unique attribute, the lion skin, does not make the possessor into Herakles. Reading images is not always an entirely straightforward operation.

At the far right, the messenger god, Hermes, wearing his characteristic traveller's hat and carrying his attribute of a herald's staff, gestures encouragingly. At the left, a young man and a woman stand observing. They have no recognisable attributes and are difficult to identify. Perhaps they are just onlookers, brought to the scene to fill up the space. Artists always have to think about the design of the image they are producing as well as the story they are telling.

The subject of Herakles' struggle with the Nemean lion had appeal to artists in other media as well. For instance, this 4th-century BC silver coin from Herakleia Lucania in South Italy (Fig. 15) shows Herakles engaging the lion in what looks very much like a wrestling match. He has grasped the lion in a sort of headlock, suggesting a struggle with anthropomorphic overtones that became increasingly popular. Herakles' club leans on the edge of the coin at the far left; it is a rather thin club of the sort normally associated with Theseus (see Fig. 11). In scenes of Herakles and the Nemean lion, Herakles does not usually wear a lion skin – the skin is still on the lion – but on rare occasions an absent-minded artist accustomed to seeing Herakles clad in the lion skin lost

15. Herakles strangling the Nemean lion. Silver stater of Herakleia Lukania, c. 330 BC. Formerly Leu Numismatic AG, Zurich. Photo courtesy of Auction Leu Numismatics.

sight of the story in hand. This wrestling type of image was extremely popular from the mid-5th century BC on and was used for small bronzes and large marble statues as well as on sarcophagi, the carved marble coffins that the Romans often decorated with mythological scenes.

Another exciting story, the climax of which was often represented by artists, was Odysseus' blinding of the Cyclops Polyphemus.

Odysseus, when he and his men had been trapped in the Cyclops' cave, had calculated that their best hope of escape lay in blinding the monster (see Chap. 2, p. 22). The problem was how to achieve this when the Cyclops was not, as it were, looking. The solution was to get him drunk first.

Various preparations were immediately set in train. A tree trunk the size of the mast of a ship was lying around in the cave. Polyphemus had been planning to make it into a walking stick. Odysseus and his men sharpened one end, hardened it in the fire, hid it and waited. When the Cyclops returned, after he had settled down and devoured two men, Odysseus approached him and offered him some very special wine. Polyphemus drank it greedily and gladly accepted more. He did not appreciate how strong the brew was and soon he fell into a drunken sleep. Odysseus and a few chosen men then grabbed the stake they had prepared and drove it into his single eye.

This is the dramatic moment that is represented in a huge sculptural group that was set up in a cave near Rome during the early Imperial period (Fig. 16). The cave was a natural one, but it was elegantly modified to serve as a sophisticated rustic retreat. This group of large statues was erected in a recess, and though the group is fragmentary, one can recognise without difficulty that it shows how Odysseus' men, small in comparison with the gigantic Cyclops, manoeuvre the large stake ready to strike. The Cyclops lies sprawled out in drunken sleep, an easy prey.

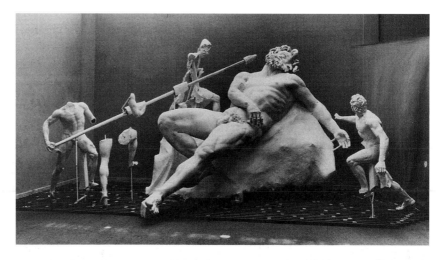

16. Odysseus and his men blinding the Cyclops Polyphemus. Statuary group in a cave at Sperlonga, 1st century BC–AD. Museo Archeologico, Sperlonga.

The blinding of Polyphemus was a popular subject from early times. It was illustrated as early as the 7th century BC. Even in a fragment of a vase (Fig. 17), it is readily identified. Two men are preserved poking a stick into the eye of a reclining giant. More men were originally present, as can be seen from the trace of the leg of a third man at the far right.

The scene was attractive to artists, not only because it was exciting, but also because it was unmistakable. Several men pushing a stake into someone's eye (he need not even be very large) is such an unusual event that it is as easy to recognise as the image of Odysseus under the ram (Fig. 10).

Artists also often chose to illustrate the climax of the story of the suicide of Ajax. Ajax was one of the foremost of the Greek heroes who fought against the Trojans. Homer, in the *Iliad*, calls him "second only

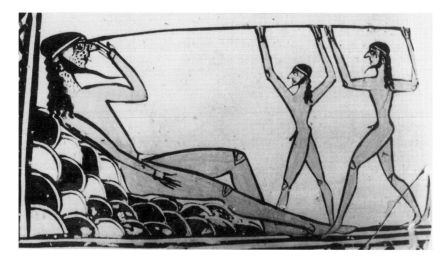

17. Odysseus and his men blinding Polyphemus. Fragment of an Argive krater, mid-7th century BC. Argos Museum, Argos. Copyright EFA (Ecole Française d'Athènes 26.322), inv. C 149. Photo: Emile Séraf.

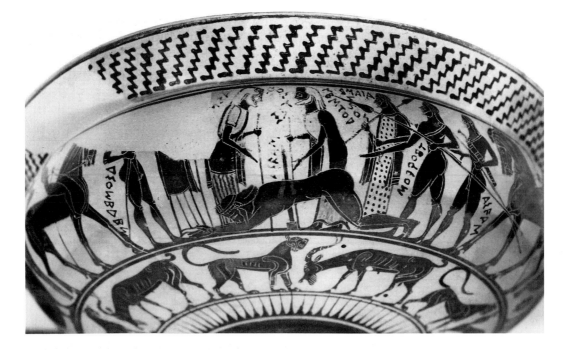

to Achilles". When Achilles was killed, his mother offered his very special armour "to the best of the Greeks after Achilles". Ajax, quite naturally, assumed that he would be the man to receive this prize, but to his astonishment another claimant appeared. This was Odysseus, who, through cunning or persuasion, was eventually awarded the armour. Ajax was devastated by the decision, and humiliated. He could not live with his wounded pride and chose the only dignified way out: he fell upon his sword. On a Corinthian black-figure cup (Fig. 18), the huge body of Ajax lies on the ground. (He was, in fact, notable for his large stature.) The hilt of his sword is visible beneath him, the tip protrudes from his back. What has happened is absolutely clear. The shocked Greek leaders – all with their names inscribed – coming upon his body can have no doubts.

18. Ajax having fallen upon his sword. Corinthian black-figure cup, c. 580 BC, by the Cavalcade Painter. Antikenmuseum Basel und Sammlung Ludwig (Inv. BS 1404), Basel. Photo: Claire Niggli.

The Choice of Other Moments

The climax of a story is a natural moment to choose to illustrate, but it is not the only one possible. The depiction of an earlier or a later moment can be both powerful and moving.

While immediately recognisable scenes of Odysseus and the Cyclops like those in Figures 16 and 17 present a unique event and are

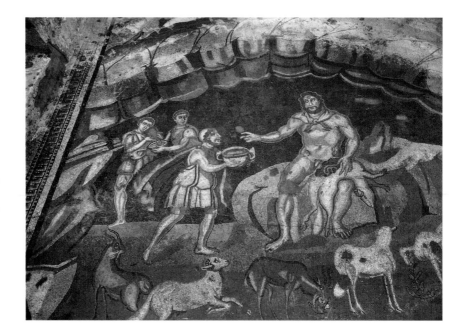

19. Odysseus offering strong wine to Polyphemus. Roman mosaic, 3rd–4th century AD. Piazza Armerina, Sicily. Photo Alinari.

satisfyingly complete, the Roman mosaic in Figure 19 is less explicit and more intriguing. Made out of tiny coloured stones assembled to produce an image, it decorated part of a grand palace in Sicily built in the late 3rd or early 4th century AD. The picture is dominated by a cave with a kind of lawn in front. Within the cave a large man with three eyes is seated on a rock. He wears the skin of a deer as a cape, the hooves knotted at his throat. The skin suggests that the wearer is a wild and uncivilised creature unskilled in the arts of spinning and weaving – a caveman, living in a cave. His three eyes are at first puzzling, but artists often characterised a Cyclops in this way, perhaps suggesting that the two eyes placed normally are merely decorative and only the central one on his forehead is operative. This is indeed meant to be Polyphemus, as further inspection of the image will reveal. Sheep and goats from the Cyclops' flocks mill about on the grass in front of the cave. One sheep turns its head to look at Polyphemus, and that directs our attention to him too. The Cyclops has the partially disembowelled body of a sheep on his lap – devouring its flesh raw is another sign of his barbarity. He steadies it with one hand while he extends the other towards the man who approaches him ingratiatingly holding out a large bowl. In contrast with the Cyclops, nude but for an animal skin, the man who draws near wears a short tunic made out of woven fabric, a hint that he comes from a more civilised environment. Two other men hover in the background,

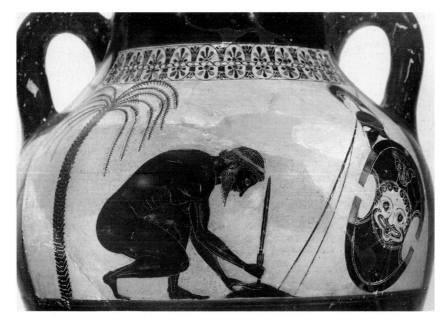

20. Ajax preparing to fall on his sword. Attic black-figure amphora, c. 540 BC, by Exekias. Musée des Beaux-Arts et d'Archéologie, Boulogne-sur-Mer.

pouring out more wine. Nothing very dramatic is happening, but, if you know the story of Odysseus and Polyphemus, you know that something dramatic is about to happen.

Getting the Cyclops drunk was a necessary preliminary to blinding him. No self-respecting Cyclops would ever let a group of puny men put out his eye if he were in his right mind. The mosaic shows this preliminary episode. There is a certain *frisson*, a little thrill of horror, for the observer who knows what the consequences of this apparently friendly offer of a drink will be. *We* know what is going to happen, but Polyphemus doesn't. The unconventional choice of moment can produce a surprisingly exciting effect.

Another example (Fig. 20) also reveals the impact of depicting an un-expected moment before the climax of a story, but in a rather different way. Ajax having fallen on his sword (Fig. 18) is an easily recognisable subject; suicide among heroes is a rare phenomenon and this is a famous one. Most artists who illustrated this myth elected to show the gory out-come, explicit and unmistakable. By contrast the gifted and subtle vase painter Exekias, who signed this work, chose instead an earlier phase of the story (Fig. 20). He drew Ajax alone in a desolate place – the palm tree suggests its isolation. The hero has put his mighty shield to one side with his helmet resting upon it; his two now useless spears lean against the frame of the picture. Ajax has not yet fallen upon his

sword; he is just planting it in the ground, carefully patting the earth down around it so that it will be steady when he throws himself on it. Once again the scene is without violent action, in this case virtually without movement. But if one knows the story this unusual choice of moment has tremendous poignancy. The hero has been humiliated. He does not want to be humiliated again. An awkward fall, a trivial wound – such incidents would only add to his disgrace. The furrowed brow suggests his anguish and his concentration, but even more eloquent are his crouched position and the meticulousness with which he performs the humble task of firming the mound in which he has placed the sword. This thoughtful image, which so profoundly reveals the character and the plight of the hero, is immensely moving. But only if you know the story.

Another artist who chose to represent the moment before a climactic event was the man who designed the east pediment of the Temple of Zeus at Olympia (Figs. 21a and 21b). The story that it illustrates concerns the fateful chariot race between Oinomaos, the king of a city near Olympia, and Pelops, a hero who came from abroad. Oinomaos was reluctant to allow his daughter to wed, but nevertheless – folktale fashion – permitted suitors to compete for her hand. He challenged each aspiring bridegroom to carry the girl off in his chariot and race for the isthmus of Corinth. Oinomaos himself proposed that he would first sacrifice to Zeus and then set out in pursuit of the couple. If he overtook them, he would kill the suitor. Since Oinomaos' horses were as swift as the wind, the suitors fared badly, and as one after the other fell, Oinomaos decorated the entrance to his palace with their severed heads. Twelve or thirteen suitors had perished in this way when Pelops arrived to try his luck. The race itself was, of course, crucial, but the sculptor has not shown this. He has concentrated his attention instead on the tense moment before it begins.

Oinomaos stands to the left of centre, his hand confidently placed on his hip (Figs. 21a and 21b). His mouth is open; he is speaking, explaining the conditions of the race. Pelops, right of centre, with his head modestly bowed, listens intently. Between the two, unseen by the contestants, stands the god Zeus, his commanding presence towering over the mortals, his authority determining their fate. The prospective bride stands to the right of Pelops, adjusting her veil; Oinomaos' wife, her arms anxiously folded before her, stands to the left of her husband. The principal figures are flanked by the two chariots, horses' heads turned towards the centre; servants in attendance kneel in front of or

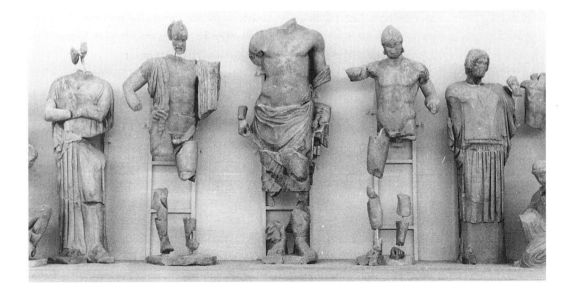

behind the horses; figures personifying the two rivers that flow past Olympia recline in the corners, locating the event in space (Fig. 21b).

Although physically isolated, the figures are psychologically closely bound together: the impending contest unites them. Oinomaos, arrogant and confident, dictating the way the race is to be run, is the sole active figure among them. The others only respond, each according to temperament. Pelops is withdrawn, listening attentively; the bride beside him looks up and out, her openness opposed to his inwardness. On the other side, Oinomaos' wife, closed in on herself (her chin would probably have rested on her hand) serves as a foil to her aggressive, assured husband. The moment is tense – the outcome as yet uncertain. The designer was innovative to choose it. And daring, too, because he had to rely absolutely on the observer knowing what the story was. Without such knowledge you just have a group of static figures in the centre flanked by chariots, servants and river gods. Local guides must have explained what story was being illustrated so that the power of the image could be appreciated. We recognise it only because Pausanias, a traveller in the 2nd century AD, was told the subject and recorded it in his guidebook.

21a. Central figures from the east pediment of the Temple of Zeus at Olympia. Olympia Museum, Olympia.

21b. Preparations for the race between Oinomaos and Pelops. Marble figures from the east pediment of the Temple of Zeus at Olympia, 465–457 BC. Olympia Museum, Olympia.

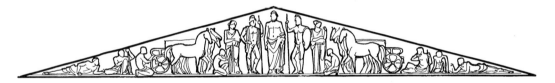

From this example you can see that choosing an unconventional moment carried a certain risk. Uninformed observers have no clue as to what is going on and might miss the point entirely. They might not even appreciate that the chariots are present because a race is about to take place; the chariots might, as in other instances, have simply been used for transport and have no further significance.

No hint is given as to the outcome of the race. It had serious implications, none of which are even suggested. Pelops won, in most versions due to a clever trick, but later had to suffer the consequences. The curse on his descendants, among them Thyestes and Atreus and their sons, Aegisthus and Agamemnon, provided the material for countless tragedies.

Illustrating the moment before the climax of a myth can produce an extraordinary impact; so, too, can illustrating the moment after. The most touching example of this comes from one of the metopes that decorated the Temple of Zeus at Olympia (Figs. 12 and 22). There Herakles' first labour, the slaying of the Nemean lion, is portrayed, not at the height of the conflict as in Figures 13, 14 and 15, but after the struggle was over. Herakles is shown with one foot on the back of the dead lion in the classic pose of the big-game hunter. But there is nothing else of such a hunter about him. He rests his elbow on his knee and his head on his hand. His pose shows that he is utterly exhausted. His face is youthful, almost boyish, only marred by one anxious wrinkle on the smooth forehead. This image captures the humanity of Herakles, revealing that heroes, like other people, get tired and discouraged. The viewer knows that this weary youth has now completed only the first of his labours and that many more lie ahead of him.

The metope is very fragmentary, but the essential message is conveyed nonetheless. To the left of Herakles stood Athena, only her head and one arm preserved. To the right was Hermes; only his foot remains. The gods looked on sympathetically, but there was nothing they could do. Herakles had to deal with his fate on his own.

You cannot recognise the image of a myth unless you already know the story. When the climax of the myth is illustrated there are usually several hints to help you – however vaguely – call the story to mind. If what is shown is not the height of the action but a moment before or the moment after, there will be fewer hints, and visually the image may seem rather dull. There is, therefore, a certain boldness involved in illustrating an unconventional moment in a myth since, if it is to be properly appreciated, the spectator not only has to know the myth but

22. Herakles and the lion. Metope from the temple of Zeus at Olympia, 465–457 BC. Olympia Museum, Olympia.

has to know it very well indeed – or else the point will be lost. But the rewards can be great and the result powerful.

A Synoptic View

A photographic snapshot records a single moment in time. The Greeks and Romans did not have cameras and probably did not have a very rigid concept of what could be seen at any one moment. It is unlikely, therefore, that they found it particularly odd if a single image suggested a number of different things, all of which could not be happening at the same time.

A black-figure cup interior (Fig. 23) gives a wonderfully comprehensive view of Odysseus' adventure with Polyphemus. The Cyclops himself is seated at the right. He holds a pair of human legs, one in each hand. We must assume that these are the leftovers of a feast consisting of Odysseus' men. A man standing in front of the Cyclops is offering him a cup of wine. At the same time the man with the cup holds a stake in his other hand and is backed up by three more men who, all together,

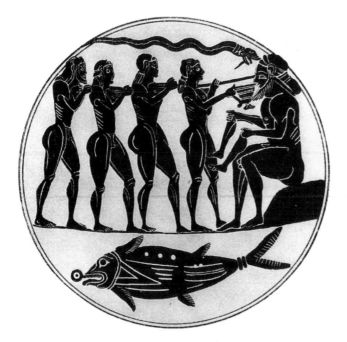

23. Odysseus blinds Polyphemus. Laconian black-figure cup, c. 565–560 BC, by the Rider Painter. Cabinet de Médailles, Bibliothèque nationale de France, Paris.

push the stake into the Cyclops' eye. Logically all the events suggested could not possibly be taking place simultaneously. The Cyclops has his hands full and so is quite unable to take the proffered cup of wine. The men would not be so rash as to try to blind the Cyclops while he was still enjoying his meal and before he had got drunk. The artist is neither giving us a single moment in the story nor presenting a sequence of events. He is just reminding us of the way the story developed episode by episode – Cyclops eats men, Cyclops is persuaded to get drunk, Cyclops is blinded – but with all the episodes collapsed into a single image, a splendidly complete synopsis. The meaning of the snake above and the fish below are harder to fathom; the snake may just be a piece of decoration or a fellow dweller in the cave, while the fish may allude to Odysseus' travels by sea. Such a synoptic image is a highly economical way of conveying several significant elements in a story.

24. Pediment of the Temple of Artemis in Corfu. 590–580 BC.

25. Pegasos being born from the neck of Medusa while Perseus escapes. Attic white-ground lekythos, early 5th century BC. Metropolitan Museum of Art, New York.

A similar synoptic image is used on the pediment of one of the earliest stone temples built in Greece. The centre of the pediment of the Temple of Artemis in Kerkyra (Corfu) is decorated with a huge and impressive figure of the gorgon Medusa (Fig. 24). Gorgons had faces that were so terrible to behold that anybody who looked at them was turned to stone. This made the beheading of Medusa a particularly challenging task. The task was assigned to the hero Perseus, who accomplished it with the aid of some winged shoes and a cap of invisibility, and by judiciously turning his head away at the critical moment.

But once he had severed Medusa's head, there was a great surprise. She turned out to be pregnant, and when her head was cut off, she suddenly gave birth, through her neck, to her two children, the winged horse Pegasos and the man Chrysaor. Such obstetric eccentricities are only to be expected from monsters like Medusa.

On the pediment Medusa occupies the centre in a bent-knee pose that was conventionally used to indicate running. Perhaps we are supposed to think that she is fleeing from Perseus. Her monstrous, truly petrifying, head faces forwards and is comfortably attached to her body. Nevertheless she is flanked by her two children, Pegasos to the left and Chrysaor to the right, something that could never have happened while her head was still in place. The artist has not worried about the time sequence. He has shown us the essential Medusa whose chief characteristic was her frightful face, but at the same time he has shown us her children – a cleverly concise and loaded image.

One can appreciate its effectiveness when one compares it to the work of a later artist who was more scrupulous about his rendition of the myth (Fig. 25). Medusa, her head severed and safely placed in a bag that Perseus carries, has fallen to the ground. The winged horse Pegasos is just emerging from her neck. He leaps out to the right, while Perseus sensibly makes his escape flying off on his winged shoes to the left. The birth scene here is rendered with great explicitness, but the totality of the story is far less clear and the headless Medusa, identifiable only by her nascent progeny, is an unpleasant image.

Epic Expansiveness versus Tragic Focus

A myth can be told either expansively, with many supplementary figures, or concisely, with the focus concentrated on the principal actors. In literature, epics are expansive, recounting a series of events with lively descriptions of settings and actions, and including many digressions and amplifications; tragedies, by contrast, are normally restricted to a single pivotal event, enacted by few characters within a limited time span.

Analogies can be found in vase painting. For instance, a frieze on a black-figure vase (Fig. 26) illustrates the tale of the death of Troilos in rich and expansive detail.

The story of Troilos may have been told at some length in the *Kypria*, one of several epic poems probably composed in the 7th century BC (not long after the time of Homer), which covered parts of the traditional myths of the Trojan War that were not included in Homer's poems, the *Iliad* and the *Odyssey*. The events described in the *Iliad* take place over the course of a few weeks when the Greeks and Trojans were already in the tenth year of the war, while the *Odyssey* was devoted to events that took place after the fall of Troy, especially the adventures of Odysseus on his way home from the war. The *Kypria* dealt extensively with the circumstances leading up to the war and the early years of the fighting, and included an account of Troilos' death. Most of the poem is now lost, and we know about it only through later summaries and a few fragments that were preserved by chance, but the stories it recounted – if

26. Achilles about to kill Troilos. Attic black-figure krater, c. 570 BC, by Kleitias. Museo Archeologico, Florence.

not the epic itself — must have been freely available to the vase painters of the 6th and 5th centuries BC.

Once the Greek army had landed at Troy, fighting was often fierce, but it was not always a matter of mature warriors confronting one another in heroic combat. For instance, when Achilles learned of the prophecy that Troy could not fall if Priam's young son Troilos were to reach the age of twenty, he resolved to kill the boy and thus to eradicate this impediment.

While under siege, Troy was short of water and Troilos, a horse-loving boy, was obliged to venture outside the protective walls of the city in order to reach the fountain-house and water his horses. There Achilles hid to await him. The vase painter sets the scene and also shows what happened next (Fig. 26).

At the far left stands the god Apollo; his role is important but only becomes apparent at the end of the story. Next comes the fountain-house. A young man is just placing his water jar beneath one lion's-head spout; a girl stands on the other side waiting for her jar to fill. She looks to the right and raises her arms in astonishment at what she sees. Beside her are three divinities (Achilles' mother Thetis, Hermes, and Athena), exerting an influence on the action, though presumably unseen by the mortals. Next, virtually in the centre, we see Achilles, or at least what has been preserved of him. He has leapt out from behind the fountain-house and speeds after Troilos. Even though the figure of Achilles is largely lost, the single leg that remains is telling. The foot has left the ground as the hero leaps forward to overtake the terrified boy. Troilos is shown urging on his horses with all his might. Polyxena, Troilos' sister, who has accompanied him to the fountain-house, runs in front of her brother; the water jar that she dropped in her fright lies overturned beneath the horses. Further to the right, the aged king of Troy, Priam, brow furrowed, sits bent under the weight of his sorrows while his friend Antenor brings him this latest piece of bad news. At the

extreme right we see two of Troilos' brothers emerging from the city gates, eager to avenge his murder.

The drawing is delicate and precise, as is the lettering which identifies every figure and even labels the fountain-house and the water jar. A sense of Troilos' terror is conveyed with exceptional sensitivity, showing him with hair streaming and lips tight as he whips on his nervous, high-bred horses, racing fruitlessly against death (Fig. 27). For, indeed, Troilos did not escape. He fled to the sanctuary of Apollo and there was overtaken and brutally slain by Achilles. This deed outraged Apollo, for it violated the sanctity of his shrine, and his stored-up anger against Achilles was finally appeased only when he had brought about the death of the hero. The long shadow of evil cast by the cruel murder of Troilos stretched even beyond the death of Achilles, for it was, according to one version of the story, at the fountain-house that Achilles first saw Polyxena and fell in love with her. His love unconsummated in life, his ghost demanded that she be sacrificed on his tomb (Fig. 2).

Kleitias, who signed this vase as painter, has given an epic breadth to his picture, weaving together insights into the bloody future with visions of an idyllic past in order to place the pursuit of Troilos within a wider context. Thus Apollo at the left hints at the death of Troilos and the vengeance that the god will take on his murderer, while the youth and girl at the fountain-house suggest the tranquil activities of common folk still undisturbed by war. The tone begins to change with the appearance of the three divinities who encourage Achilles to a prodigious burst of speed that enables him to overtake galloping horses. The central scene, the life-and-death race between Achilles and Troilos, is fraught with tension; one would like to know what kind of emotional contribution was made by the fleeing Polyxena, whose skirt and feet

27. Achilles about to kill Troilos. Attic black-figure krater, c. 570 BC, by Kleitias. Museo Archeologico, Florence.

alone are preserved. At the far right, we see the consequences of the
horrors of war: the old king Priam, crushed by suffering, is preparing
to mourn the death of one child while two others emerge from the city
fully armed and ready to join the fray – a significant contrast with the
peaceful scene at the fountain-house.

Narrow friezes like this required many figures to fill them. They
encouraged artists to choose generic subjects like processions, races,
hunts, battles or revels that could be indefinitely expanded. When a
specific myth was illustrated, painters had either to think it out in an
extended form or just add rather meaningless figures to fill up the space,
as on Figure 14, where the vase painter included a pair of spectators at
the left whose only function appears to be decorative.

Vase painters of greater talent were able both to create a beautiful
piece of decoration and to tell a story in a meaningful way. Kleitias had
such talent. In Figure 26 he filled a long narrow frieze with thirteen
figures and two buildings – all of them contributing significantly to the
impact of the tale he was depicting.

Another vase painter (Fig. 28), instead of giving an expansive version
of the myth, condensed the story. As in a tragedy, he eliminated all
extraneous elements and filled his space grandly with only two large
figures: Polyxena, at the far right, arms flailing as she flees desperately
to the right, looking back in terror; Troilos, riding one horse and leading
another, who whips on his steed as he glances fearfully behind him.
There is no room to show Achilles, nor is his presence actually necessary:
the effects of his attack are amply illustrated. Polyxena's water jar, which
she has dropped in flight, has smashed on the ground and the water
pours out, just as, all too soon, the blood of Troilos will be spilt.

* * *

The story that tells of Herakles' encounter with the centaur Nessos
could also be treated in an extensive form or more briefly. An expansive
representation, full of exuberance, is given by a 7th-century BC vase
painter (Figs. 29a and 29b). As centaurs were part horse and part man
(cf. Fig. 8) they were prey to a double nature, but they could also
serve a double function. Nessos made use of his anatomical diversity to
ply the trade of a ferryman, carrying passengers across a river. When
Herakles arrived with his bride Deianeira, Nessos offered to carry the
woman across. Partway he succumbed to the centaurs' unfortunate
susceptibility to feminine charms and began to assault her. Deianeira
cried out and Herakles responded by killing the offending monster.

28. Troilos and Polyxena fleeing from Achilles (not represented). Attic red-figure hydria, c. 480 BC, by the Troilos Painter. British Museum, London.

The vase painter shows Herakles in the centre brandishing a sword as he charges toward Nessos at the left. Nessos seems to collapse at the very threat, hands extended piteously, legs breaking at the knee. You will notice that he has human legs in front and a horse-body attached only at his buttocks. (Most other, later centaurs [see Figs. 8, 30, 31, 68–71, 73, 142, 143, 145 and 146] are human only down to the waist and horse below, but it took a while until this type of image was universally accepted. After all, a centaur is an imaginary monster and there was no standard model that could be copied from nature.) To the right of Herakles, Deianeira sits in the chariot, competently holding the reins of the four horses whose heads fan out at the far right. Only part of her head and arms and the bottom of her skirt are preserved. What is left of her suggests that she has regained her composure. The chariot seems superfluous to the story. One wonders whether it was introduced simply to fill out the scene or because the artist wanted to contrast the lean, athletic horse-body of Nessos with the stolid bodies of the

29a. Nessos collapsing under Herakles' onslaught, while Deianeira holds the reins of the chariot. Proto-Attic amphora, c. 660 BC. Metropolitan Museum of Art, New York.

workaday chariot horses. In any case, the story could be conveyed more immediately in a more compact form.

This is what a 5th-century BC red-figure vase painter has done (Fig. 30). He has reduced the scene to the three principal figures and concentrated on the heart of the action. Herakles has rushed to the rescue – notice how his lion skin floats out behind him; he has grabbed Nessos by his beard and threatens him with his raised club; Nessos sinks to the ground, and, as he tries to escape from Herakles' grasp, he releases Deianeira, who daintily slips from his grip. The arms of the three figures meet in the centre of the image, Deianeira pleading, Herakles avenging, Nessos struggling against the firm hand that prevents his flight. The clean lines of Herakles' handsome face contrast with the bestial features of horse-eared Nessos, just as the hero's bold response contrasts with the crude attack of the centaur.

A still more condensed version of this myth has even more impact (Fig. 31). On a late 7th-century BC black-figure vase, the painter has reduced the story to just two figures: the outraged Herakles and the outrageous Nessos. The power of the image comes from the differentiation of the two protagonists. Herakles is firm and implacable. He has overtaken Nessos and leaps upon him, placing one foot on the spot where human and horse forms join. With one hand he grabs Nessos by the hair; with the other he grasps his sword. Nessos is beginning to buckle at the knees under the heavy weight of the muscular hero. He raises one hand to touch the beard of Herakles. This was a traditional gesture denoting supplication, and here we see Nessos begging for his life. His other hand echoes the gesture, but it looks as if there is little hope for him. Herakles' vigour and energy are contrasted with the

29b. Drawing of Figure 29a.

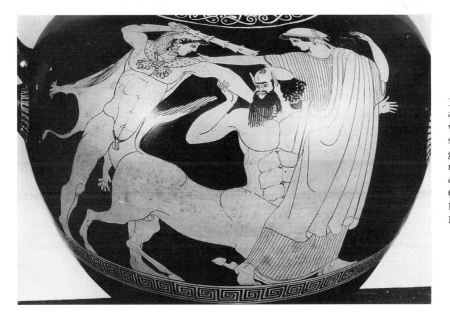

30. Herakles attacks Nessos, while Deianeira slips from his grasp. Attic red-figure hydria, c. 480 BC, by the Oreithyia Painter. British Museum, London.

31. Herakles about to kill Nessos. Attic black-figure amphora, late 7th century BC, by the Nettos Painter. National Archaeo-logical Museum, Athens.

stationary centaur collapsing under attack. Herakles, with his heroic aquiline nose, clothed in a neat tunic, his beard and moustache tidily barbered, epitomises the civilised man, protector of wife and upholder of marriage. The snub-nosed centaur with his messy moustache and untidy beard, unable to control his animal instincts and cowardly when caught out, represents the force of savage instincts. In other stories Herakles himself is guilty of rape, but the flexibility of myth has allowed him another role here, and the genius of an early artist has captured the essence of the story through the subtlety of his characterisations.

* * *

A last example of two different treatments of the same myth comes from the rich mythology surrounding the city of Thebes. It concerns the hero and prophet Amphiaraos. Amphiaraos had married Eriphyle, the sister of Adrastos, king of Argos. When Adrastos resolved to lead an expedition against Thebes so that the exiled Polyneikes could make

good his claim to the Theban throne, Amphiaraos was reluctant to join. He foresaw that if he fought against Thebes, he would never return. Adrastos and Amphiaraos had previously agreed that when differences arose Eriphyle should adjudicate between them. Now they turned to her. Her decision ultimately bore dire consequences.

Polyneikes had brought with him from Thebes a most beautiful necklace, an heirloom that had been given as a wedding present to the founders of Thebes by the gods. He now offered that necklace to Eriphyle as a bribe to persuade her to send her husband along. Eriphyle accepted the necklace – the cause of endless trouble – and did as she was bidden. However unwilling he may have been, Amphiaraos now had to join the expedition against Thebes.

A Corinthian vase painter (Fig. 32) shows Amphiaraos before his palace striding forward with one foot in his chariot ready to depart. Betrayed and angry, he has drawn his sword from its scabbard and turns to look back threateningly at Eriphyle. Eriphyle stands at the far left, at the very back of the crowd bidding farewell to Amphiaraos. She is veiled and holds her cloak out in the gesture of a bride, much like Andromache in Figure 6. But she is a very different sort of wife from Andromache, and this is indicated by the huge necklace that she holds conspicuously in her right hand – an eloquent reminder of what the story is all about. A boy stands in front of the crowd of women, holding loving arms out to his departing father. This is Alkmaion, Amphiaraos' son. Amphiaraos charged the boy to avenge his death: this meant that he was supposed to kill his mother, Eriphyle. When he grew to manhood, Alkmaion fulfilled his father's wish, but this brought him little solace. Pursued as a matricide by the Furies, he was eventually killed, once again through the malign influence of the

32. The Departure of Amphiaraos. Corinthian black-figure krater, c. 570 BC. Antiken-sammlung, Staatliche Museen zu Berlin – Preussischer Kulturbesitz, Berlin.

33. Polyneikes and
Eriphyle. Attic
red-figure pelike,
460–450 BC, by the
Chicago Painter.
Museo Provinciale
Sigismondo
Castromediano,
Lecce.

necklace. A seer, seated on the ground in front of the horses at the far
right, clasps his forehead and rocks with despair. He has foreseen the
grim sequence of events that will follow upon such an unhappy scene
of departure.

This rich image not only focuses on the moment of Amphiaraos'
departure but, like an epic, casts a glance backward to the cause and
forward to the consequences. The way the whole story is packed into
a single scene reminds us of the synoptic approach (Figs. 23 and 24)
in which a compact image is elaborated to carry hints of the past and
future (Polyphemus eating men, getting drunk and being blinded). The
difference – a subtle one – is that in such epic narrations (Figs. 26
and 32) the scope of the story is conveyed by a variety of figures spread
over the space of the vase, suggesting the expanse of the story in time

(Eriphyle accepting the necklace, Amphiaraos setting off, the ultimate failure of the expedition).

An Attic red-figure vase painter chose quite another way to convey the myth (Fig. 33). Using only two figures, he concentrated all attention on the pivotal event. Polyneikes has come to visit Eriphyle in private at home. The long-legged bird between the two figures is a domestic pet. Out of a jewel box Polyneikes has drawn the fatal necklace. He dangles the attractive bauble temptingly before Eriphyle. She reaches out her hand to receive it; their eyes meet and her husband's fate is sealed.

Little seems to be happening. At first glance, this might be any man offering jewellery to any woman, but the names written beside the figures lift the image into the realm of myth. The tragic consequences of this seemingly simple exchange charge the air with ominous forebodings.

PART THREE

BUILDING IMAGES

FIVE

Formulas and Motifs

ome things are more difficult to depict than others. Actions are easier than emotions. A hero fighting a monster or a man kissing a woman are simple to portray, but how can one convey the emotion of fear or of love?

The Greek gods, according to the myths, were very susceptible to the power of love and were often enamoured of mere mortals. But being the object of a god's affection seldom resulted in a happy outcome for the beloved. Many mortals apparently anticipated the disastrous consequences involved in any amorous entanglements with divinities and endeavoured as best they could to avoid them.

Attic vase painters of the 5th century BC, intrigued by tales of gods falling in love with mortals, wished to illustrate instances of divine passion. In order to do so they had to invent some image that might convey the emotions involved. But how can an image reveal the way one's heart beats faster at the sight of the beloved, the catch in one's throat, the thrilling sense of longing?

Formulas with Flexibility

Greek Vases

The vase painters devised a formula: the amorous pursuit. They showed the divinity hot on the heels of the fleeing mortal – longing and desire

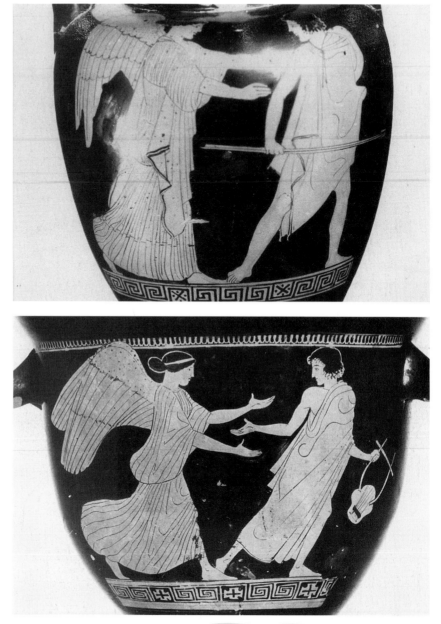

34. Eos pursuing Kephalos. Attic red-figure amphora, 460–450 BC, by the Sabouroff Painter. Museo Nazionale, Naples.

35. Eos pursuing Tithonos. Attic red-figure bell krater, 460–450 BC. Museo Archeologico Nazionale di Ferrara, Ferrara. By permission of the Ministero per i Beni e le Attività Culturali, Soprintendenza Archeologica dell' Emilia Romagna.

embodied in the image of the pursuer reaching out, trying to grasp the beloved person; reluctance and fear conveyed by the flight of the pursued.

The formula lacks subtlety, but it works. It became extremely popular and was used to show not only divinities but also mortals striving to capture the objects of their desire. Three examples (Figs. 34, 35 and 36) illustrate the formula that evolved.

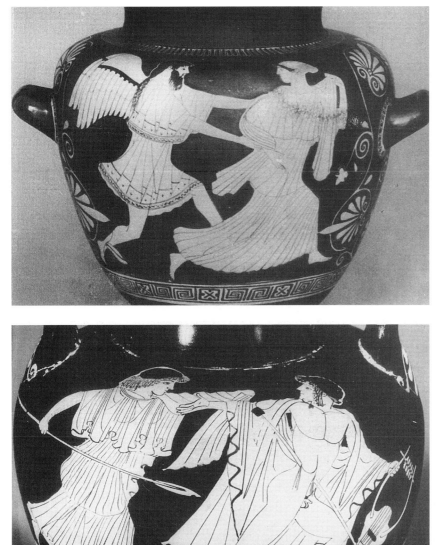

36. Boreas pursuing Oreithyia. Attic red-figure stamnos, 470–460 BC, by the Deepdene Painter. Badisches Landesmuseum, Karlsruhe.

37. Thracian woman attacking Orpheus. Attic red-figure amphora, 470–460 BC, by the Oionocles Painter. British Museum, London.

In Figure 34 a winged woman runs after a youth. Her arms are extended, her hands ready to grab him, the left already on his shoulder. The boy wears a short cloak and has a sun-hat tied at his neck; it is just visible behind his left shoulder. He is obviously an outdoor type and is carrying two spears which indicate that he is a hunter. He looks back anxiously as he strides rapidly away from his pursuer.

Winged women do not exist in real life, so this scene must illustrate a myth. Among mythological winged women, one pathetically prone to falling in love was Eos, the goddess of dawn. One of her loves was the Athenian hunter Kephalos, and it is he, presumably, whom she is chasing in this image.

A very similar scene appears on Figure 35. The winged woman extends both arms as she rushes after a boy. He looks back at her and extends one hand toward her, as if in protest or argument, while trying to flee. This youth has no hunting equipment, but instead holds a lyre. He is the Trojan prince Tithonos, who, like other Trojan princes, for a time worked as a shepherd. Shepherds, isolated and alone with their flocks, like to make music to while away the long hours and it was for this that Tithonos used his lyre.

In the ecstasy of her passion for Tithonos, Eos begged Zeus to make him immortal. This happy thought had sad consequences for Tithonos, because Eos forgot to ask that he should remain forever young. As his immortality dragged on, Tithonos grew older and older, shrunken and withered, little more than a croaking voice within a shell, so that finally Eos simply confined him inside a cricket cage, a suitable dwelling for his reduced circumstances. Eos' unfortunate lapse made him a victim of one of the most refined tortures in Greek mythology: a life detested but death denied.

Images of Eos and her loves proliferated during the 5th century BC. Once a formula had been devised, it was used over and over again. Indeed, such formulas were vital to artists. They provided an essential shorthand for telling a story; they enabled an artist to cast a myth in visual form without having to think out the story from scratch; and they allow the experienced observer to recognise the myth in question without hesitation. Thus the image of a distressed boy on a galloping horse, preceded by a fleeing girl who has dropped a water jar (Figs. 27 and 28), signals at once that Troilos and Polyxena are the pair portrayed, while the image of a group of men driving a stake into the eye of a seated (or reclining) giant (Figs. 16, 17 and 23) indicates that the blinding of Polyphemus is being depicted.

Once the formula had been established, the artist could modify or elaborate the image at will. He could make it more profound and moving or more comical and amusing. The availability of the formula was not only necessary for the artist, but also liberating for him. At worst it enabled him just to get his story across; at best it allowed him to create something startling and original.

The formula provided a framework, but it was not rigid. There was a good deal of flexibility within well-used formulas. Thus, for instance, a small detail – whether a youth is carrying hunting equipment (Fig. 34) or a lyre (Fig. 35) – is enough to distinguish Kephalos from Tithonos, both loved by Eos but different characters with different occupations. If other details were changed, the helpful formula could be retained but used to illustrate another story. On Figure 36 the winged figure is male and the one he pursues is female. The sexes have changed but the schema has not. The winged man is Boreas, the north wind, fierce and violent; the woman he pursues is the Athenian princess Oreithyia. Athenian vase painters may have been charmed by the idea that citizens of their illustrious city were beloved of the gods, and they liked to think that the north wind, their "son-in-law", had considerably blown at the right moment and helped them smash the invading Persian fleet off Cape Artemisium in the year 480 BC.

Although many images are easy to identify, details must always be studied with care. The formula used on Figure 37 is very similar to those we have just been looking at. The fleeing youth carries a lyre like Tithonos on Figure 35, but the woman pursuing him has no wings and holds a spear threateningly. This is no amorous scene but something much more sinister. The wingless woman is not Eos – though occasionally even Eos is shown without wings (Fig. 171), and her quarry is not Tithonos. The story here is of Orpheus, the famed musician, who so charmed the men of Thrace that their wives became jealous and in a rage killed him. Closer inspection reveals that the hapless musician has already been pierced by one spear (running diagonally from his midriff almost down to his groin). The hand he holds out in supplication to the woman pursuing him may resemble that held out by Tithonos to Eos on Figure 35, but in the context the meaning has been intensified and transformed. The established formula provided a point of departure for the artist, one that he modified so as to depict quite a different story. The observer can appreciate this, but only after carefully noting both details and context.

Vase painters produced a huge number of vessels relatively quickly and cheaply, and it is easy to see how valuable the availability of formulas was for their work. For an artist to invent a new type of image to illustrate every subject would have been immensely time-consuming and the results probably less effective.

Although figured scenes on vase paintings were produced in Greece and wherever Greeks lived from the 8th century BC, by the end of

the 4th century BC they had died out almost completely. But myths continued to be illustrated in other media.

Roman Sarcophagi

From around 120 AD wealthy Romans began to favour the idea of being buried in richly carved marble sarcophagi. Unlike painted vases, carved sarcophagi were expensive items and their very showiness may have contributed to their attraction. Sculptors of Roman sarcophagi had to work much more slowly than vase painters, chipping away bits of stone until they had carved out the images they desired, but formulas with flexibility were just as useful for them.

Sarcophagi were decorated in many different ways – some with simple patterns, some with garlands, some with a selection of episodes from a distinguished incumbent's life. Many were decorated with themes taken from Greek mythology. Sometimes the reason for the choice of a particular myth is baffling, especially when the theme is horrific. It is easier to understand why themes were selected which contained hints that death was merely a sleep from which the sleeper awakes to a happy afterlife.

Though the Romans used Greek myths freely, they usually reinterpreted them in the light of their own culture. While a divinity's infatuation with a mortal generally led to disaster in Greek myths, the Romans often took a more positive view of such interactions and when possible chose those myths to decorate their sarcophagi in which the love affair had a happy ending. One such was the story of Ariadne.

Ariadne was a daughter of Minos, the king of Crete, and so half-sister of the Minotaur. When Theseus bravely ventured into the labyrinth to kill the monster, Ariadne, who had fallen in love with Theseus, offered her help. The labyrinth was a maze that was difficult to navigate. The enamoured Ariadne provided Theseus with a thread that helped him find his way out again after he had dispatched the Minotaur. Once the deed was done, Theseus prepared to flee from Crete. Ariadne, having betrayed her family to help the foreign Theseus, fled with him. Theseus, however, was fickle; his eye and heart had already been captured by Ariadne's sister, Phaedra, whom he had stowed away on the ship. On the way from the island of Crete to Athens, the ship stopped overnight at Naxos. When it set sail again in the morning, Theseus and his new love were aboard, but Ariadne was left behind. Grief-stricken, abandoned and forlorn, Ariadne eventually drifted off to sleep. When she awoke,

matters had improved considerably. The god of wine, Dionysus, had landed on Naxos with his tumultuous band of followers. The slightly tipsy but highly attractive god came upon the sleeping Ariadne, immediately fell in love with her, married her, and swept her off to eternal bliss.

What better story could there be to decorate a sarcophagus? The suggestion here is that death is only sleep and the prelude to an afterlife full of joy. Not surprisingly, it was popular on sarcophagi.

While many vase paintings are decorated with only a few figures and these are clearly set off against the background, sarcophagi are covered with a mass of figures, large and small, designed to fill the entire rectangle with visual activity, leaving no gaps or blank spaces. Some figures are, of course, more important than others in conveying the myth, but it is not always easy to pick them out at first glance.

In Figure 38 the right half of the front of a particularly richly decorated sarcophagus is illustrated. The sleeping Ariadne lies in the lower right corner. Her elbow rests on some sort of support and her head upon her hand. Though most of the sarcophagus has been carefully finished, her face and hair have been only sketchily roughed out. The reason is that this popular type of sarcophagus was often prepared in nearly final form in the workshop to await a customer who would require that the features of Ariadne should be a carved into a portrait of his wife. Portrait features were often imposed on mythological figures, especially by the Romans – sometimes in rather more puzzling contexts.

38. Dionysus discovers the sleeping Ariadne. Detail of a Roman sarcophagus from the first half of the 3rd century AD. Louvre, Paris.

Ariadne's right arm is thrown over her head – this was a conventional pose used to indicate that someone was asleep. Her drapery has slipped off her body, so that her torso is fully revealed. Various large and a few small figures surround the sleeping figure. The important one is Dionysus (the fourth from the right). The three other large figures turn their heads left to look towards him, but he looks to the right, as in wonder and delight he beholds Ariadne. Like Ariadne, his torso is bare, his drapery having slipped to just above his groin. He is shown descending from a chariot; the wheel and the car are just to the left of his draped leg. The crowd of figures filling up the space are the rowdy members of his entourage, maenads (inspired female followers), satyrs (male, with horses' ears and tails), and Pans (also male, with goats' legs and horns). Often little love gods (winged babies) help the action along.

The principal figures are, of course, Dionysus and Ariadne, and it is their relationship – the standing divinity descending from a chariot approaching the recumbent sleeper – that establishes a useful formula. The other figures are fillers that can be freely varied according to need.

A similar consoling idea of death as sleep blessed by divine love may be drawn from the story of Endymion, a shepherd on Mount Latmos. Having been granted whatever he wished, Endymion chose the gift of eternal sleep, thus permanently retaining his youth. As he slept, he caught the eye of the moon goddess Luna (Selene in Greek). Enraptured by his beauty, she was said to visit Endymion discreetly while he slept. According to one version, she merely admired him; according to another, she bore him fifty daughters. While Eos, who was equally susceptible to male beauty and also tied to a rigid timetable, usually relied on her wings to pursue her lovers, Luna travelled in a chariot. Part of a sarcophagus (Fig. 39) shows her alighting, drawn forward by a little love god. Others flutter about. One lifts Endymion's drapery to reveal his attractions.

At first glance, the crowd of figures obscures the principals. Endymion himself lies on the ground in the centre, left forearm resting on the ground, right hand over his head to show that he is asleep. The moon goddess, Luna, descends from her chariot at the far left, her eyes fixed on the sleeping Endymion as she approaches him. Three little love gods fill the space around her, and above them is seated a small nude figure identified as Mount Latmos. Hovering above Endymion is the bearded personification of sleep, sprinkling poppy juice over him. At the far right, Luna appears again, in her chariot, departing. She looks back amorously at Endymion, while the chariot horses leap over a small

reclining figure thought to represent the earth. Notice how, despite the assortment of ancillary figures filling the space, the formula for the approaching divinity and the recumbent sleeper is the same as for the Ariadne sarcophagus (Fig. 38).

The Romans had their own national legend of the love of a god for a mortal. The war god Mars was enamoured of Rhea Silvia, who was either a daughter or a descendant of the hero Aeneas. She was a Vestal Virgin and so supposed to be untouched by men. But a god is not a man and the god Mars raped her. This brought little benefit to Rhea Silvia, who died shortly after the birth of her twins, but it greatly benefited Rome, for the twins, Romulus and Remus, initially exposed beside the river Tiber, were suckled by a wolf and grew up to found the city.

A sarcophagus (Fig. 40) shows Mars approaching Rhea Silvia. The energetic, helmeted god of war cuts rather a different figure from the languid god of wine (Fig. 38), though, like him, he is approaching a sleeping woman. Notice how similar the god is to Luna in the way he approaches the sleeping figure and how similar Rhea Silvia is to Endymion. There are, however, small differences introduced into the formula; Mars has not descended from a chariot, Rhea Silvia does not rest her forearm on the ground like Endymion, but rather, like Ariadne (Fig. 38), rests her elbow on some support and her head on her hand. Though the principal figures are close together and so perhaps easier to spot, they are still surrounded by numerous subsidiary figures both large and small, filling out the space and the story, giving indications

39. Selene (Luna) discovers the sleeping Endymion. Roman sarcophagus, first third of the 3rd century AD. The J. Paul Getty Museum, Malibu, California.

40. Mars discovers the sleeping Rhea Silvia. Roman sarcophagus, mid-3rd century AD. Palazzo Mattei, Rome.

of time and place. The heads of Mars and Rhea Silvia have been carved as portraits, as was the intention (unfulfilled) for the blocked-out head of Ariadne in Figure 38. Rhea Silvia even has her hair styled in the manner that was fashionable at the time the sarcophagus was finished.

These three examples show how a formula had been developed for representing a divinity approaching a sleeping figure, a formula which could be transferred from one pair of lovers to another, while the ancillary figures that fill up the rest of the space could be varied.

41. Mars discovers the sleeping Rhea Silvia and Selene discovers the sleeping Endymion. Roman sarcophagus, first quarter of the 3rd century AD. Museo Gregoriano Profano, Vatican, Rome.

A fourth sarcophagus (Fig. 41), unfortunately rather damaged and restored, brings two of these formally related themes together. At the left, Mars approaches Rhea Silvia on foot, while further to the right, Luna descends from her chariot to meet Endymion. In both cases a little love god pulls away the drapery covering the sleeper to reveal the beauty that might otherwise be hidden. Notice how Rhea Silvia assumes

42. Ariadne asleep. Roman sarcophagus, c. 280 AD. Photo: Ny Carlsberg Glytotek, Copenhagen.

the pose usually – though not invariably – assigned to sleeping women, with elbow on a support and head on hand, while Endymion simply has his left arm resting on the ground.

The stories of Ariadne and Endymion were such powerful symbols that the sleepers alone provided an adequate theme for less elaborate sarcophagi. Thus Ariadne (Fig. 42) is shown by herself reclining in the usual manner, left elbow resting on a support, right arm thrown over her head. She is rather more fully clothed than other examples of the type, but otherwise very like them. She is surrounded by three enthusiastic little love gods who might be thought to herald the approach of Dionysus and thus hint at the imminent rescue of the abandoned Ariadne.

A very similar sarcophagus (Fig. 43) is at first glance rather disconcerting. The central figure is meant to be asleep, as one can tell from the arm slung over the head, and is the concern of five fluttering love gods, though the other smaller figures seem to be occupied with other activities. This figure looks very much like Ariadne, even right down to the position of the left arm, elbow resting on some sort of support, head (more or less) on the hand. But something is very wrong with the sex of this Ariadne, who is flat-chested, has hair cropped in a military

43. Endymion (formerly Ariadne). Roman sarcophagus, 250–280 AD. British Museum, London.

style, a masculine face, and traces of an attachment (now lost) in the crotch.

How can one explain the ambiguous appearance of this figure?

What seems most likely is that a normal abbreviated Ariadne sarcophagus (much like that on Fig. 42 but with the head only blocked out) was part of the stock in a workshop. Perhaps unexpectedly, an urgent order was received for a dead man. Rather than declining the order, the clever sculptor quickly realised that his Ariadne could easily be transformed into an Endymion simply by means of a little surgery on the chest, an addition to the genital area, and the final touch – the carving of a portrait head. This happy recognition of the formula's flexibility saved the sale.

Motifs: Unique or Transferable

A formula consists of a group of figures (Troilos and Polyxena, Eos and Tithonos, Dionysus and Ariadne, for example); a motif is a single element (a water jar, a lyre, a child held by the ankle, or even one person carrying another if the two are so tightly bound together that they constitute a single visual unit).

Some motifs are virtually unique to particular myths. The image of a man riding upside-down under a sheep (Fig. 10) is so odd and (under normal circumstances) so impracticable that it can only be associated with Odysseus' escape from Polyphemus' cave. The dropped water jar (Figs. 26 and 28) is so much a part of the story of Troilos and Polyxena, the events that began at the fountain-house and the chase that caused the frightened Polyxena to let her water jar fall, that a water jar in itself, whether broken or just lying on the ground, indicates that Achilles' ambush of Troilos is the intended subject.

Other motifs, which are less specific, can function much like attributes and need not be confined to just one person. Thus a lyre may be carried by the shepherd Tithonos (Fig. 35) or by the musician Orpheus (Fig. 37) or by any number of other mythological and non-mythological figures.

Some motifs can appear in a variety of different contexts. Perhaps surprisingly, this is true of even such an awkward motif as the image of a child being held upside-down by the ankle. The earliest use of this image is in representations of the aftermath of the sacking of a city,

44. Slaying of Astyanax and Priam. Attic red-figure cup, c. 490–480 BC, by the Brygos Painter. Louvre, Paris.

when children were heartlessly slaughtered. But Attic vase painters of the 6th century BC discovered an even more emotion-laden context: individualising the generic motif by giving the child in question a name and family.

The setting was the end of the Trojan War, the final Greek sack of the city, a night of brutal slaughter. In the midst of the turmoil, the old king Priam took sanctuary on an altar, the sanctity of which ought to have conferred protection on him, but in the fury of battle there was no sanctity, no protection. Achilles' blood-soaked son, Neoptolemos, rushed at the aged monarch and slaughtered him upon the altar (Fig. 44, and see also Fig. 82). Thus was the father of heroic Hector slain. But Hector's son still lived, the baby Astyanax; he remained the hope of those Trojans who survived the massacre that their city might one day revive. The Greeks, cognisant of this hope, decreed that the child should be eliminated, thrown from the lofty walls of the city. This, in any case, is the idea preserved in the literary tradition: Priam killed on the altar, Astyanax hurled from the walls.

There are many images of Priam being killed on the altar but none of Astyanax being thrown from the walls. The walls may have been too big, the baby too small to allow for an effective representation, but in any case the vase painters had arrived at a more powerful formulation (Fig. 44). They took the motif of the child held by the ankle and combined it with the ancient king on the altar, thus creating an image in which Neoptolemos uses the helpless infant as the implement with

which to strike his grandfather. Dehumanising Astyanax by employing him as a weapon against Priam produced an image rich in implications: one single, heartless blow simultaneously extinguishing both the past and the future of the doomed city.

Astyanax, in this context, is about to be killed. There is no way that the action of Neoptolemos can be stayed. As in the literary tradition, both Priam and Astyanax die, but the means by which this is achieved is a creation of the vase painters, its horrifying visual immediacy ensuring its use from the 6th century BC on.

A South Italian vase (Fig. 45) shows a man kneeling upon an altar. He holds a baby by the ankle and appears to threaten it with a sword. To the left an anxious woman tears her hair; to the right another woman restrains a man with drawn sword, who rushes at the man upon the altar. Elements of the scene here remind us of Priam and Astyanax, but why would Priam threaten Astyanax? There is, of course, no reason, and in fact the man on the altar is not Priam but Telephos.

Telephos was a son of Herakles, but he had grown up in Asia Minor, near Troy, and did not have much to do with the Greeks on the mainland of Greece. This changed suddenly when the Greeks set off to attack Troy after Helen had been abducted. They did not know the exact location and so landed somewhat too far south in Mysia, where Telephos was king. A fight broke out between the invading Greeks and the astonished Mysians and, in the course of the battle, Telephos was wounded in the leg by Achilles. Eventually the Greeks realised their error and went home.

Time passed, but Telephos' wound did not heal. At last he received an oracle that his wound could only be cured by whatever had inflicted it. Thus, with much trepidation, Telephos set off for Greece to seek Achilles and his cure. According to a tragedy on the subject by Euripides (now lost) Telephos came disguised, fearing that having once been an enemy of the Greeks they would still be hostile to him. When his disguise was penetrated and he was in mortal danger, to save himself he rushed to the altar for sanctuary; but, just to be sure, he grabbed Agamemnon's baby son Orestes as a hostage.

Figure 45 shows the critical moment when Telephos has just reached safety upon the altar – notice his bandaged thigh – and holds the terrified Orestes aloft, vulnerable belly open to his menacing sword. Agamemnon (far right), enraged, rushes forward to rescue his son, but Clytemnestra, his wife, fearing what consequences any precipitate act might have for the child, restrains him. In the end matters

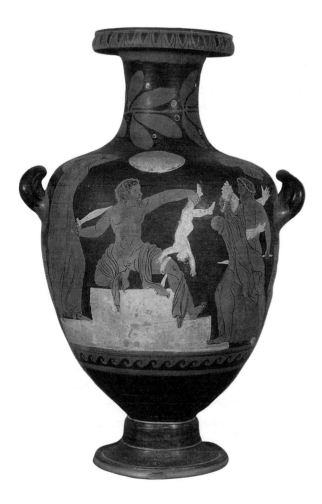

45. Telephos
seated on an altar,
threatening the
baby Orestes.
Campanian red-
figure hydria, c.
330–310 BC. Museo
Nazionale, Naples.

were settled amicably and the baby was returned unharmed to his parents.

A Roman mosaic (Fig. 46) depicts a woman holding a baby by the ankle. The woman is labelled Thetis and the baby Achilles, so there is no doubt as to the persons in this scene. Thetis was Achilles' mother and, as shown here, she neither wished to threaten him nor to murder him, but to confer upon him the blessing of invulnerability, a very useful attribute for a warrior to have. She is, therefore, according to one tradition, dipping him in the waters of the Underworld river, the Styx. If she immersed him entirely, we would not see him and would not understand the image; if she let go of his ankle, he might slip away and drown. Alas, Thetis' holding on to Achilles by his ankle (or, impractically, by his heel) compromised his invulnerability, for in the one place where the waters did not touch him, he remained

46. Thetis dipping Achilles in the river Styx. Roman mosaic (from Xanthos), 5th century AD. Antalya Museum, Antalya, Turkey.

vulnerable, and it was there that he was finally fatally wounded at Troy.

In these three instances, each depicting an infant held upside-down by the ankle, three very different stories have been illustrated with three very different outcomes for the babies involved: death for Astyanax, rescue for Orestes, and partial invulnerability for Achilles.

In the next chapter we shall see more examples of how motifs can be transferred from one context to another and formulas reused to tell totally different stories.

Transference of Types

According to an unpleasantly xenophobic Greek myth, a certain Busiris was king in Egypt at a time when many harvests failed. Famine threatened, and the king was anxious. A Cypriot seer, who happened to be visiting the court, advised Busiris that all would be well if he were to sacrifice a foreigner. Being quite desperate, and finding the foreign Cypriot conveniently to hand, Busiris thought he ought at least to give the advice a try, and so sacrificed the seer.

It worked. Busiris was convinced. In order to avert further famines, he made it a rule to kill any foreigner who came to Egypt. This had become the usual practice when Herakles arrived in the course of his labours. As was the custom, the Egyptians prepared the intruder for sacrifice. This was a mistake, for Herakles quickly turned the tables, and it was the Egyptians, not the Greek hero, who met their deaths. The comic aspects of this unexpected reversal often appealed to vase painters and later to dramatists as well.

But how were artists to show an Egyptian scene and an Egyptian sacrifice? To what model could they turn? When a new subject had to be depicted, the first thing an artist might do was to look around for some familiar form to guide him.

One ingenious vase painter (Fig. 47) drew on the art of the Egyptians themselves and produced a clever parody of a familiar type of Egyptian painting: the mighty pharaoh trampling his puny enemies. The vase painter replaced the traditional pharaoh with the mighty Herakles.

47. Herakles and Busiris. Caeretan black-figure hydria, c. 530 BC. Kunsthistorisches Museum, Vienna.

Depicted in heroic nudity, the irrepressible hero crushes two white-clad Egyptians under his feet, while at the same time he subdues four more, one caught in the crook of each of his elbows, a third strangled in his right hand, and a fourth (at the far right) carelessly grasped by the ankle. Other Egyptians flee, crouch behind the altar or even climb up on it. The wit in the painting comes from fitting the style to the subject; Herakles turns the tables on the Egyptians, the artist turns the tables on the Egyptian style!

But there was also a Greek tradition that a vase painter could draw on: the Egyptian held by the ankle, who dangles helplessly upside-down in the air, may not have got into that position simply because the busy hero was inattentive. This is a motif we have seen before used in other contexts (Figs. 44, 45 and 46).

Another illustration of the Busiris story (Fig. 48) makes the source of inspiration much clearer. Once again Herakles holds centre stage and frightened Egyptians flee. One, presumably the king, in the centre, has fallen over the altar. Herakles holds a white-clad Egyptian by one ankle and prepares to smash him down upon the fallen monarch, using the hapless figure as a weapon. This looks remarkably like the schema used for illustrations of the combined deaths of Priam and Astyanax (Fig. 44), a type invented in the 6th century BC but so widely known that even in Italy toward the beginning of the 4th century BC (Fig. 49) it was still current.

This example shows how eagerly artists drew on established formulas and motifs and how ready they were to transform them. The highly

48. Herakles and Busiris. Attic black-figure amphora, c. 540–530 BC, by the Swing Painter. Cincinnati Art Museum, Cincinnati, Ohio.

49. The death of Astyanax. Faliscan red-figure calyx krater (detail), early 4th century BC, by the Nazzano Painter. Villa Giulia, Rome.

charged tragic image of the child Astyanax murderously used as a tool in his own and his grandfather's murder is cheerfully reused in the Busiris story in a racist context to show the superiority of a Greek hero over his foreign enemies.

Formulas and motifs are the elements out of which images are built. Modifying an existing type is much easier than inventing something entirely new. Artists were always grateful for the help provided by established types, and so they repeated them time and time again, often with small but telling alterations through which the artist could express his own interpretation and individual sensibility.

Clever reuse of a motif or formula could transform it: the poignant could be made banal, the serious comical, the merely sad positively tragic.

An image of Ajax carrying the body of Achilles (Fig. 50) was made to decorate the handle of the large bowl used for mixing wine and water – the very same vessel on which the epic telling of the story of Troilos was painted (Fig. 26). Kleitias, who was an unusually sensitive vase painter, showed Ajax, the Greek hero of the Trojan War known as "second only to Achilles", carrying the dead body of Achilles out of battle. The two, as portrayed by Homer, were close and sympathetic

50. Ajax with the body of Achilles. Attic black-figure volute krater handle, c. 570 BC, by Kleitias (François vase). Museo Archeologico, Florence.

friends, and something of this feeling is captured in the sombre wide-open eye of Ajax and his deliberate movements as he steadies the huge body of Achilles on his shoulders. The solemnity of Ajax is emphasised by the strong verticals and horizontals along which his body and limbs are arranged. Delicate incisions mark the well-developed muscles and robust knees of Achilles, "swift-footed Achilles", as Homer calls him. But now Achilles' feet are swift no longer, nor can he any longer outrun galloping horses as he did when overtaking Troilos (Fig. 26). His man-slaying hands hang helplessly, his hair dangles lifelessly, his eye is dead and closed, in contrast to the large, round eye of Ajax.

The motif of a warrior carrying a dead comrade was not created by Kleitias – it existed already – but Kleitias refined it and imparted to it a new depth and resonance.

A later vase painter took over and modified the motif further to illustrate another incident from the saga of the Trojan War (Fig. 51). Late in the course of the war a group of Amazons, brave women warriors, came to the aid of the Trojans. Their leader and queen was Penthesilea, the bravest of them all. At first the Amazons won stunning victories for their allies, but finally Penthesilea was pitted against Achilles, then at the height of his powers, and there she met her match. A romantic myth suggests that as Achilles dealt the fatal blow, he was much touched by the beauty of his gallant opponent and fell in love with her. Some vase painters chose to show the eyes of victor and victim meeting at

51. Achilles with the body of Penthesilea. Attic black-figure hydria, c. 510–500 BC, by one of the painters of the Leagros Group. British Museum, London.

the crucial moment, but this artist chose another way to illustrate how the Greek hero was obsessed with his female adversary: he showed Achilles carrying the body of the Amazon, her femininity indicated by her pale flesh painted white, out of battle.

It is perfectly normal to carry a comrade's body out of the fray to safety, as Ajax did for Achilles (Fig. 50), but to carry the body of an enemy is so unusual as to suggest special circumstances. The image therefore recalls the only mythological event that answers to this portrayal: Achilles' infatuation with Penthesilea. The artist has cleverly adapted the type used for Ajax with the body of Achilles and has included piquant details like the helpless dangling fingers and the hair, released from the protective helmet, falling freely. Around the central group, fighting between Greek and white-fleshed Amazon continues (to the left), while a warrior and an archer depart to the right. The adaptation is successful and serves its purpose well, but it somehow lacks the power and pathos of Kleitias' creation.

Another example of an adaptation of an image with a change in tone comes from the stories surrounding the sack of Troy. On this terrible occasion many noncombatants suffered – not only those too young to fight (like Astyanax) and those too old to fight (like Priam) but also harmless women like Cassandra. Cassandra, a prophetess whose prophecies were always true but never believed, was one of the most beautiful of the daughters of King Priam. On the night of the sack she sought refuge at the sacred statue of Athena, but she was brutally wrenched away by one of the Greek heroes and raped.

On a cup interior (Fig. 52) you see her clinging to the stiff upright statue, identified as that of Athena by its helmet, spear and shield. The desperate plight of the woman contrasts with the rigid indifference of the statue, as the merciless Greek warrior grasps Cassandra by the hair and prepares to drag her away. This formula was sometimes illustrated on its own, as here, and sometimes combined with other images of the devastation on the night of the sack (for instance the deaths of Astyanax and Priam). It could be rendered with touching eloquence, though this particular example is relatively crude. Nevertheless the formula, however commonplace it had become, could still stimulate a lively comic imagination. A South Italian vase painter adapted the formula to produce a gross and amusing parody (Fig. 53). To the right, a temple attendant (inscribed "priestess") holding a large temple key (the staff with a bent part at the top) retreats in astonishment at the scene which, alas, is preserved only in part. In the centre, clearly

52. Rape of Cassandra. Attic red-figure cup, c. 430 BC, by the Codros Painter. Louvre, Paris.

53. Role-reversal parody of the rape of Cassandra. Paestan red-figure krater fragment, c. 350–340 BC, by Asteas. Villa Giulia, Rome.

visible, is the stiff upright statue of Athena, suitably armed with spear, shield and helmet, as on the cup (Fig. 52). Clinging to it is a grim-faced warrior. He wears a helmet and scaly breastplate, but his grimacing face reveals that all his courage has turned to fear. His right arm embraces the statue, his left hand appears clutching it from behind. Further left, a female arm is visible, the hand grasping his helmet, and still further left, part of a feminine face is preserved; some delicate drapery is also visible attached to the arm and behind the warrior's shoulder. Clearly, a woman is exerting force on the suppliant warrior, trying to pull him away from the protective sanctity of the statue — and he is mortally afraid of the fate that awaits him. Here the artist has turned the tables on the myth, just as Herakles turned the tables on the Egyptians.

Myths were constantly retold, modified, elaborated and expanded. Even when the general framework of a myth was well established, intervening episodes could be expanded or even invented. No single form of a myth was considered final, as incidents, characters and events were constantly added or reworked.

Although the main lines of the story of the Argonauts was well established by the 6th century BC, nevertheless before the end of that century an extraordinarily chilling myth was inserted into it. According to the established tradition, Pelias, the wicked king of Iolcos in Thessaly, deposed his half-brother, the rightful king, Aeson. When Aeson's son Jason appeared and tried to claim the throne that should have been his, Pelias sent him on what seemed to be an impossible mission: to fetch the Golden Fleece. The Golden Fleece was kept, well guarded, far away at Colchis, at the furthest end of the Black Sea. In order to acquire it, Jason assembled a group of heroes (the Argonauts) to sail with him on the treacherous journey to Colchis. At Colchis, Medea, a daughter of the king, fell in love with Jason and helped him achieve his goal. Like Ariadne, having aided a stranger and betrayed her own family, she was ready to flee with the man to whom she had given her help and her heart. Luckier (at first) than Ariadne, Medea accompanied Jason when he returned to Iolcos triumphantly bearing the Golden Fleece.

What happened next is the part of the story that interests us here. Back in Iolcos the infatuated Medea, eager to avenge the wrongs that Pelias had inflicted on her lover, devised a cruel plan. She pointed out to the daughters of Pelias that their father was getting rather old and

frail and suggested to them that it would be nice if there were some way that he could regain his youthful strength and vigour. The affectionate girls gladly agreed, but could not imagine how this might be done. Medea, who was a sorceress, explained that she was in possession of some magic herbs that had the power to rejuvenate anybody or any living thing. The object of rejuvenation only had to be cut up and boiled along with these herbs, and youth would return. The girls were intrigued but doubtful. In order to prove her point, Medea took a weary old ram, slaughtered it, cut it up and threw the pieces into a cauldron; she then sprinkled in her magic herbs. Shortly after the concoction was brought to the boil, a frisky young lamb leaped out of the cauldron.

The girls were impressed. They loved their father and wanted to help him. Nevertheless, one of them doubted and another hesitated, but the third, perhaps the one closest to her father, was firm and decisive.

On a 5th-century BC vase painting (Fig. 54) you see, in the centre, one of the daughters helping the frail old man to rise from his seat. Behind him (at the left) stands a thoughtful daughter, withdrawn and unconvinced. To the right of the elderly man is the fateful cauldron, and behind it (at the far right) stands the most determined daughter of the

54. Pelias with his daughters. Attic red-figure cup, c. 440 BC. Musei Vaticani, Vatican City.

three, one hand raised to greet her father, the other lowered, holding a naked sword. She must have been the one who boldly slaughtered her father, cut up the pieces and threw them into the boiling cauldron. According to the myth, Medea sprinkled in some herbs, but not the magic ones.

No young man emerged.

After patiently waiting for some time, the daughters of Pelias realised to their horror that nothing was going to happen. The fact slowly dawned on them that they had murdered their father and whether they had done so out of love or out of hate hardly mattered: the deed was done. Jason and Medea fled and the daughters of Pelias were left to consider the consequences of their well-intentioned actions.

By the end of the 5th century BC the image of the determined daughter of Pelias had become psychologically richer and more complex. She appears on the right of one of the so-called Three Figure Reliefs (Fig. 55) (reliefs created in the late 5th century BC in Greece but now known only through Roman copies). On the left, Medea, self-assured and clearly in control of the situation, stands opposite her. Medea's hand rests on the crucial box of herbs, while her headdress indicates her foreign origins. Between the two, one of the compliant daughters of Pelias adjusts the placement of the cauldron.

The once determined daughter does not seem so determined now. She holds the bared sword in her right hand, the empty scabbard in her left and reflects. The pose, one hand supporting the elbow, head resting on the other hand, closed in and sorrowful, may have been invented by the wall painter Polygnotos in the first half of the 5th century BC. He was a great innovator in the portrayal of character and states of mind and had a considerable influence on other artists. The sword-holding daughter, no longer decisive, appears to be torn between love for her father and her reluctance to kill him. She still holds the sword that will do the deed, but her pose now resembles that of the reluctant daughter on Figure 54.

Much later in the course of the myth, Medea herself was faced with a similar dilemma, but, characteristically, it was hatred, not love, that motivated her.

Years had passed since Medea had incited the daughters of Pelias to murder their father and she and Jason had escaped to Corinth. They had been living there peacefully enough for some time and had had two sons, when the opportunistic Jason decided to marry the daughter of

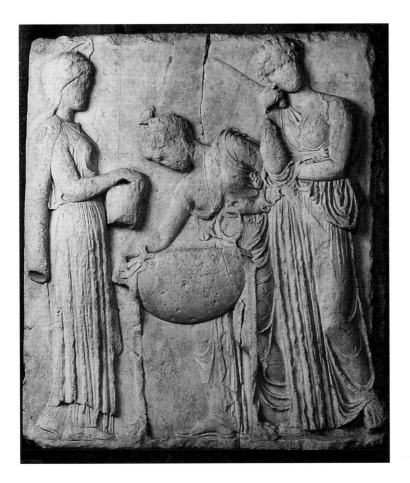

55. Medea with two of the daughters of Pelias. "Three Figure Relief", Roman copy of a Greek original of the late 5th century BC. Musei Vaticani, Vatican City.

the king of Corinth and callously repudiated Medea. Medea's fury was vividly dramatised in Euripides' tragedy that bears her name. Resolved to avenge the injury, Medea arranged a painful death for the innocent princess and her father, but feeling that this was not punishment enough for Jason, she set about plotting a blow yet more severe. Though any future marriage for Jason was now blighted, he still had his sons. Medea (in Euripides' innovative play) decided to eliminate this last source of consolation for her ungrateful, faithless lover. She planned to kill the children. Certainly this final disaster would break Jason's heart. And Medea's own heart as well.

Euripides' bold tragedy powerfully delineated Medea's plight. One moment driven by hate to wish to kill the children, the next moment driven by love to wish to spare them, Medea in Euripides' portrayal was an inspiration to artists in other media. It must have informed a

celebrated painting by a certain Timomachos of Byzantium. The paint-
ing is now lost, but a poem that describes it has survived:

> The art of Timomachos has mixed together the hate and love of
> Medea, as her children are being drawn to their death; for at one
> moment she has been nodding assent toward the sword, but now
> she refuses, wishing both to save and to kill the children.
>
> *The Greek Anthology* 16.135 (trans. Pollitt)

There are several Roman paintings that appear to reflect this lost
masterpiece. Some show Medea watching the children at play, some
show her seated, some standing. The position of her arms varies from
painting to painting; none, perhaps, is an exact copy. The most moving
of them (Fig. 56) seems to capture Medea's anguished uncertainty and
so may come closest to the famous original, at least in mood. Style,
drapery, pose, all are somewhat different from the anguished figure

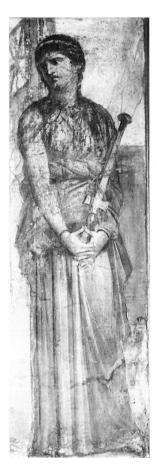

56. Medea
contemplating the
murder of her
children. Roman
painting from
Herculaneum,
third quarter of
the 1st century AD.
Museo Nazionale,
Naples.

in the Three Figure Relief (Fig. 55), and yet does this not look rather like an intelligent, sensitive adaptation of the earlier image? And is not this image of Medea subtly enriched by its visual similarity to the image of the victim of her machinations? Medea now finds herself in the same position as the daughter of Pelias, eager yet reluctant to kill a beloved person. One may be motivated by love, the other by hate, but the consequences will bring similar heartache to both.

The originals of the Three Figure Reliefs are lost and we know them only through copies. Clearly they were much admired and appreciated. We cannot know whether Timomachos was inspired by the image of the troubled daughter of Pelias on the Three Figure Relief when he was formulating his portrayal of the anguished Medea, but he may have been.

The transmission of motifs and formulas is easier to appreciate in some contexts than in others. Vase painting, for example, is a field in which an element of continuity is easiest to perceive. From the 6th through the 4th centuries BC the production of vases was enormous and trade was considerable, so that vases travelled widely. The abundance of examples made images freely available; the identity of material and technique encouraged adaptations. Thus even when vase painters lived in different centres and were separated by several generations, a tradition persisted, providing material suitable for modification.

In a similar way, though the products were fewer and the scale of manufacture smaller, workshops that specialised in carving sarcophagi from the 2nd century AD on developed recognisable formulas applicable to various popular subjects. By this time pattern books of some kind had probably been circulating throughout the Roman world for quite a while, providing images that could be used in a variety of media, and one sees similar schemata appearing, for instance, in paintings and mosaics and sometimes even in sculpture as well. In the course of time a corpus of themes, motifs and formulas became available to artists in a variety of media, an inexhaustible source of stimulation and a spur to creativity.

SEVEN

Creating Compositions

Formal beauty and narrative clarity are not always compatible and reconciling the two can be a formidable task. Artists rose to the challenge in various ways.

When Troy fell to the invading Greek army, Menelaus finally recovered his wife, Helen, whose elopement with Paris had been the cause of the war. The beautiful Helen was justly frightened of what her angry husband would do. And indeed, when Menelaus found her, he fully intended to kill her.

A red-figure vase painter (Fig. 57) leaves no doubt as to Menelaus' intentions when he shows the aggrieved husband driving his errant wife before him, his sword drawn menacingly. Helen extends one imploring hand toward Menelaus, as she moves away from him to the right, where another woman stands, arms extended protectively. This woman is probably the goddess Aphrodite, the deity who persuaded Helen to run away with Paris. Aphrodite never forgot her role in determining Helen's fate, and she continued to feel responsible for her. Thus before Menelaus could put his threat into action, Aphrodite inspired him with such awe for Helen's loveliness that he gave up all idea of punishing her and meekly took her back. Helen is here placed in the centre of the image, properly the centre of attention between her angry husband and her divine guardian.

Another artist, again making use of just two women and a warrior, has arranged the scene differently (Fig. 58). He has placed Menelaus in

57. Menelaos threatens Helen while Aphrodite protects her. Attic red-figure hydria, c. 480 BC, by the Syriskos Painter. British Museum, London.

58. Menelaos drops his sword, dazzled by Helen's beauty. Attic red-figure amphora, 475–450 BC, by the Altamura Painter. British Museum, London.

the centre, his sword dropping from his hand as he is overwhelmed by the beauty of his wife. Helen rushes away from Menelaus to the right. A second woman, who flees to the left, is unlikely to be Aphrodite – a goddess would have a more commanding presence. She can be taken, rather, as an anonymous Trojan woman, alarmed at the sight of the man

with the sword. For the artist, she serves to balance the figure of Helen on the other side. In comparing Figures 57 and 58 one can appreciate the different factors that can influence an artist's arrangement of three figures. The artist of Figure 57 seems to have been more committed to telling the story and differentiating the roles of the two women; the artist of Figure 58 was more interested in producing a balanced composition: the two women are practically mirror images of each other; both rush away from the centre but turn their heads to look back and raise one hand towards the warrior between them. Only the dropped sword gives us the clue that the woman on the right is Helen.

Vase painters illustrating myths were sometimes more concerned with composing well-balanced images that would effectively decorate their vessels than with producing meaningful interpretations of traditional stories.

Another example of how the drive for symmetry can compromise the meaning of a myth also involves the goddess Aphrodite and takes place after the fall of Troy.

Aphrodite's son Aeneas was a brave Trojan warrior eager to fight to the last for his city, and the goddess found it difficult to persuade him to flee with his family before it was too late. Finally, however, Aeneas agreed, and accompanied by his wife and little boy, carrying his aged father on his back, he made his escape. One black-figure vase painter (Fig. 59) shows Aphrodite (at the far left) anxiously watching over her son's departure, while Aeneas, bent under the weight of the old man, strides away to the right. He is preceded by his wife carrying a little

59. Aeneas escapes from Troy with the blessing of his mother, accompanied by his wife and child, carrying his father. Attic black-figure amphora, c. 520–510 BC, by the Antimenes Painter. Museo Nazionale, Tarquinia.

60. Aeneas escapes from Troy, carrying his father on his shoulders, accompanied by his wife and child and others. Attic black-figure amphora, c. 520–500 BC, by one of the painters of the Leagros group. Antikensammlungen, Munich.

child and an (unidentified) archer wearing a pointed hat of the sort that was thought characteristic of Trojans.

The image of Aeneas piously carrying his father to safety impressed many black-figure vase painters, and they delighted in representing it, often as the centre-piece of their decoration (as on Fig. 59). The painter of Figure 60 has also done this, but rather unthinkingly he has flanked the central group with a pair of female figures in mirror image. The women seem to dance away from Aeneas, turning their heads to look back at him. The one to the right resembles the conventional figure of Aeneas' wife preceding him, but the one to the left is nothing but a decorative addition, a woman perversely fleeing in the wrong direction. Here again the artist's love of symmetry has overruled his concern for meaningful narrative. The picture is markedly successful in terms of decoration, but less successful in terms of the story. The tension between decoration and narration is a real one for vase painters, and some are better at resolving it than others.

Aphrodite's involvement with the Trojan War was even more important at the beginning of the war than at the end. She was one of the three goddesses – Hera and Athena were the other two – who were brought before Paris, a Trojan prince temporarily acting as a herdsman, to have him judge which of them was the most beautiful. All three attempted to bribe the judge. Whether it was Aphrodite's indisputable beauty or her irresistible offer, Paris awarded her the prize. Aphrodite had offered Paris the most beautiful woman in the world in exchange for his vote. The most beautiful woman in the world happened to be Helen, then

married to Menelaus, but a promise was a promise (or a bribe a bribe), and so Aphrodite helped Paris persuade Helen to run away with him. And it was, of course, to recover Helen that Agamemnon, Menelaus' brother, assembled the Greek troops and after ten years' long siege finally sacked Troy.

The Judgement of Paris was a theme that fascinated vase painters. At first their preferred form for representing it was a procession, as on Figure 61, where, on one side of the vase, the three goddesses in single file follow Hermes (the messenger god) and a white-haired old man (perhaps a local guide), to be greeted on the other side by Paris, accompanied by three cows, a bird and a dog. The five figures on the one side are evenly spaced, the animals on the other side overlap, but on both sides a handsome pattern is produced by means of a good deal of added dark purplish-red and white paint and a fine sense of design. Paris raises one hand to greet the approaching group, and the white-haired old man, who carries a herald's staff, responds. Hermes, young and beardless, also carrying a herald's staff, turns back to instruct Hera, who follows holding her veil out in a bridal gesture. Next comes Athena carrying a spear and wearing a smart helmet, while climactically last comes Aphrodite, elegantly attired and raising her hand in a gesture of salutation matching that of Paris.

It is a delightful piece, effectively combining a vivid portrayal of the myth with a pleasing design. The 6th-century BC Etruscan vase painter who created it may not have been very sophisticated, but he had a good eye for pattern.

A subtler image was produced by an Athenian vase painter in the second quarter of the 5th century BC (Fig. 62). This painter covered the cylindrical terra-cotta box he was decorating with a white slip on top of which he drew the figures in black outlines and coloured their rich draperies in flat tones of red and yellow. The rustic Paris sits on a pile of rocks, an unidentified man standing behind him. Hermes, his traveller's hat tied on to the back of his neck and carrying his messenger's wand,

approaches Paris. Hera, holding a sceptre, turns towards Athena, who wears her characteristic scaly aegis and holds her helmet in one hand and her spear in the other. To the left of the two future losers, Aphrodite stands with a libation bowl in one hand, addressing a boyish winged Eros, the god of love through whose power she is destined to win the contest.

62. The Judgement of Paris. Attic white-ground pyxis, c. 460 BC, by the Penthesilea Painter. Metropolitan Museum, New York.

Around this time, writers tell us, major wall paintings began to be produced. Although the murals themselves no longer exist, Figure 62 with its pale background, figures delicately drawn in outline and decorated with simple colours, gives us an idea of one aspect of what these wall paintings might have looked like. It fails, however, to give any hint of the scale of these monumental works, the multitude of figures that they contained and the drastic new compositions that had been created so that large areas could be covered with interesting images.

The name of Polygnotos of Thasos, whose murals painted during the second quarter of the 5th century BC in Athens and Delphi (now unfortunately lost) were greatly celebrated, is associated with these novel designs. Polygnotos, as we learn from descriptions made by Pausanias hundreds of years later, was particularly noted for his ability to convey character and emotion, and he often did this not through action but more subtly through stance and attitude, as had been done on the east pediment of the Temple of Zeus at Olympia (Fig. 21b) where a tense mood is conveyed through quietly standing figures.

Prior to Polygnotos, apparently even in wall paintings, figures had been assembled standing on a single ground line, but when the number of figures was greatly increased and there was no action to bind them together, some new mode of organisation had to be invented. In order to accommodate a larger number of figures, Polygnotos decreased the size

63. The Judgement of Paris. Attic red-figure hydria, c. 420–400 BC, by the painter of the Carlsruhe Paris. Badisches Landesmuseum, Karlsruhe.

of each figure, and in order to make the whole surface of the wall visually interesting, he placed some figures higher up and others lower down, as if they were disposed on a sloping hillside. Whether intentionally or not, this new organisation also suggested that some figures were further away than others and so introduced the idea of a space that the figures occupied rather than just a surface that they decorated. This spatial effect was enhanced by a pale, empty background.

These astonishing pictorial innovations made many traditional modes of decoration look hopelessly old-fashioned. Even red-figure vase painters, whose conventional black backgrounds negated any suggestion of space, were eager to espouse the new compositions. Thus when a vase painter of the late 5th century BC (Fig. 63) undertook to illustrate the Judgement of Paris, he did it in an up-to-date, sophisticated manner.

The figures are small in relation to the space available and they are scattered up and down the surface of the vase. A landscape of hillocks and rocks must be imagined, hinted at by barely perceptible white lines. Paris, in elaborately embroidered exotic garb, sits in the middle, his dog at his feet. He turns his head towards a little love god who stands at his shoulder. Half-hidden by a hillock directly above him, Eris, the goddess of discord, can be glimpsed. It is appropriate that she should appear here, as it was she who had produced the Golden Apple inscribed with

the words "For the fairest" which had induced the goddesses to vie for the prize and so initiate the Trojan War. Hermes, youthful and nude, holding his herald's staff, stands on lower ground to the right of Paris. The contesting goddesses themselves are more difficult to find amid the scattered supplementary figures, yet Athena, with her shield, spear and helmet, can be spied just to the left of Paris, and Hera, holding a sceptre and lifting her veil, on slightly lower ground further to the left. Aphrodite is seated to the right of Hermes, her arm around a little love god. This is a clever rearrangement of the traditional scene, intriguing and challenging to the viewer, who is helped to decode the image by the fact that all the figures have their names inscribed beside them.

A Roman mosaic (Fig. 64) sets the scene more comfortably within a landscape. Having a wide range of coloured stones available and none of the conventions that restricted vase painters, the mosaicist had no trouble indicating that his figures are placed within a credible space. Paris (a little to the left of centre) sits before a column, his herds and flocks

64. The Judgement of Paris. Roman mosaic. 2nd century AD (from Antioch). Louvre, Paris.

around him, listening to Hermes to the left. At the right, diagonally receding into space, are the three goddesses: Hera nearest leaning back against a rock, Aphrodite comfortably seated in front of a column topped by a little love god, and Athena, wearing her identifying helmet and carrying a spear, standing furthest away. The rocky landscape and the leafy tree in the background are all plausibly suggested. The artist has conjured up a rural idyll in which a crucial mythological event is taking place. The forms may not be as decoratively balanced as in the early vase painting (Fig. 61), nor the story so immediately intelligible. By the complexity of the spatial rendering, the artist was endeavouring to evoke a scene so vivid that you might imagine you are seeing it enacted before your very eyes. This ambitious goal eliminated any simpler composition that might look contrived.

It may seem that in creating such an image the artist had a great deal of freedom. He could make his figures any size he wished, put them in any setting he liked and arrange them in any way he pleased. But artists were never entirely free; they were always limited by the space they were allowed, or obliged, to fill. Sometimes they were limited by the shape available as well.

The most uncompromising demands were imposed on sculptors decorating architecture. The shapes were determined by the architecture and the sculptures not only had to fill them but had to fill them entirely – from top to bottom and from side to side – in order to be effective from a distance.

Classical architecture provided three shapes admitting sculptural embellishment: long, thin ribbons (for Ionic friezes, Fig. 65); almost square rectangles (for Doric metopes, Fig. 66); and broad, low triangles (for pediments in either order, Fig. 67). All of these presented problems to the designer, especially if he wanted to illustrate a myth.

There are, of course, many ways in which a myth can be depicted: the moment chosen and the participants included can be varied as required. Some myths, particularly those which involve fighting, are particularly flexible when it comes to filling different kinds of shapes. For long, thin friezes, combatants can be multiplied until the requisite space is filled; for rectangular metopes, the combatants can be reduced to a series of single pairs; for pediments, a presiding deity can be placed at the highest point, in the centre, while the consequences of the fight – figures standing, lunging, falling and fallen – can have their heights adjusted to the sloping sides of the triangle.

The clever adaptation of the myth of the Lapiths and the centaurs to different architectural contexts is a case in point.

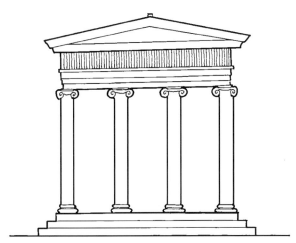

65. The usual placement of a sculptured frieze.

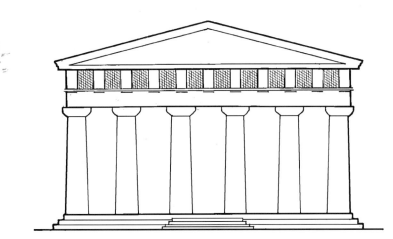

66. The usual placement of sculptured metopes.

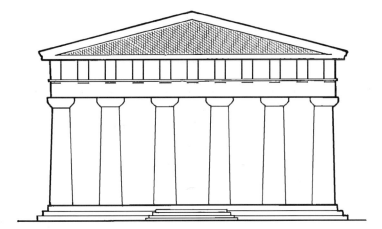

67. The placement of sculptured pediments.

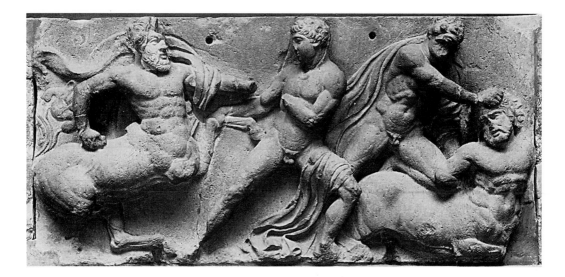

68L. Centaurs and Lapiths fighting. Frieze from the temple of Apollo at Bassae, late 5th century BC. British Museum, London.

The Lapiths were a people living in the north of Greece. When the Lapith king got married, he invited his neighbours the centaurs to the wedding. This was a necessary courtesy but a risky business, as the centaurs had two great weaknesses: women and wine. As they were exposed to both at a wedding, things were unlikely to go smoothly.

At first all began well; the centaurs arrived politely offering gifts (Fig. 73), but as the wine began to flow, they started to get excited, to grab the women (or even serving boys) (Figs. 68 and 71) and the Lapiths had to restrain them with whatever came to hand. Eventually the Lapiths drove the centaurs away, went home to fetch their armour and weapons, and finally defeated the centaurs in an open fight out-of-doors.

The temple of Apollo at Bassae was decorated with a sculpted frieze which, unusually, did not adorn the outside of the building but its interior. This long narrow strip ran around the inside of the main room of the temple. It was filled with scenes from two mythological battles: the battle of the Lapiths and the centaurs on one half, the battle of the Greeks and Amazons on the other. The heads of most of the figures had to reach the top of the frieze, otherwise there would be unsightly gaps. To avoid gaps at the sides, figures had to be multiplied until they filled the entire space available. The result was an ingenious array of combatants in vigorous movement often emphasised by elegant swirling drapery. Figure 68 shows part of the frieze involving four centaurs. At the far left a centaur rears up against a Lapith who staggers back from the attack, while to his right another Lapith, who has successfully brought

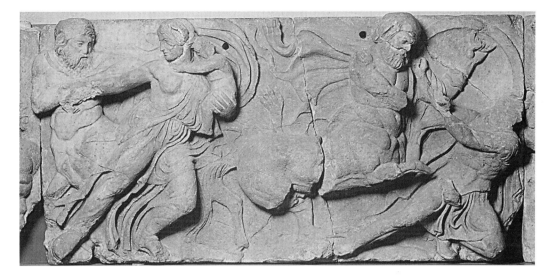

68R.

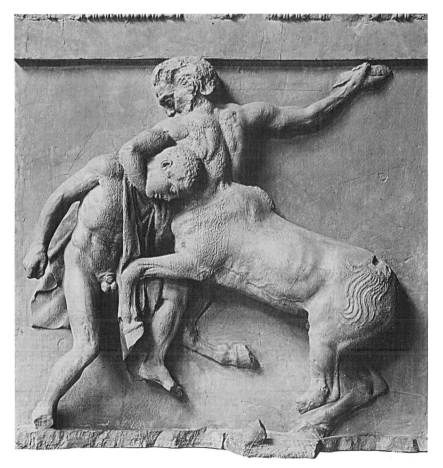

69. Centaur and Lapith engaged in combat. Metope from the south side of the Parthenon, 447–442 BC. Photo from a cast, metope in situ on the building.

a centaur down, kneels on the centaur's back and seizes him by the hair. Still further right, a centaur moves to the left, having grabbed hold of a woman who holds a baby. (It is unusual to find children or babies depicted in this story, and scholars have wondered whether the Bassae frieze reflects a local variant of the legend that has not come down to us.) At the far right a centaur charges a fallen Lapith, the force of his attack emphasised by the way the windblown animal skin that he uses for a cloak billows out behind him.

The battle between Lapiths and centaurs was also adapted as the subject for some of the metopes of the Parthenon. Instead of having to extend the fighting, adding incidents and combatants as necessary to fill a long frieze, the opposite approach had to be taken: the story was drastically reduced to its essentials, and each metope contained just two figures. In one of the metopes (Fig. 69) centaur and Lapith are locked in combat. The centaur holds a rock in his raised right hand, while the Lapith thrusts a weapon (now lost) into the centaur's back, just above the tail. The weapon was probably originally made of metal; it may have been a spit used for roasting meat at the wedding feast, for the Lapith has no armour and probably would not have had a proper weapon. The combat is charged with energy. Quite a different impression is created by another metope (Fig. 70). Here the Lapith lies crumpled on the ground, while the centaur rears triumphant above him. Strong horizontals, marked by the supine body of the Lapith and the extended arm of the centaur, contrast with the vertical torso of the centaur and the fall of the lion skin to provide a stable structure, while the dynamic diagonals of the centaur's horse-body and legs ensure a dramatic effect. Notice the way the animal skin underlines the barbarity of the centaur in contrast to the woven garment of the civilised Lapith.

The pediment was the most awkward shape that sculptors had to deal with: a long, low triangle. In order to fill the whole space, the figures' heads all had to reach the top, but if a unified scale were to be maintained, the figures could not all stand up to their full height as in metopes and friezes. Once again, depicting a fight provided a solution. In the centre, a divinity presided, taller than any human figure. He (or she) could be flanked by standing men, whose heads would not come up quite so high, while further from the centre the accidents of battle would ensure that some figures were brought to their knees and others crouched, and finally those in the corners lay almost flat.

On the west pediment of the Temple of Zeus at Olympia (Fig. 71) the god Apollo occupies the centre of the scene, flanked on one side by

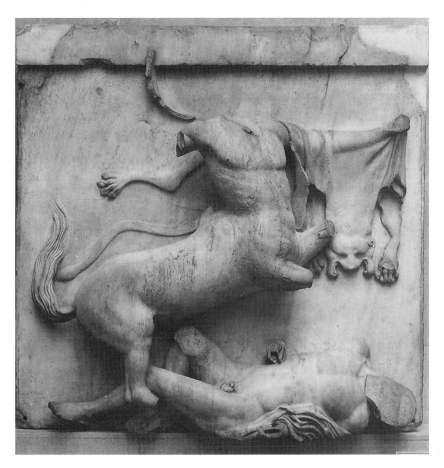

70. Centaur who has killed a Lapith. Metope from the Parthenon, 447–442 BC. British Museum, London.

Peirithoos, king of the Lapiths, and on the other side by his friend, the Athenian hero Theseus. These standing figures are flanked in turn by centaurs, each of whom has taken hold of a woman. Further out to the sides a dynamic struggle is portrayed, a mêlée including men, women, centaurs and boys, some brought down to their knees, some lunging, some retreating to the comparative safety of the corners away from the heart of the violence. An ingenious variety of situations has been imagined, cleverly designed so that the level of the struggling figures' heads gradually becomes lower along with the slope of the pediment.

71. Battle of Lapiths and centaurs, with Apollo in the centre. West pediment of the Temple of Zeus at Olympia, 465–457 BC.

Other themes of conflict proved equally versatile. A battle between Greeks and Amazons occupied half of the internal frieze at Bassae. As with the battle of the centaurs, there was no problem in multiplying the number of combatants, but other aspects of the battle were also explored here; for instance the gentleness and compassion shown to injured comrades (Fig. 72). Notice how the Amazon at the right tries to lift her comrade, while the battle surges around them and a helmeted Greek attacks another Amazon at far left. Mythological encounters allowed for the depiction of a wide range of human experiences. The tension between aesthetic charm and narrative impact is revealed here in the way the drapery swirls around the fighters in unlikely calligraphic patterns, their purely decorative character strangely at odds with the violence and passion of the human figures.

Battles of Greeks and Amazons were also adapted for use on metopes, again reduced to pairs (for instance, on the west end of the Parthenon) and for use in pediments (as on the temple of Asklepios at Epidauros), but these sculptures are poorly preserved and therefore difficult to illustrate.

Of course, other subjects – even ones without violence – could also be adjusted to fill these demanding spaces. Thus on the Temple of Zeus at Olympia the theme that informs the whole series of metopes over the porches is the labours of Herakles, and the interpretations and compositions are brilliantly varied (Fig. 12), some of them being wholly free of conflict, like Herakles with the slain Nemean lion (Fig. 22).

72. Greeks and Amazons fighting. Frieze from the temple of Apollo at Bassae, late 5th century BC. British Museum, London.

The sculptures of the east pediment of the Temple of Zeus at Olympia were ingeniously designed so that the figures fit the space but are not involved in any conflict (Figs. 21a and 21b). The scene is tense, but absolutely still. Quite different again were the subjects of the pediments of the Parthenon (better known from Pausanias' description than from the actual remains): the birth of Athena (on the east) and a contest between Athena and Poseidon for the patronage of Athens (on the west). Friezes could be filled with hunts (mythological or otherwise), processions, or sacrifices just as easily as battles, so long as the personages involved were sufficiently numerous to fill the space.

A painting for either wall or panel, like the mosaic in Figure 64, allows more licence to the designer than a metope, which requires the whole space to be filled with very few but very large figures. Thus a wall painting from Pompeii (Fig. 73) shows the centaurs just arriving for

73. Peirithoos greeting the centaurs. Roman painting from Pompeii, third quarter of the 1st century AD. Museo Nazionale, Naples.

the wedding feast within an ample spatial setting. They are all courtesy and good manners. The leading centaur has just presented his offering of a basket of fruit and politely kisses the hand of his host. A woman and a child (to the left) look on rather anxiously, while the rest of the centaurs can be seen outside the doorway to the right, about to crowd in. There is a good deal of space above the heads of the figures and even a view of a columned building to the left and of blue sky to the right. The mass of centaurs beyond the doorway recede into the distance. There is an abundance of space and air, and an architectural setting complete with a large supporting column and a beamed ceiling, but the composition as a whole is neither beautiful nor compelling. Clearly it is the talent of an artist, not his freedom from constraining conditions, that determines the quality of his creations.

PART FOUR

INNOVATIONS,
DEVELOPMENTS
AND CONNECTIONS

Innovations Inspired by Poets

From time to time new subjects appear in art. Since so much Greek and Roman art has been lost, it is often difficult to know what has inspired them, but in some cases there is sufficient evidence for us to make a pretty good guess.

In 458 BC Aeschylus' trilogy of tragedies, the *Oresteia*, was produced. It presented the story of the murder of Agamemnon and how it was avenged. Agamemnon, as you remember, was forced to sacrifice his beloved daughter Iphigeneia in order to enable the Greek fleet to set sail for Troy (see Chapter 1).

The first of Aeschylus' tragedies (*Agamemnon*) recounted how Agamemnon returned home after ten years, having triumphed over Troy, and how he was received by his embittered wife, Clytemnestra, still unreconciled to the death of her eldest child, Iphigeneia. During Agamemnon's absence, his wife had taken a lover, his cousin Aegisthus. When Agamemnon arrived, after giving him a seemingly warm welcome, she contrived to murder him (along with his concubine, the unfortunate daughter of Priam, Cassandra, whom Agamemnon had brought along as part of the spoils).

Agamemnon and Clytemnestra's only son, Orestes – the very one once threatened by Telephos when he was a baby (Fig. 45) – had been spirited away to a place of safety, but Electra, Agamemnon and Clytemnestra's second daughter, had remained in Mycenae, at first

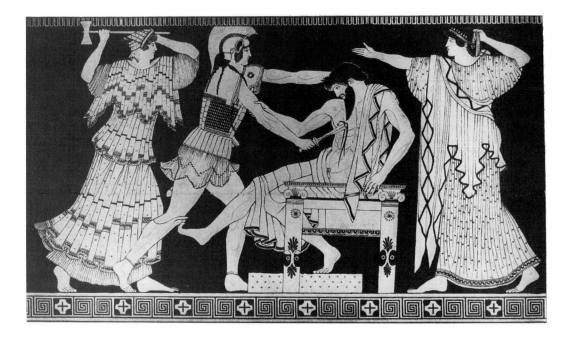

74. Orestes kills
Aegisthus. Attic
red-figure
stamnos, c. 470 BC,
by the Copenhagen
Painter. Antiken-
sammlung,
Staatliche Museen
zu Berlin –
Preussischer
Kulturbesitz,
Berlin.

angry at her mother's adultery, later grieving over her father's mur-
der. She longed for Orestes' return and for vengeance.

The second of Aeschylus' tragedies (*The Libation Bearers*) tells how
Orestes finally returned and how brother and sister met at the tomb of
Agamemnon. There they planned the murder of their mother and the
usurper Aegisthus. Once this was accomplished, they assumed, honour
would be satisfied. But the murder of a mother is not without its price.
Orestes was pursued by the Furies, the spirits that avenge the killing of
a blood relative, and they drove him mad. In the last play in the trilogy
(*The Eumenides*), this impasse was finally resolved.

Parts of this story had been known from the time of Homer and much
of the rest had been added by various poets since then. Around the end
of the 6th century BC and the beginning of the 5th, there had been a
brief vogue among vase painters for illustrating the death of Aegisthus.
One vase (Fig. 74) shows Aegisthus seated on his usurped throne while
Orestes plunges a sword into his chest. Rushing up behind Orestes,
Clytemnestra, wielding an axe, endeavours, too late, to save her lover.
At the right a girl clutches her head and gestures in alarm; presumably
she is Electra, warning her brother of the threatened danger.

By the middle of the 5th century BC representations of the death
of Aegisthus had virtually ceased and instead there arose an unprece-
dented interest in depicting the meeting of Electra and Orestes at the

tomb of Agamemnon (Fig. 75). Electra, to the right, has placed her water jar (from which she would pour libations) on the ground and extends one hand to Orestes, seated at the left, his sword in his raised right hand. Beneath him sits Pylades, his loyal companion, his chin in his hand. Between brother and sister looms the tomb of their father. Other representations show Electra seated on the tomb (or standing beside it) as Orestes and Pylades approach. Such images continued to be made well into the 4th century BC.

The fact that the meeting of the siblings, so powerfully dramatised by Aeschylus, suddenly came into fashion shortly after the production of the tragedy strongly suggests that it was this play that provided the inspiration for the artists who developed the theme.

The third play in the trilogy clearly also impressed artists, because it was only after its production that vase painters began to portray scenes of Orestes pursued by the snake-wielding Furies, as on Figure 76, where the unfortunate Orestes seeks sanctuary with the god Apollo, at

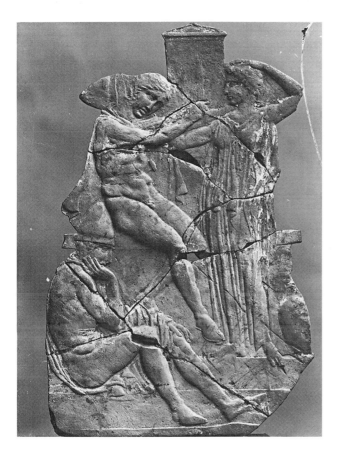

75. Electra meets Orestes at the tomb of Agamemnon. Clay relief plaque, "Melian Relief", c. 440 BC. Antiken-sammlung, Staatliche Museen zu Berlin – Preussischer Kulturbesitz, Berlin.

the far left, while fleeing from two women who brandish snakes. The Furies themselves are disappointingly tame-looking, quite lacking in the impact they were supposed to have had in the theatre (and the terror they struck into Orestes, according to the play). They are, however, faithful to Aeschylus' description in being wingless.

The plight of Orestes became a popular subject for vase painters. Many of them gave the Furies wings, even though the text of the play specifies that they did not have them. But texts were rare at this time, and vase painters certainly did not consult them. Like others in the audience, they must have carried away little more than a general impression of the action, which they fleshed out in the way they thought best. What is important is the fact that a scene which we know Aeschylus was the first to dramatise had a sudden (and lasting) impact on artists.

Another Aeschylean tragedy, only traces of which survive, reworked the traditional story of Telephos. Telephos was king of Mysia, where the Greek forces landed by mistake when they first set out for Troy to recover Helen. Once the Greeks discovered their error, they departed, but not before Achilles had wounded Telephos (see Chapter 5). To find a cure for his wound, Telephos had to come to Greece, a hazardous undertaking for one who had fought in a battle against the Greeks. For that reason, according to the early form of the myth, Telephos immediately took refuge on an altar and from that place of sanctuary stated his

76. The Furies pursue Orestes. Attic red-figure hydria, c. 450 BC, by one of the later Mannerists. Antikensammlung, Staatliche Museen zu Berlin – Preussischer Kulturbesitz, Berlin.

77. Telephos seeks sanctuary on the altar. Attic red-figure cup, c. 485 BC, by the Telephos Painter. Museum of Fine Arts, Boston. H. L. Pierce Fund 98.931.

case (Fig. 77). Here he is shown seated on the altar surrounded by Greeks, his left thigh conspicuously bandaged, gesticulating emphatically as he addresses a thoughtful bearded man, while an excitable Achilles (to the right) impulsively draws his sword.

Aeschylus, it appears, rethought and embellished the story. He tried to imagine what it was like to beg a favour of your enemy, and his imagination may have been helped by a recent historical event.

Themistokles, the Athenian general, who in 480 BC had engineered the Greek victory at Salamis during the Persian wars, had fallen foul of his countrymen and had been forced to flee from Greece. As luck would have it, he had to seek temporary asylum in Molossia, where the king, Admetus, was a man whom he had once offended. According to the historian Thucydides, the king was

> not there at the time, and Themistokles was instructed by the king's wife, to whom he applied as a suppliant, to take their child in his arms and to sit down by the hearth. Before long Admetus returned and Themistokles told him who he was Admetus listened to him and then raised him to his feet, together with his own child, whom Themistokles had been holding in his arms as he sat there – and this indeed had had the greatest effect on the success of his supplication
>
> Thucydides 1.36–1.37 (trans. Rex Warner)

Aeschylus appears to have had much sympathy for the exiled Themistokles, and it is likely that he had him in mind when he was thinking about the plight of Telephos – wounded, alone, afraid in

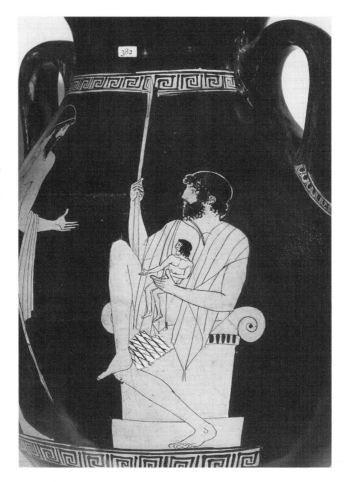

78. Telephos seeks sanctuary on an altar and increases his suppliant power by holding the baby Orestes. Attic red-figure pelike, c. 450 BC, by a painter near the Chicago Painter. British Museum, London.

the camp of his enemies. Perhaps that is why (in a tragedy now lost) he invented the story of Telephos, an anxious stranger in the palace of Agamemnon, aided by Agamemnon's sympathetic wife, holding Agamemnon's beloved only son, Orestes, on his lap as he seeks sanctuary on an altar, an innovation portrayed in this vase painting (Fig. 78). The baby, hovering improbably above Telephos' wounded thigh, seems quite at ease, unthreatened and ready to join in the pleas of the suffering man.

Later in the 5th century BC, the tragedian Euripides was intrigued by the complexities he saw in this tale, which he dramatised early in his career in a tragedy now lost. In dealing with the story, he took invention and elaboration further still. He puzzled over how Telephos could infiltrate the Greek camp undetected and decided that he must have come in disguise. He therefore portrayed Telephos as a beggar

in what was rather a startling innovation in the Greek theatre at the time, and one that thoroughly caught the imagination of the comic poet Aristophanes, who must have seen the play while he was still something of a youngster himself. He never forgot it.

Euripides apparently gave the plot of his tragedy many twists. Telephos' disguise was penetrated and his identity revealed. In this parlous state, surrounded by menacing enemies, it was not enough for him just to sit quietly on an altar holding the infant Orestes, but he actually had to threaten the baby, now a hostage, in bargaining for his life. This dramatic turn of events was striking and memorable, and it remained vividly in people's minds even if the action took place offstage and was only reported by a messenger. Several vase painters dramatised the event (Figs. 79 and 45). These show the anxiety of Agamemnon to rescue his son and how Agamemnon is being restrained by his wife, Clytemnestra, who is even more concerned that he should do nothing to imperil the safety of the baby.

In Figure 79 Telephos kneels on the altar holding a sword pointed toward the unprotected stomach of the frightened child, while a nurse (to the right) rushes to his aid. To the left Agamemnon holds his spear menacingly but is restrained by Clytemnestra.

Artists were particularly good at portraying the reaction of the unhappy mother: her anxiety for the safety of Orestes and her natural mother love are all the more moving (and ironic) if you recall the gruesome end of the relationship between this mother and son.

79. Telephos, kneeling on the altar, threatens the infant Orestes. South Italian vase, preserved only in tiny fragments, known from an engraving made by Tischbein for Sir William Hamilton. Original vase from the 4th century BC.

Euripides' version of the story was immensely popular and is reflected in numerous works of art, quite crowding out all earlier versions. Although most of Euripides' tragedy no longer exists, its influence in stimulating images of Telephos seated on the altar threatening the baby Orestes is unquestionable.

The comic playwright Aristophanes, who lived in the later 5th century BC, found Euripides' *Telephos* irresistible for parody and parodied it more than once. In one play (*Thesmophoriazousai*) he had fun showing the plight of a man disguised as a woman. When the man's disguise is penetrated (as was that of Telephos), he snatches a baby away from a nursemaid (as Telephos snatched up Orestes) and, impersonating Telephos, threatens to kill it. But as he unwraps the supposed baby, he discovers that it is in fact no baby at all, but a wineskin. "Ah," he exclaims, "doesn't it look sweet in its little Persian booties?" And that is exactly what a vase painter has shown (Fig. 80): the Telephos impersonator is seated on the altar and approached by a servant with a bowl prepared to catch the blood of the sacrifice. The man on the altar holds a threatening sword in one hand and the baby that turned out to be a wineskin in the other. The image is such an accurate portrayal of the scene in the comedy – right down to the little boots at the ends of the wineskin – that there can be no doubt that this odd representation was inspired by Aristophanes' comedy.

80. Parody of Euripides' *Telephos*. South Italian, Apulian red-figure bell-krater, c. 380–370 BC, by the Schiller Painter. Martin von Wagner Museum, Würzburg.

At the formal Athenian dramatic festivals, each playwright who produced a set of three tragedies also produced a satyr play to follow them. Satyr plays were often mythological parodies in which satyrs, the wild, mischievous, amoral and often inebriated followers of Dionysus, were introduced into a plot in which they originally had no place. Only one satyr play has survived complete, the *Cyclops* of Euripides. It tells the story of Odysseus and the Cyclops Polyphemus (see Chapter 3) but tells it with a difference. The satyrs have been shipwrecked and captured by Polyphemus, who has enslaved them. But they make very bad slaves – with comic results. They, and especially their leader Silenus, constantly clamour for wine, a crucial element in the traditional story. When Odysseus arrives and produces some of the desired potion, Silenus' greed (he tries to drink even more than the Cyclops) nearly leads to the collapse of Odysseus' scheme and the whole plot misfiring. Much of the amusement and suspense comes from knowing how the story ought to come out and anxiously observing how it appears to be getting derailed.

We can assume that this play caught the attention of a vase painter (Fig. 81) who shows Polyphemus asleep at the front of the scene. Notice that he is shown with one arm thrown over his head and the other lying on the ground, the very same pose for indicating that a male figure is asleep that we see used hundreds of years later on sarcophagi (Figs. 39 and 41). The cup that contained the wine that brought about his

81. Odysseus and his men prepare to blind Polyphemus while satyrs interfere. South Italian, Lucanian red-figure calyx krater, c. 415–410 BC, by the Cyclops Painter. British Museum, London.

downfall stands beside him. He has one large empty-looking eye in the centre of his forehead and two more normally placed eyes, apparently closed to indicate that they are unseeing. Odysseus directs the three men preparing the tree that will be used to poke out his single functioning eye. The clue to the inspiration for this scene comes at the far right, where two horse-tailed satyrs caper onto the scene. The boastful but unreliable satyrs in Euripides' play had offered to help blind the Cyclops, but at the critical moment their courage failed. In the end, of course, everything was resolved in the expected way, but the whole tone was more comic than heroic.

* * *

When a new theme suddenly becomes popular in art, it is tempting to search for the source that may have inspired it. We know that traditional myths were constantly reworked, reinterpreted and given new twists. Sometimes, as in the examples here drawn from tragedy, comedy and satyr play, we can trace how innovations in drama stimulated artists to create new types of images. Other types of poetry – and even prose – also influenced artists, but only rarely can we identify them.

Innovations Inspired by Artists

So many works of classical art and literature have been lost that it is often hard to find links that explain why new images occur, and all too easy to miss them. It is often assumed that innovations in art were stimulated either by current political events or by new poems or plays; and it is difficult ever to prove that this was not the case. Still, in some instances it may be argued that artists went their own way independent of any outside influence.

One such artistic innovation appears to have been made in the horrific representations of the old king Priam being bludgeoned to death by the body of his own grandson, Astyanax (Figs. 82 and 44). Priam, father of the Trojan hero Hector, and Astyanax, Hector's son, died, according to surviving literature, in two different places at two different times. Priam was slain on an altar during the night of the sack of the city; Astyanax was hurled to his death from the ramparts on the following day. Artists combined the two murders to produce a powerful vision of the completeness of the destruction of the city, the eradication of both the memory of the past and the hope for the future. Such a compressed image has an immediacy and impact that would be lost in the time required to describe the situation in words; it is a creation of graphic artists that finds no parallel in literature.

In Figure 82 Priam has been pushed down across the altar on which he had taken refuge (his position is similar to that of the pharaoh in Figure 48, though he lies face up and the pharaoh face down). The

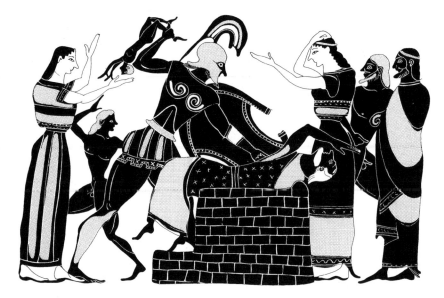

82. Neoptolemus uses the body of Astyanax as a weapon with which to batter Priam, who has taken refuge on an altar. Attic black-figure amphora, c. 550 BC, by the Persephone Painter. British Museum, London.

cruel warrior standing above Priam grasps the tiny body of the child Astyanax by the ankle, about to use him as a weapon to finish off the old man. Women flank the central scene making gestures of dismay, while a small boy escapes to the left, a nude man makes off to the right and a draped man stands by apparently unperturbed.

This type of scene was invented sometime in the 6th century BC. It soon became popular among vase painters but seems to have always remained independent of the literary tradition.

The next example of what might be an artistic innovation is harder to verify. We could see how differently the deaths of Priam and Astyanax were treated in art and in literature because we could compare surviving depictions in art with surviving descriptions in literature. By contrast, depictions of Ajax and Achilles playing a game (Fig. 83) survive in abundance in art, but there is no surviving work in literature to compare with them. Perhaps none ever existed. If that is so, the theme is one that was actually invented by an artist.

Images of Ajax and Achilles playing a game begin to appear a little after the middle of the 6th century BC. Arguably the earliest representation is on one of the most beautiful black-figure vases preserved (Figs. 83 and 84). It was painted by Exekias, the same thoughtful vase painter who chose so imaginatively to depict the troubled Ajax preparing with anxious care for his own suicide (Fig. 20).

On one side of the vase Exekias showed the two great heroes, Ajax and Achilles, engrossed in playing some sort of board game (Fig. 83).

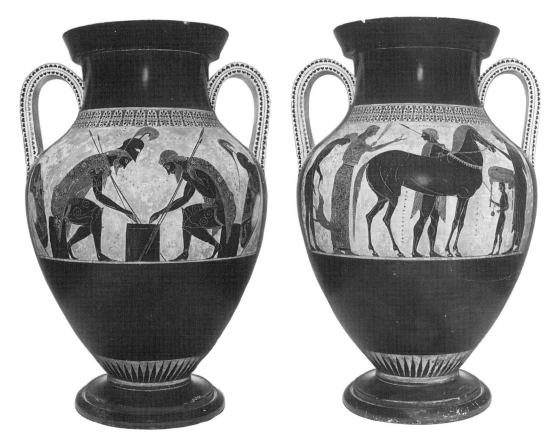

They have set their shields down to lean against the frame behind them. They hold their spears loosely as they bend into the game with intense concentration. The composition is brilliantly designed to fit the shape of the vase, the discarded shields leading the eye up to the bottom of the handles, the spears pointing up to the top of the handles, and the inclined backs of the heroes echoing the curve of the vase itself. The detail is no less exquisite than the composition: incisions of the greatest delicacy delineate the embroidery on the cloaks, the curls of the hair, and the beards. Finally, a subtle hierarchy is suggested by Achilles gaining height through wearing his helmet, while Ajax, unhelmeted, seems smaller. This detail alone failed to find favour with other artists, for they generally preferred to show both heroes helmeted or both bareheaded. For the rest, they were delighted with the splendid new image. Over a hundred examples survive; there may have been thousands. All appear to be later than Exekias' vase.

Occasionally, artists elaborated the scheme in one way or another, placing a tree between the two warriors, or more frequently the goddess

83L. Ajax and Achilles playing a game. Attic black-figure amphora, c. 540–530 BC, by Exekias. Musei Vaticani, Vatican City.

84R. Kastor and Polydeukes with Leda and Tyndareus. Attic black-figure amphora, c. 540–530 BC, by Exekias. Musei Vaticani, Vatican, Rome. The other side of Figure 83.

85. Ajax and Achilles playing a game with Athena between them and warriors fighting at each side. Attic red-figure cup exterior, late 6th century BC, by Epiktetos. Aberdeen 744 and Florence B 20.

Athena. Sometimes, if there was more space to fill (Fig. 85), other warriors were shown pursuing military activities at either side of the scene.

The idea that Homer's greatest heroes, when not playing the game of war, were playing a war game, placed symmetrically opposite each other just as Homer describes their two camps symmetrically disposed at the two ends of the Greek line, combined with the stillness of the image and the intensity of the competing heroes, all united to make this a tremendously appealing theme. But where did the theme come from?

Some scholars suggest that the scene illustrates some poem of which not a single trace remains; others suggest that Exekias was thinking out what heroes do when they are "off duty," independently of any external inspiration.

Perhaps a clue can be found by looking at the other side of Exekias' vase (Fig. 84). On this side the painter showed the illustrious mythical royal family of Sparta at home in a quiet moment. Polydeukes (at the far left) has just arrived to be enthusiastically greeted by a dog, in the manner typical of dogs. His mother, Leda, has her back to him; all her attention is turned to her other son, Kastor, who is about to mount the fine horse that occupies the centre of the scene. Leda offers him a flower, and he turns his head to thank her. Tyndareus, Leda's husband, stands at the far right, stroking the horse's nose, while a small servant brings a stool and a container of oil, appropriate objects to welcome a tired rider home.

No story seems to be associated with this image; it seems simply to record the everyday activities of heroes, the moments when they are not

being particularly heroic. It never became popular with other artists, unlike the scene with Ajax and Achilles (Fig. 83). But if no story appears to be attached to the side of the vase showing Leda and her sons, why must there be one attached to the side showing Ajax and Achilles, which also seems no more than a slice of life in a heroic context?

A third example of what might be an artistic innovation deals with a work that is now lost; we know about it because it was mentioned by the Roman polymath Pliny. It is the sculptor Leochares' image of Ganymede being carried off by an eagle (see Fig. 88).

Ganymede was one of a number of strikingly handsome youths who were produced by the ill-fated city of Troy. Three were so handsome that even the gods could not resist them. Eos, the dawn goddess, was enamoured of the Trojan Tithonos (Fig. 35) and Aphrodite, the goddess of love herself, succumbed to the charms of the Trojan Anchises, to whom she bore her son Aeneas (see Fig. 59). Ganymede's seductive beauty so enthralled Zeus that the great god swept him away to serve as his cupbearer among the gods.

A late 6th-century BC vase (Fig. 86) shows Ganymede, still a young boy, performing this service. He stands attentively before Zeus holding a jug, while the impressive god sits facing him, thunderbolt gripped in his left hand, the right holding out a libation bowl; other gods and goddesses flank the central group.

In the 5th century BC, vase painters became less interested in the results of the abduction and more interested in the abduction itself.

86. Ganymede serving Zeus in the midst of other gods and goddesses. Attic red-figure cup exterior, late 6th century BC, by Oltos. Museo Nazionale, Tarquinia.

87. Zeus pursues Ganymede. Attic red-figure kantharos, c. 490–480 BC, by the Brygos Painter. Museum of Fine Arts, Boston (Perkins Collection).

They enjoyed imagining it as a sort of amorous chase and represented it this way frequently for about half a century. Typically (Fig. 87), a vase painter showed Zeus, dignity thrown to the winds, in hot pursuit of his quarry, sceptre held in one outstretched hand, the other with fingers extended, ready to grasp the elusive boy. Ganymede holds his hoop – a hint that he is still hardly more than a child – and dashes away from the eager god. In his haste, he unveils his enticing body. Does the vase painter mean to suggest that this is an accident or is he rather hinting that there might be something intentional, perhaps even provocative, in the gesture?

After the middle of the 5th century BC this kind of encounter fell out of favour with artists, and from the 4th century BC the rape of Ganymede came to be represented in quite another way. This may have been inspired by the famous image (now lost) by the 4th-century BC sculptor Leochares that illustrated the new fashion: it did not show Zeus himself, but rather the bird sacred to Zeus, the eagle, carrying Ganymede off. Leochares' statue was praised for revealing that "the bird is aware of what his burden is and for whom he is carrying it, and is careful not to let his claws hurt the boy even through his clothes . . ." (Pliny the Elder *Natural History* 34.79 [trans. Rackham]).

Leochares' invention seems to have revolutionised portrayals of Zeus and Ganymede. The new type was not only reproduced in statues, perhaps based on Leochares' original, but also in various other media. In a delicate pair of gold earrings (Fig. 88), the lithe adolescent is shown rising gracefully into the air held in the firm but tender grip of the eagle. Ganymede lifts one arm to embrace the head of the bird and the eagle dips his beak as if to kiss the boy.

Later, people occasionally wondered whether the eagle was just the emissary of Zeus or Zeus himself in bird disguise. The potential ambiguity appears heightened in a Roman relief (Fig. 89) on which Ganymede offers a drink, not to Zeus as in Figure 86, but to an eagle. Ganymede is identified by the soft peaked cap that he wears, thought to be characteristic of Trojans. A personification, difficult to identify precisely, reclines beneath the eagle. Zeus is nowhere to be seen, unless the eagle, instead of being his messenger or attribute, is meant to be the god himself in avian guise. The Greek writer Lucian in the 2nd century AD addresses this problematic ambiguity in his usual humorous manner in the following dialogue:

> ZEUS: All right, Ganymede, now that I've got you here, you can give me a kiss — just to make sure that the hooked beak and sharp claws have really gone.
> GANYMEDE: [*turning round and staring*] Why, you're a human being! But weren't you an eagle a moment ago? Didn't you come swooping down and whisk me away from my sheep? What's happened to all your feathers? Are you moulting, or what? You look completely different all of a sudden.
> ZEUS: No, my boy, I'm not really an eagle. Nor am I a human being. [*Grandly.*] You see before you the king of all the gods.

88L. The eagle carries off Ganymede. From a pair of gold earrings, c. 330–300 BC. Metropolitan Museum, New York.

89R. Ganymede serving the eagle. Roman sarcophagus relief, end of 2nd century AD. Musei Vaticani, Vatican (Cortile del Belvedere), Rome.

[*Reverting to an ordinary tone*.] That eagle business was just a
temporary disguise. . . .

> Lucian *Dialogues of the Gods* 10.208 (trans. Paul Turner)

Did the whole idea of Ganymede abducted by an eagle rather than
pursued by the anthropomorphic Zeus originate with Leochares' in-
ventive statue? The statue seems to have been made earlier than any
surviving verbal description of the eagle transporting Ganymede and
appears to have influenced both art and literature.

We know that Leochares invented the new type of image of the abduc-
tion of Ganymede only because the writer Pliny (in the 1st century AD)
mentions it. Another, rather charming, invention by an artist is also
known only through a written description: the female centaur. Lucian
describes her and her creator, and they are discussed in Chapter 10,
page 135.

Our last example of artistic innovation is less clear-cut. It deals with
the battle of the gods against the giants, sons of the goddess Earth,
whose threat to the Olympian gods had to be fiercely fought off. The
subject was long popular in both art and literature, and it is not always
easy to decide which of the two took the lead in the transformation of
the ways in which the giants came to be represented.

Early images focused on the idea of the battle, and the giants were
normally characterised simply as warriors, armed in the conventional
way and fighting with conventional weapons (Fig. 90). Part of the frieze
decorating a small treasury set up in Delphi by the Siphnians is devoted

90. Apollo and
Artemis
confronting three
giants. Part of the
frieze of the
Siphnian Treasury,
c. 530 BC. Delphi
Museum, Delphi.

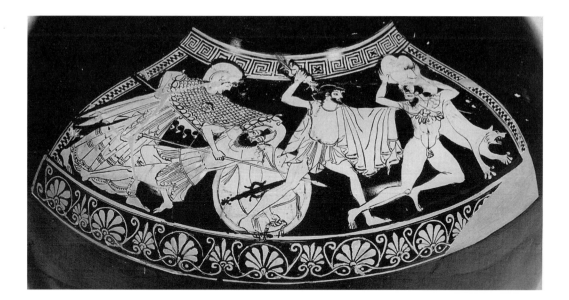

to this subject. In Figure 90 Apollo and Artemis, the divine twins, march in step shooting arrows at three heavily armed giants who approach them in a neat phalanx, all helmeted and with shields overlapping. A fourth giant (also helmeted and carrying a shield) apparently caught in the cross-fire, flees the onslaught, and a fifth, the body already stripped of its armour, lies on the ground.

According to the myth, the giants were not just simple warriors who attacked the gods, but barbaric enemies challenging the Olympian order. This aspect was increasingly stressed in the course of the 5th century BC, so that in Figure 91, while Athena (at the far left) has downed a giant in the conventional guise of a warrior, Zeus, further right, wielding his thunderbolt, is threatening a giant who is nude, with an animal skin knotted at his neck and equipped with a huge boulder rather than any more civilised weapon.

After the middle of the century this barbaric aspect of the giants became ever more prominent, probably under the influence of a rather spectacular work of art. In the decade following 447 BC, Phidias, the celebrated sculptor, created the huge and magnificent statue of Athena that was placed in the Parthenon, the largest temple in Athens dedicated to the city's patron goddess. The image was richly decorated, veneered with gold and ivory, and the shield held by the goddess was emblazoned with a scene of Athenians fighting Amazons in relief on the exterior and with a depiction of the gods fighting giants painted on the interior.

91. Athena and Zeus fighting giants. Attic red-figure hydria shoulder, c. 480 BC, by the Tyszkiewicz Painter. British Museum, London.

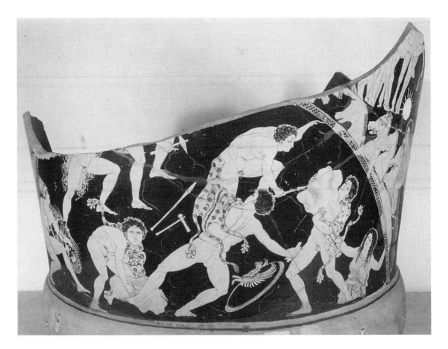

92. Skin-clad giants fighting gods. Attic red-figure fragment, 430–420 BC, by a painter near the Pronomos Painter. Museo Nazionale, Naples.

93. Hekate and Artemis and their opponents. From the Great Altar, Pergamon, c. 180–160 BC. Antikensammlung, Staatliche Museen zu Berlin – Preussischer Kulturbesitz, Berlin.

Only slight hints of what this painting looked like survive, but it seems that the giants were mostly skin-clad, savage creatures who used primitive weapons like rocks and tree trunks, and that the gods were placed higher up and fought them from above – a natural arrangement for the decoration of a round shield with a large vertical surface to fill.

A fragment of a later vase (Fig. 92) appears to reflect the Phidian composition and characterisation of the giants. Four vigorous nude

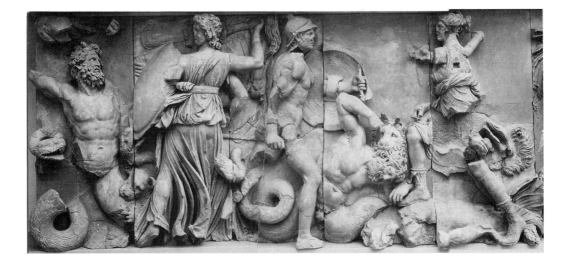

or animal-skin-clad giants are fully preserved occupying the centre of the fragment, while a more old-fashioned giant wearing a helmet and carrying a shield crouches to the left and the hapless mother of the giants, the goddess Earth, in distress emerges from her own element at the far right. Part of a circle, probably reflecting the structural support required for the original shield held by the statue, has been cleverly used to indicate the vault of heaven over which, at the far right, the four-horse chariot of the sun can be seen rising up towards the left.

The innovative composition with gods attacking giants from above and the original and complex poses of the giants suggest that the vase painter was inspired by some major work of art. It can hardly be doubted that Phidias' renowned statue fired the imagination of artists working in humbler media.

But the transformation of the giants did not stop there. Even as early as the 4th century BC, perhaps influenced by the images of other enemies of the gods, for instance the snake-legged Typhon, artists began to characterise the giants as not merely barbaric but actually partly animal. By the Hellenistic period giants whose torsos terminated in snaky limbs had become common (Fig. 93). On the dynamic sculptured frieze that decorated the Great Altar at Pergamon, a wonderful variety of bestial giants is portrayed. At the far left of Figure 93, a snake-legged giant with an apprehensive look prepares to attack the triple-bodied goddess Hekate, whose multiple nature is indicated by a profusion of arms. Her dog cooperatively bites the giant on the thigh, while the snake head that terminates his legs rather stupidly attacks her shield. Further to the right a pot-bellied, snake-legged giant lies on the ground, one

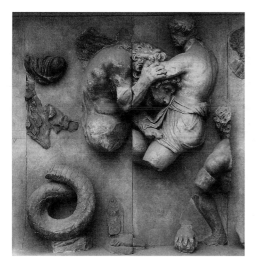

94. Lion-headed giant. From the Great Altar, Pergamon, c. 180–160 BC. Antikensammlung, Staatliche Museen zu Berlin – Preussischer Kulturbesitz, Berlin.

hand raised to gouge out the eye of Artemis' dog, which has sunk its teeth into the giant's head. Artemis herself, at the far right, is attacking the giant confronting her, who is of the old-fashioned type, a fully human warrior. Blinded by her beauty, he has dropped his sword hand to his side and has let his shield swing wide, serving no longer as protection.

The imagination of the 2nd-century BC sculptors at Pergamon was magnificent and particularly manifest in the variety of forms they imparted to giants. In Figure 94 a god wrestles with a giant in much the same way that Herakles wrestles with the Nemean lion on the coin from Herakleia Lucania (Fig. 15). The giant has a human body but a lion's head and claws. The transition from man to beast is extraordinarily subtle and surprisingly visually plausible.

By this time a range of possibilities for the representation of giants was available. They could be shown as normal warriors, as in the earliest period (Fig. 90), as wild and barbaric creatures wearing skins and using trees and boulders as weapons (Figs. 91 and 92), or even as semibestial monsters (Figs. 93 and 94). How much of this development was due to the initiative of artists alone or how much of it was due to poetic works, many of which no longer exist, is difficult to determine.

TEN

Changing Interests

lthough the *story* of the battle of the gods and giants changed very little throughout antiquity, *the way it was represented* changed markedly. As time passed, different aspects of the giants impressed artists, whether it was their valour as warriors (Fig. 90) or their crude savagery (Figs. 91 and 92) or their more bestial qualities (Figs. 93 and 94).

Other myths were similarly subject to changes of interest and changes in taste. In general, during the archaic period artists liked depictions of monsters and action-packed scenes; during the classical period they often preferred a more subtle, psychological approach; from the 4th century BC they became increasingly inspired by theatrical representations; and in the Roman period romance was often favoured.

Though certain preferences appear to have prevailed in one or another period, they were never absolute. Just as one can find the old-fashioned kind of wholly human warrior giant in quite late representations (Fig. 93), so too one can find psychological interpretations in the Roman period (Fig. 56) and theatrical influence in the 5th century BC (Figs. 75, 76 and 78–81). Nevertheless, over time shifts of emphasis can be traced.

For instance, the story of the hero Perseus was popular throughout antiquity, but different episodes interested artists more at one time than another. Thus Perseus' dread encounter with the Gorgon Medusa

was particularly popular in an early period and his romantic rescue of Andromeda later.

Perseus, in a reckless moment, had offered to fetch the head of Medusa. Medusa was one of three Gorgon sisters – the other two were immortal. All three had faces so terrible that merely to look at them was enough to turn a person to stone.

For Perseus, it was a challenge to decapitate Medusa without fatally glimpsing her face; for the artists it was a challenge to depict a monster so horrible-looking as to appear capable of inducing such grievous terror. A type was eventually devised (Figs. 95, 96 and 24) with large staring eyes, snaky hair, hideously grinning mouth, fearsome tusks and lolling tongue. On an archaic vase (Fig. 95), Perseus is shown (at the left) carving away at the neck of the monstrous creature, prudently turning his head away. The god Hermes (often a helper of heroes) stands at the far right holding the messenger's wand that identifies him, apparently unafraid of the effects of the dread visage. Perhaps gods were immune.

Another artist (Fig. 96) shows what happened next: the headless Medusa collapsed (far left) and Perseus fled (far right), as her two angry sisters set out in pursuit (centre).

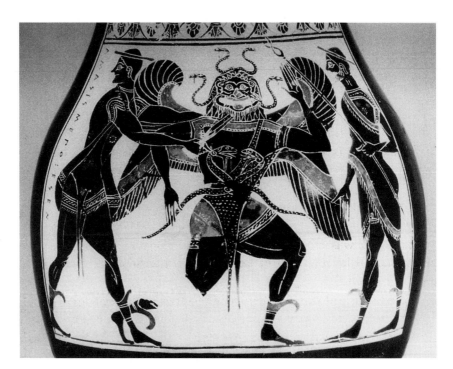

95. Perseus beheads the Medusa. Attic black-figure oinochoe, c. 550 BC, by the Amasis Painter. British Museum, London

96. The two immortal Gorgon sisters pursue the fleeing Perseus. Attic black-figure dinos, c. 600–590 BC, by the Gorgon Painter. Louvre, Paris.

By the middle of the 5th century BC the horrid image of the Gorgons no longer seemed so fascinating and other aspects of Perseus' story became more interesting.

As Perseus was returning home triumphantly bearing the head of Medusa, he saw a lovely maiden tied to a rock, exposed to a threatening sea monster. This was Andromeda. Her mother had foolishly boasted that either she herself (or her daughter) was more beautiful than the Nereids (sea goddesses) and on their behalf Poseidon, god of the sea, sent the sea monster to ravage the coast. It was to satisfy this beast that Andromeda had been placed in the jeopardy in which Perseus found her. He was immediately smitten by her beauty and, once he was promised that he could marry her, slew the monster and released the girl.

The cruel fate of this guiltless maiden appealed to the tragedians of the 5th century BC – both Sophocles and Euripides composed plays (now lost) on the subject – and both the drama and the romance of the rescue appealed to visual artists. Thus where Medusa loomed large

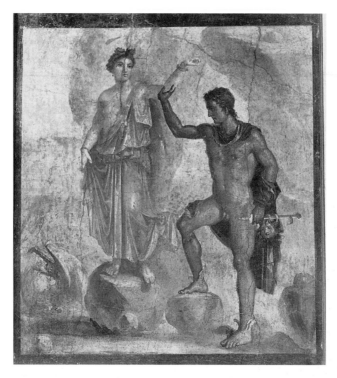

97. Perseus freeing Andromeda. Probably a Roman copy of a 4th-century BC Greek painting by Nikias, third quarter of the 1st century AD. Museo Nazionale, Naples.

in early representations of Perseus, Andromeda became much more important later, whether while still in peril or after Perseus had slain the sea monster. A Roman painting (Fig. 97), probably derived from a Greek painting originally produced in the 4th century BC, shows Perseus gallantly helping Andromeda down off the rock where she had been exposed. The body of the defeated sea monster lurks at the bottom left. This scene was popular with the Romans and was copied (more or less faithfully) in several Pompeian houses.

A more original Roman painter devised his own complex rendering of the romantic story, complete with its more practical aspects (Fig. 98). In a rocky landscape by the side of the sea, Andromeda occupies the centre of the scene, arms chained to the rock, grave goods at her feet. The head of the toothy sea monster emerges menacingly from the bottom left, but higher up Perseus can be seen, flying in to the rescue. (He had been equipped with winged shoes, which had helped him in his assault on Medusa.) But Perseus did not set about slaying the monster at once. First he wanted to be assured of his reward. For that reason the painter has shown him again (at the right) shaking hands with Andromeda's father to seal the promise that, if he saves the girl, he will be entitled to marry her. Thus, in this painted panel more than one moment in the story is

98. Perseus pre-
pares to free
Andromeda after
negotiating with
her father. Roman
wall painting from
Boscotrecase, early
1st century AD.
Metropolitan
Museum of Art,
New York.
(20.192.16 Rogers
Fund, 1920).

hinted at, as in some archaic images (for instance, Odysseus blinding Polyphemus, Fig. 23, or Medusa giving birth to her children while still keeping her head, Fig. 24), but it differs from these earlier examples in repeating the figure of the protagonist rather than compressing many moments into a single image.

Another example of a shift of interest with time can be observed in the story of Phineus and the Harpies. Phineus was punished for some offence – traditions vary as to what it was – by being blinded and furthermore having his food either stolen or soiled by the loathsome Harpies. When the Argonauts approached him for the information that he was said to possess, he was willing to oblige them in exchange for being freed from the blight of the Harpies. The Harpies were notoriously quick in all their actions, but the Argonauts fortunately had among them heroes who were equally renowned for their speed. These were the two sons of Boreas, the north wind. Charged with getting rid of the Harpies, the sons of Boreas promptly and effectively chased them away.

A lively chase is portrayed on the exterior of a 6th-century BC cup (Fig. 99), as the two sons of Boreas, swords raised, pursue the female Harpies, who are making a dash for the sea, the waves of which lap the far left side. All four are winged and depicted in rapid flight. Phineus reclines on an elaborate couch at the right, attended by three women who were, apparently, powerless to deter the Harpies from stealing most of his food and fouling what was left.

The tone is very different in a vase painting from the early 5th century BC (Fig. 100). Although three Harpies flutter about, as nasty as wasps or mosquitoes, carrying off Phineus' food, much more emphasis is placed

99. Phineus watches as the sons of Boreas chase the Harpies away. Chalkidian black-figure cup, c. 530 BC. Martin von Wagner Museum, Würzburg.

100. The Harpies
steal food from the
hapless Phineus.
Attic red-figure
hydria, c. 480–470
BC, by the
Kleophrades
Painter. The J. Paul
Getty Museum,
Malibu, California.

on the plight of their poor victim seated at the far left. His eye is closed
to show his blindness, but even more revealing are the wild gestures
of his hands, fingers spread in a vain attempt to capture or fend off his
tormentors, hopelessly missing his mark. It is a pathetic vision of the
helplessness of the blind man. This compassionate image is a far cry
from the comfortably accommodated, composed Phineus in Figure 99,
reclining on an expensively decorated couch.

Rethinking Monsters

The changes in taste that encouraged changes in the way myths were
represented could also have a significant impact on monsters – or at
any rate, on the portrayal of some monsters. Well before the end of the
5th century BC, the dread Medusa had already undergone a transfor-
mation (Fig. 101). While artists in the 6th century BC had struggled to
produce a face that was truly terrifying, this grotesque image no longer
suited later periods, in which most monsters had lost their novelty and
uglincss was gcncrally avoided.

On a mid-5th-century BC vase painting (Fig. 101), a winged woman
lies sleeping. Her three-quarter-view face has nothing particularly terri-
ble about it and is as handsome and naturalistic as the accomplishments
of the painter at the time could make it. Nevertheless, the man who
saws through her neck, just as deliberately as Perseus saws through
the neck of the hideous Medusa in Figure 95, is turning his head away.

101. Perseus cuts off the head of Medusa in the presence of Athena. Attic red-figure pelike, 450–440 BC, by Polygnotos. Metropolitan Museum of Art, New York (Rogers Fund, 1945).

And it is this apparently inexplicable inattentiveness that identifies the scene and identifies the sleeping woman, for the man must be Perseus and the head he severs must be that of Medusa, even though her face has been aesthetically improved to suit the sensibilities of the classical period. At the far left stands Athena, a helpful deity (like Hermes in Fig. 95) unintimidated by the presumably awful visage of Medusa. The ingenuity of the artist was challenged by the need to accede to the taste that deplored the grotesque yet at the same time to make clear which myth was being illustrated. He met the challenge with a compromise: creating an acceptable face of the Gorgon but combining it with the characteristic pose of Perseus with head averted. Although Perseus wears winged shoes and a winged hat to help identify him, these attributes are not unique to him. It is Perseus' pose and his action that give the decisive clue to the story, despite the watered-down appearance of Medusa.

When images of monsters lost their power to impress, most simply fell out of favour and ceased to be represented at all. Some, however, were subjected to a rationalising process and, in a way, humanised.

This was the case with one group of monsters, the centaurs, and one individual, the Minotaur.

Centaurs originally were just a tribe of fierce, part-equine adults whose infancy and family life were no concern of either poets or artists. By the end of the 5th century BC, however, when monsters as such had generally ceased to be popular, centaurs had to develop new features if they were to continue to be of interest. Perhaps this is why people began to think about centaurs in a different way, to wonder how they came about, what their childhood was like, and so on, and this process of thought led to the invention of the female centaur. She appears first in a painting of the late 5th or early 4th century BC by Zeuxis. As usual in the case of ancient painting, this one is lost, but we know about it from a description by Lucian:

> I'd like to tell you a story about Zeuxis. This great artist was ... always trying to do something different.... One of his many such daring experiments was a picture of a female centaur – and what's more she was depicted in the act of suckling two centaur-babies
>
> The mother centaur was shown with her horse-part lying on some soft grass, and her hind legs stretched out backwards. The woman-part was slightly raised from the ground and propped on its elbow.... She was holding one of the newborn babies in her arms and breast-feeding it in the normal human manner, but the other was suckling away at the horse-part like an ordinary foal. In the upper half of the picture, on a bit of rising ground, appeared a male centaur, presumably the husband of the lady who was suckling a baby at each end of her anatomy ... he could be seen bending down with a smile on his face. In his right hand was a lion cub which he was waving about over his head as if in a playful attempt to scare the babies.
>
> Lucian *Zeuxis and Antiochus* 3–4 (trans. H. W. and F. G. Fowler)

Until this time, there had been no theories about the early life of centaurs, nor were they thought to exist in more than one generation. As monsters, centaurs were no longer important; but as *rationalised monsters* a whole new world of art opened up to them.

The tender family life of centaurs came to be portrayed on Roman sarcophagi (Fig. 102). Male centaurs had already been used to pull a chariot for Herakles in classical times (Fig. 8), but after Zeuxis' invention of the female centaur, pairs of centaurs, male and female, began to be used in art for this function; the Romans even seem to have considered

102. Centaur family. Detail of a Roman sarcophagus from the first half of the 3rd century AD. Louvre, Paris.

them as breeding stock. Thus, in a number of examples of sarcophagi where centaurs are used to pull the chariot of Dionysus, the female centaur, still in harness, has lain down on the ground in order to suckle a baby centaur, a charming family vignette!

Zeuxis' image of the tranquil centaur family seems also to have inspired the representation of a tragic sequel: a Roman mosaic, possibly copied from a Greek original of the Hellenistic period (Fig. 103), shows a brutal scene of death and destruction. The lion cub which the father centaur used to tease the baby centaurs is nowhere to be seen, nor are the baby centaurs. Instead the female centaur lies dead upon the ground, her delicate white body torn by a marauding tiger, which looks up in surprise at the male centaur about to hurl a great rock down upon him. To the right lies a dead lion, presumably the first victim of the male centaur, who has returned suddenly to find his mate slain. Sophisticated viewers acquainted with Zeuxis' famous painting might be led to imagine that the lion here was taking revenge on the centaur for having stolen his cub.

In this way an original image, the invention of an artist (like those discussed in Chapter 9), seems to have generated a remarkable artistic progeny.

Centaurs had begun as wild and bestial creatures, uncivilised guests at a wedding feast (Figs. 68–71 and 73), male only and existing in only a single generation. Tamed, humanised and transformed into fathers and

husbands, a greatly enlarged emotional range now became available to them.

The Minotaur (Fig. 9) was a unique monster, the unfortunate offspring of Pasiphae, the queen of Crete, and a very handsome bull. The queen had become enamoured of the bull – perhaps through the curse of some god – and with the help of the clever Athenian craftsman Daidalos, then resident at the court, had contrived to mate with it. The fruit of this union was the Minotaur, a man with a bull's head, a creature of mixed nature that betrayed its mixed parenthood.

The Minotaur was a peculiarly unfortunate creature combining the weakness of a man with the limited intelligence and inarticulateness of a bull. It was full of defects; one of the worst was its appetite for human flesh. Minos, king of Crete and husband of Pasiphae, was suitably embarrassed by this peculiar addition to the royal household. In order to conceal the disgraceful secret he had Daidalos build a labyrinth full of false entrances and complicated corridors in the centre of which he hid the Minotaur; he fed the beast with a regular tribute of seven youths and seven maidens collected from Athens at intervals, until the hero Theseus replaced one of the youths intended as Minotaur fodder and finally slew the creature.

103. Sequel to Zeuxis' centaur family. Mosaic, either a Roman copy of a Greek prototype of c. 300 BC or a Roman original of the 2nd century AD. Antikensammlung, Staatliche Museen zu Berlin – Preussischer Kulturbesitz, Berlin.

104. The baby Minotaur on his mother's lap. Etruscan red-figure cup interior, first half of the 4th century BC. Cabinet des Médailles, Bibliothèque nationale de France, Paris.

One would not think there would be much sympathy for the Minotaur, who had such doubtful parentage and such nasty habits, but an Etruscan artist recognised that any child born of a woman is entitled to mother love (Fig. 104). He portrayed the baby Minotaur in the arms of its mother, its back being gently patted by a tender hand.

It is unlikely that before the 5th century BC anybody gave much thought to the babyhood of the Minotaur. It seems to have been generally regarded as just a monster, a disgrace to its family and a challenge to a hero. When it was portrayed (Figs. 9, 11 and 105) it was usually only in order to be killed.

The whole idea of a baby Minotaur was a novel one, but it did not originate with the Etruscan vase painter. The imaginative playwright Euripides had composed a tragedy called *The Cretans*, only fragments of which are preserved, in which the nature of the Minotaur was revealed and the pathetic Pasiphae attempted to justify her unnatural passion. Euripides' plays fascinated people from the late 5th century BC through Roman times. He often gave a new twist to an old story, for

instance in having Telephos threaten the infant Orestes when he held him hostage (cf. Chapter 8), and artists when illustrating myths often chose to show them in the form that had been devised by Euripides (for instance, Figs. 45 and 79). A number of Etruscan sarcophagi are decorated with scenes derived from Euripides' *The Cretans* and show the baby Minotaur, but none is quite so appealing as this vase painting.

The fate of the Minotaur was tied to that of Theseus, not only in myth but also in art. Theseus' popularity in the 6th century BC depended on his being one of the renowned monster slayers of myth, his monster being the Minotaur; his popularity in the 5th century BC rested on his being an Athenian national hero. During both periods, though for different reasons, scenes of his conflict with the Minotaur were numerous,

105. Theseus slays the Minotaur in the labyrinth. Roman mosaic, 1st–2nd century AD. Museo Civico "Ala Ponzone", Cremona.

but in later times, as Theseus' importance faded, representations of his encounter with the Minotaur became increasingly scarce. A revival of their fortunes came, however, from an unexpected source.

From the 1st century BC on, Romans liked to decorate their floors with mosaics, small square-cut stones of many colours often arranged with figured subjects in the centre surrounded by patterned borders. These were handsome and decorative and at the same time practical, long-wearing and easy to clean. One increasingly popular patterned border took the shape of a labyrinth (Fig. 105). When it came to putting a figured subject in the centre of such a labyrinth it was clear that no story could be more appropriate than that of Theseus and the Minotaur. And so, after centuries of near neglect, the myth once again found favour – not so much because of its intrinsic interest but as the consequence of an artistic vogue.

History and Myth in Art

Myths had a vividness and immediacy for the Greeks and Romans that are difficult for us to imagine now. The flexibility of myths allowed them to be remodelled easily to embody new ideas or modified and elaborated to reflect recent events.

The boundaries between history and myth were fluid. Real people could be recognised in mythological figures: Plutarch recorded that when the Athenians watching a tragedy heard a description of the mythological Amphiaraos that strongly reminded them of the real Aristeides, the whole audience turned around to look at the man seated in their midst.

Similarly, mythological figures could be refashioned on the model of real people. This may have been the case if Aeschylus did indeed make his tragic Telephos resemble the historical Themistokles (cf. Chap. 8, Fig. 78).

It is often difficult to prove connections, especially in an early period like the 6th century BC, when historical documents are scarce and surviving works of art may be unrepresentative. Nevertheless many people are tempted to relate subjects that suddenly became very popular – for instance, images of Theseus on his heroic travels from the Peloponnese to Athens in the later 6th century BC (see Chapter 2) – to contemporary historical events and personalities. But the fact that equally competent scholars often arrive at diametrically opposed conclusions reveals the

inadequacy of the evidence available to them. The vase paintings on which they mainly rely are, in any case, unlikely to embody very much in the way of political statements or allegiances.

The pride and self-consciousness of Athenians in the 5th century BC, on the other hand, give more substance to the idea that some elements of propaganda, in mythological disguise, have been introduced into monumental projects like large-scale wall paintings or the sculptures decorating temples. Thus, the themes of the sculpted metopes on the Parthenon (carved shortly after the middle of the 5th century BC) are usually taken to be metaphors of the Persian wars.

These wars began when some Greeks from the mainland (the Athenians and the Eretrians) sent aid to the Greeks in Asia Minor who had revolted against the Persian empire to which they were subject. The revolt failed, but the Persians, mightily angered, in reprisal sacked the Greek city of Miletus in Asia Minor, where the trouble had begun, and attacked the cities of Eretria and Athens. They quickly overwhelmed Eretria, but were defeated by a small but efficient force of Athenian hoplites (heavily armed foot soldiers) on the plains of Marathon in 490 BC. Smarting from this disgrace, the Persians prepared a huge invasion by land and sea that in 480 succeeded in sacking Athens before meeting defeat at the hands of the combined forces of many Greek cities in the bay of Salamis and finally being driven back home after a battle at Plataea in 479.

Although the Greeks were immensely proud of their victory, they seem to have been generally reluctant to represent historical events directly in drama or art. Exceptions are few: an early 5th-century BC tragedy by Phrynichos (now lost) on the recent sack of Miletus was deplored by the Athenians, who fined the dramatist for distressing them by showing "their own suffering", and *The Persians*, an early tragedy by Aeschylus that portrayed the Persian wars from the losers' side. These were experiments that were never repeated. A large painting in a public building (now lost) depicting the celebrated battle of Marathon not long after the event stands virtually alone among numerous images drawn from myth.

By contrast, using myths to explain what happened in history and to point moral conclusions had considerable appeal; particular events could thereby be placed within a cosmic context. This is why the four mythological subjects that decorated the metopes of the Parthenon (Fig. 185) – the combats of Athenians and Amazons, of Greeks and Trojans, of gods and giants, and of centaurs and Lapiths – are usually

assumed by modern scholars to allude to the Persian wars, with the Persians seen as aggressive eastern invaders (like the Amazons), defeated by the united Greeks (like the Trojans), impious (like the giants attacking the gods) and barbaric (like the centaurs). But even this, though arguable, is impossible to prove.

More tenable is the suggestion that the myth of Hercules (the Roman name for the Greek Herakles) and Apollo struggling for the Delphic tripod had particular appeal to the emperor Augustus (sole ruler of the Roman Empire from 31 BC to 14 AD).

According to the myth, Hercules became enraged because the oracle of Apollo at Delphi would not vouchsafe the information he required. In frustration and anger, he tried to carry off the tripod sacred to Apollo, intending to set up an oracle of his own. Apollo resisted. Jupiter (the Roman equivalent of the Greek Zeus) intervened and the tripod was restored to its rightful owner.

To see the struggle for the tripod as an allegory of Augustus' and Antony's struggle for supremacy in Rome is relatively easy. By this time historical documents are plentiful and rich in circumstantial detail. We are reliably informed that Augustus considered Apollo his divine patron, the god who aided him in his decisive battle against Antony at Actium in 31 BC. Furthermore, Augustus was even reported to have impersonated Apollo at a banquet, while Antony, who claimed descent from Hercules, was known to have masqueraded as the hero.

Augustus probably favoured the myth as part of the decoration of the temple he dedicated to Apollo on the Palatine Hill in Rome (Fig. 106) because he regarded the attempted theft of the tripod as a violent act, the sort of act he wished to have attributed to Antony. The restoration of the tripod to Apollo (in the myth) could then be seen (in allegorical terms) to justify his own victory over his rival. The tripod itself was an attribute of Apollo, and some reliefs on the temple showed personifications of victory flanking the tripod, perhaps alluding to Augustus' victory over Antony in the critical battle.

Hercules (to the right), lion skin over his head with the paws knotted at his neck, his club in his left hand, grasps the tripod with his right; Apollo, on the other side, his bow in his left hand, firmly holds onto the tripod with his right (Fig. 106). The bold Hercules laying impious hands upon the sacred tripod may have called to mind the impetuous challenge of Antony, while the elegant Apollo maintaining his rightful claim to its possession, confirmed, in mythological analogy, the justice of Augustus' cause. Although the design of the terra-cotta relief is a handsome piece

106. Hercules and Apollo. Terra-cotta Campana relief, late 1st century BC or early 1st century AD. Louvre, Paris.

of decorative symmetry, the balance of the two contestants on either side of the tripod is tense and dramatic. Nevertheless, the outcome is a foregone conclusion.

Sometimes the imagery is more obvious. This is particularly true when a ruler is kitted out with the attributes of a god. The 4th-century BC painter Apelles flattered Alexander the Great by depicting him holding a thunderbolt, the attribute of Zeus, king of the gods. In a similar vein (Fig. 107), the emperor Claudius was depicted on a heroic scale accompanied by the eagle of Jupiter (the Roman equivalent of Zeus). Here the portrait head sits a little oddly on the heroic body, but to the Romans the portrait head was the feature that mattered. Thus two different empresses, Sabina (Fig. 108), the wife of Hadrian (who ruled from 117 to 138 AD), and Julia Domna (Fig. 109), the wife of Septimius Severus (who ruled from 193 to 211 AD), could both be represented as the goddess of grain, Ceres, both empresses making use of the same

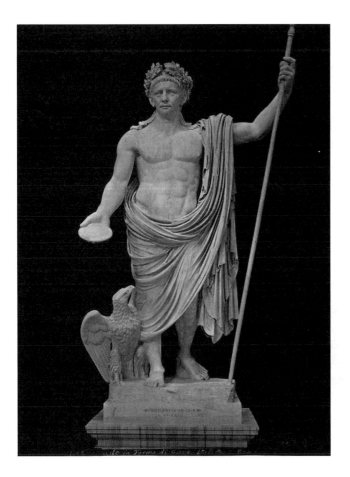

107. Emperor Claudius as Jupiter. 1st century AD. Musei Vaticani, Vatican City.

sculptured prototype but each with her own portrait head. Certainly to people living in the Roman Empire, the power of the Roman emperor must have seemed analogous to the power of Jupiter; and the empresses, who were able to procure grain in times of famine, must have appeared just as benevolent as the goddess of grain herself.

But sometimes an analogy could be anything but benevolent; thus the sadistic emperor Commodus liked to dress up as Hercules, not so much in order to perform arduous labours for the betterment of mankind (as Hercules did, according to the myth), but in order to execute bloody massacres in charades that imitated the deeds of the hero. For instance, he once had all the legless inhabitants of Rome gathered together in the amphitheatre. These unfortunates were fitted with serpent-like trappings attached to the stumps of their limbs and given sponges to hurl instead of rocks, while Commodus swaggered about, slaying them mercilessly with his club, declaring that he was Hercules punishing the

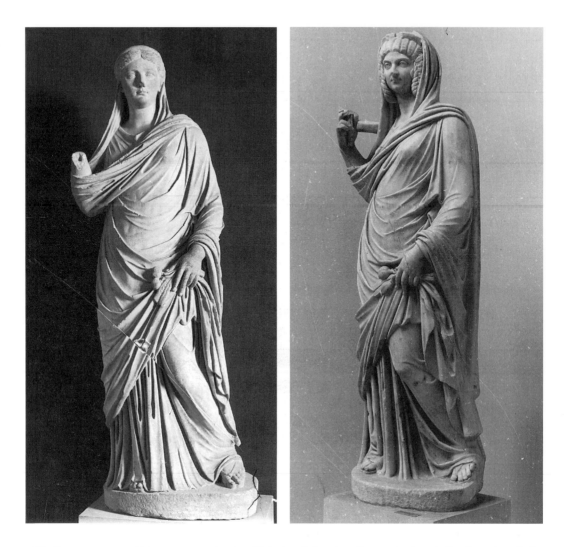

108L. Empress Sabina as Ceres. 2nd century AD. Ostia Museum, Ostia.

109R. Empress Julia Domna as Ceres. 3rd century AD. Ostia Museum, Ostia.

obstreperous giants. This brutal ruler thus acted out the hero's role in hideous parody, but must have rejoiced in the brilliant portrait (Fig. 110) which shows him with lion skin and club, holding the apples of the Hesperides, an image that cleverly preserves his official dignity while hardly hinting at the perverted sadist under the Herculean disguise.

Ordinary Romans also liked to be represented in mythological contexts (e. g., on sarcophagi, see Figs. 40 and 43).

It seems obvious that men (or women) should gain lustre by being associated with mythological figures rather than the other way round, but there appears to be an instance in which a mythological character gained glory by being made to resemble historical men. This is the

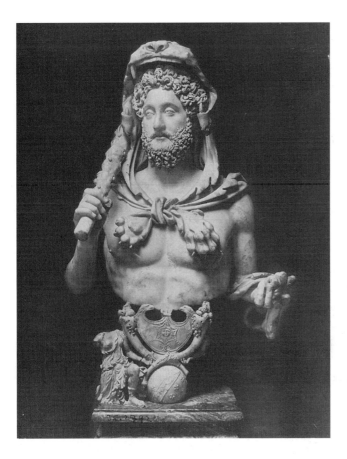

110. Commodus
as Hercules. 2nd
century AD.
Capitoline
Museum, Rome.

case of the mythological Theseus, whose image, in the course of the 5th century BC, became assimilated to that of the historical Tyrannicides.

The Tyrannicides were two real Athenian men, Harmodios and Aristogeiton by name. In 514 BC they tried to overthrow the tyranny in Athens by assassinating the tyrant Hippias. The plan went awry, and in the end they only succeeded in murdering his younger brother and were themselves captured and killed, Harmodios immediately, Aristogeiton a little later.

In fact they achieved little, for it was only after four more years had passed and with outside help that an end was finally put to the tyranny. Nevertheless the Athenians were eager to give Harmodios and Aristogeiton the credit for having struck the first blow and given their lives for the cause. At some time before 480 BC they erected statues in honour of the Tyrannicides. These were carried off by the Persians when they sacked the city.

By 480 BC it had become clear to the Athenians that the huge invading Persian land force that was sweeping down on them could not be stopped. In the face of the immediate danger they evacuated noncombatants to safety elsewhere and the fighting men sailed to the nearby island of Salamis. The city was taken but the people survived. In the Bay of Salamis, the fighting men won a decisive victory, and a year later the remaining Persians were driven out of Greece.

It was, therefore, in an elated mood of triumph that the Athenians returned to their devastated city in 479 BC. They left their temples and sanctuaries in ruins, a testament to Persian barbarity, but they immediately set about ordering replacements for the statues of the Tyrannicides. They felt that the freedom from tyranny that the Tyrannicides had died for was what had given them the strength to defeat the Persians. The new statues were ready by 477 BC. A picture of them decorating a shield held by Athena painted on a vase (Fig. 111) shows their vigour and the freedom of their poses, poses that were appropriate to figures made in bronze.

By the beginning of the 5th century BC a technique for casting large-scale statues in bronze had been mastered and the advantages of the medium were fully appreciated. The first step in making a bronze statue is constructing a model in clay. This can be viewed from all four sides and easily modified if one or another view seems unsatisfactory.

111. The Tyrannicides, Harmodios and Aristogeiton. Bronze group, made by Kritios and Nesiotes in 477/6 BC, represented on the shield of Athena painted on an Attic black-figure Panathenaic amphora. British Museum, London.

Furthermore, the statue can take on virtually any kind of complicated pose. Bronze has great tensile strength, which means that limbs can be extended without fear of their breaking, and figures can be poised on very slight supports. Bronze, therefore, quickly became the favourite material of the most creative and innovative sculptors, those wishing to show figures in uninhibited action.

Unfortunately for us, the intrinsic value of bronze was great and it is easily melted down to be reused in different forms. It is also easily destroyed in natural or man-made disasters, with the result that few of the many bronze statues made in antiquity have survived to our day. Fortunately, however, the Romans greatly admired bronze statues from this and later periods and made copies of them in marble, which was cheaper than bronze and less prone to destruction. Thus they have preserved for us the main lines of the original creations. (The copies can be quite accurate with respect to pose, but often have lost the spirit and exquisite detail of the originals.)

Marble, unlike bronze, has very little tensile strength. Extended limbs and complicated poses have to be carefully supported if they are not to break under their own weight. Converting bronze originals into marble copies was a sensitive and demanding task, but the Romans were extremely skilful and determined. One example of their ingenuity in carving marble can be seen in the portrait of Commodus (Fig. 110), an original Roman work, in which the heavy head and chest appear to rest on very slight, almost filigreed, supports. In fact there is a massive support at the back of the bust, where it is not seen.

Thanks to the Roman copyists and their patrons, we can get a better idea of what the Tyrannicides looked like, for, although the bronze originals disappeared long ago, many (mostly fragmentary) copies in marble still survive. Figure 112 is a reconstruction in plaster derived from several of these.

The sculptors who replaced the commemorative statues taken away by the Persians had little idea what Harmodios and Aristogeiton, who had died some forty years before, actually looked like, but they knew what kinds of men they were. They knew that Harmodios was the younger, aristocratic one who was killed at once and that Aristogeiton was more mature and captured only later. On these slight facts they based their characterisations (Fig. 112).

Harmodios, to the right, is young and impetuous. His right arm is bent back, almost touching his head. The slashing blow he uses is one that is usually reserved for the *coup de grâce* dealt to an already disabled

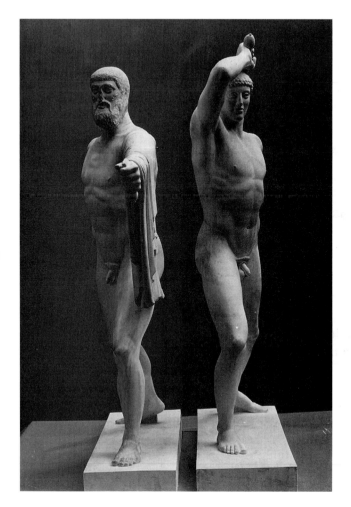

112. Restored copy of the group of the Tyrannicides. The Metropolitan Museum of Art, New York.

adversary. To use it otherwise is foolhardy, as the whole body of the attacker is left exposed.

What a brilliant idea of the sculptor's to have characterised both the man and his fate by means of this bold but imprudent action! Exposed as he was, Harmodios could easily be killed.

Aristogeiton, by contrast, is depicted as older and more cautious. He attacks warily, holding his cloak in front of him; it would have been useful in entangling any weapons that might have been directed at him. He holds his sword low, watching for his opportunity to strike.

The statues of Harmodios and Aristogeiton stood conspicuously in the Agora (the marketplace of Athens) and so were well known to all Athenians and reflected in many works of art (for instance, Fig. 111). Although the poses of the two men were not in themselves unique and appeared in isolation in various scenes of conflict, seeing them related

113. Theseus fighting centaurs in the pose of Harmodios. On the frieze over the west porch of the Hephaisteion in Athens, second half of the 5th century BC (from a cast).

to one another was something else again. Pairing the two gave them a certain impact; they were immediately recognisable. They were glorious representatives of the Athenian love of freedom and of the Athenian democracy, and it must have been with this glamorous aura that they were adapted for use in representations of Theseus, both in architectural sculpture (Figs. 113 and 114) and in vase painting (Figs. 115 and 116).

The friezes over the porches of the temple of Hephaistos (the Hephaisteion) in Athens were carved in the second half of the 5th century BC. The frieze on the west side shows a battle of Lapiths and centaurs in which Theseus took a prominent part. He is shown in this section at the far right, in a pose resembling that of Harmodios (Fig. 113). The subject of the frieze on the east side is disputed, but it is likely that Theseus was also represented there, and on that side was shown at the far left in a pose recognisable as very like that of Aristogeiton, despite the loss of the head and right arm and leg (Fig. 114).

114. Theseus (?) fighting boulder-throwing adversaries in the pose of Aristo-geiton. On the frieze over the east porch of the Hephaisteion, second half of the fifth century BC. In situ. Photo: American School of Classical Studies at Athens: Agora Excavations.

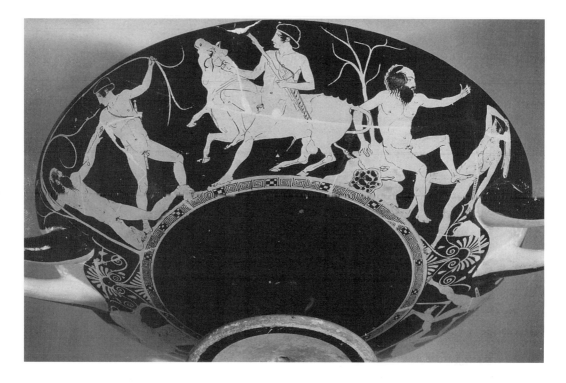

115. Theseus fighting Skiron in the pose of Harmodios. Attic red-figure cup, c. 440–430 BC, by the Codros Painter. British Museum, London.

Similarly, on the exterior of a cup that illustrates the deeds of Theseus, in two of the deeds Theseus again assumes the poses of Harmodios and Aristogeiton (Figs. 115 and 116). At the far right, Theseus attacks Skiron in the pose of Harmodios (Fig. 115), while near the centre of Figure 116 he attacks the troublesome sow with his sword lowered and his cloak held out defensively, in a pose close to that of Aristogeiton. On the inside of the same cup (Fig. 11) Theseus in the guise of the two statues occurs again, this time in back view, as Harmodios attacking Skiron (at four o'clock) and as Aristogeiton attacking the sow (at eleven o'clock).

The fact that the figures are shown in the same poses from the front on the outside of the cup and from the back on the inside suggests that the vase painter knew the statues of the Tyrannicides in the Agora well and had come to appreciate them from both points of view.

Theseus was one of the few mythological heroes who had traditionally been associated with Athens and one who at first had very few adventures to his name. Sometime late in the 6th century BC his prestige had been enhanced by the invention of the deeds he performed on his way from the Peloponnese to Athens (see Chapter 2). During the 5th century BC he seems to have been made to embody the Athenians' national

aspirations when Athens was at the height of its power. The above examples suggest how the imagery of the Tyrannicides was assimilated to depictions of Theseus and show how the mythical Theseus could acquire glory from real-life prototypes in a curious reversal of the usual procedure in which myth was used to validate history, not the other way around.

116. Theseus fighting the sow in the pose of Aristogeiton. Attic red-figure cup, c. 440–430 BC, by the Codros Painter. British Museum, London. The other side of Figure 115.

TWELVE

Life and Myth in Art

The immediacy of myth meant that artists often imagined mythological events taking place in familiar settings and with participants looking and behaving much as they did in real life. This was particularly true for the Greeks.

Greek vase painters had two main subjects: the world of myth and the world around them. This led to lively interaction between images of myth and images of life.

Sometimes only small details, inscriptions or the addition of an unexpected feature, are all that distinguish mythological representations from scenes of ordinary life. For instance, vase painters often depicted women fetching water from a fountain-house. This activity was a cherished opportunity for women to chat and exchange gossip, and in Figure 117 we see two pairs of women doing just that. The women facing left are just arriving, their empty water jars sideways on their heads, while the women facing right are leaving with full jars upright on their heads, but are pausing to exchange a few words with the new arrivals. One girl, at the far left, stands quietly waiting, her jar well placed under the lion-head spout. There was usually nothing out of the ordinary in such a depiction.

But to other similar images a sinister touch was added (Fig. 118). At first glance, the left side of the picture looks perfectly normal. A girl, to the left of the fountain-house, is about to place her water jar under the spout. A youth riding one horse and leading another (the eight

117. Girls fetching water at a fountain-house. Attic black-figure hydria, c. 530 BC. Martin von Wagner Museum, Würzburg.

118. Achilles prepares to ambush Troilos and Polyxena at the fountain-house. Attic black-figure amphora, c. 520–510 BC, by the Edinburgh Painter. Antiken-sammlung, Staatliche Museen zu Berlin – Preussischer Kulturbesitz, Berlin.

legs — seven of them clearly visible — and extra nose indicate the riderless horse almost entirely hidden behind the other) patiently waits behind her. This seems a quiet, everyday slice of life. But to the right things are different: concealed behind the fountain-house squats a warrior, a figure full of menace.

Suddenly the whole mood is changed. An unseen threat has entered the peaceful scene, no longer just a simple image of a girl fetching water and a boy tending his horses, free from anxiety. What are the intentions of the warrior who strikes such a discordant note?

For those who remember the story of Troilos, the myth leaps to mind. Achilles ambushed Troilos when he went out to water his horses accompanied by his sister Polyxena (see Fig. 26). It was then that Achilles caught sight of the lovely Trojan princess, a glimpse with dread

119. Herakles with his wife and child. Attic red-figure lekythos, c. 450 BC, by a painter near the Villa Giulia Painter. Ashmolean Museum, Oxford.

consequences, for long afterwards Achilles' ghost demanded that this very Polyxena be sacrificed upon his tomb before the Greeks could sail home after sacking Troy (Fig. 2). The myth puts names to the otherwise ordinary-seeming figures. The girl waiting for her water jar to fill is Polyxena, the youth with horses Troilos, and the lurking warrior Achilles. The scene is no longer calm, but full of foreboding. The artist has chosen a quiet moment before the climax of the story (see Chapter 3). If you know the myth, the whole tragic sequel unfolds within your mind: the death of the boy, the punishment of Achilles, the bloody sacrifice of the girl.

Sometimes images are gentler and more intimate, for instance a mother and father sharing delight in their baby, as all parents do. Even the heroic Hector in the *Iliad*, taking a break from the fighting, meets his wife on the walls of Troy accompanied by their little child, and dandles the baby in his mighty arms. So, too, the labouring Herakles was supposed to take pleasure in playing the family man whenever he had a chance to snatch a moment in private (Fig. 119). Herakles' wife is shown sitting at home – the indoor nature of the scene is indicated by the hand mirror hanging on the wall. Their baby, sitting on her lap, holds out his arms to his father, who stretches his hand out toward him. Such an image differs from the representation of an Athenian family only in the fact that the father is wearing a lion skin and holds a club and bow and quiver. This was the sort of thing that Euripides had in mind later in the century when he portrayed Herakles rescuing his children from the threat of death, exclaiming:

> "... for I too do not reject the care of my children; here all mankind are equal; all love their children, both those of high estate and those who are naught; 'tis wealth that makes distinctions among them: some have, others want, but all the human race loves its offspring."
>
> *Madness of Herakles*, lines 633–636 (trans. E. P. Coleridge)

Humanising a hero in this way did much to make myths popular and live in people's minds and hearts.

Even catastrophic events could begin in a seemingly ordinary way. Helen running away with Paris set off the Trojan War. How did an Athenian vase painter imagine the scene (Fig. 120)? In the form of a proper Athenian marriage, it would seem, for there is little in this painting, except for the fluttering love god and the identifying inscriptions, to distinguish this scene from a normal wedding. Note in particular the

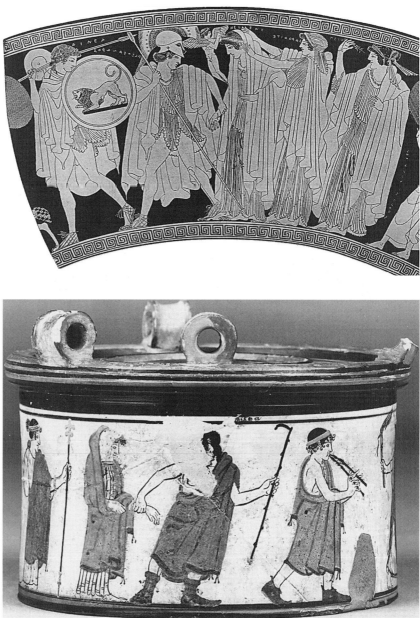

120. Paris abducts Helen. Attic red-figure skyphos, c. 490–480 BC, by Makron. Museum of Fine Arts, Boston (Francis Bartlett Fund).

121. Ritual grasping of the bride's wrist in the Athenian marriage ceremony. Attic white-ground pyxis, c. 470–460 BC, by the Splanchnopt Painter. British Museum, London.

way Paris holds Helen's wrist. This was the ritual gesture of the bridegroom in the Athenian marriage ceremony (Fig. 121).

Herakles' twin brother, Iphikles, could be shown attending his music lesson (Fig. 122) in just the way an Athenian youth would, even though his music teacher is the mythical Linos, brother of the legendary musician Orpheus. Notice how the teacher sits on a chair with a back,

122. Iphikles learning to play the lyre from Linos. Attic red-figure skyphos, c. 470 BC, by the Pistoxenos Painter. Staatliche Museum, Schwerin.

123. Herakles coming for his lesson. Attic red-figure skyphos, c. 470 BC, by the Pistoxenos Painter. Staatliche Museum, Schwerin. The other side of Figure 122.

while his pupil occupies a backless stool. The master has to teach throughout the day, while the student only has a limited period of instruction. When Iphikles' lesson has finished, Herakles will take his place. Herakles is shown on the other side of the vase (Fig. 123), accompanied by the tattooed Thracian slave who carries his lyre for him. He would be indistinguishable from an upper-class Athenian youth of the 5th century BC were it not for the inscription of his name and the menacing arrow that he uses as a walking stick.

124. Departure
of Hector. Attic
red-figure
amphora,
c. 510–500 BC, by
Euthymides.
Antikensamm-
lungen, Munich.

The mere addition of an inscription has the power to transform and elevate an ordinary scene. For many an Athenian family the moment when a treasured son took his leave to fight for his country must have been heart-rending. The departure of a warrior, his parents bidding him farewell, his father admonishing him, his mother standing by, is a poignant scene. Figure 124 may at first glance appear to portray real life, but the inscriptions explain that the brave young man is none other than the Trojan hero Hector, solemnly attaching his corselet as he listens to his father, Priam, while his mother, Hecuba, holds his helmet and spear ready for him. In such an image, the mythological character gains depth and resonance from being shown like an ordinary mortal, but conversely, an ordinary mortal could gain heroic quality by analogy with a mythological one.

When the hero Sarpedon, son of Zeus, was slain, his divine father sent the gods Sleep and Death to carry his body off the field of battle (Fig. 125). The vase painter has drawn the huge horizontal body of the hero being lifted with difficulty by the two bearded deities, while Hermes stands behind, supervising. In the *Iliad* Homer says that Zeus charged Apollo to wash the wounds of Sarpedon before Sleep and Death carried his body back home. The vase painter did not have the text beside him, and he rethought the story in his own terms. He knew that Hermes was the conductor of the souls of the dead to

the Underworld and so he introduced that god into the picture instead. Sleep and Death are twin brothers, hardly distinguishable except for the labels that identify them. Death, in his dark cuirass, lifts the upper part of the great sprawling body, while Sleep grasps the legs. The artist's main effort went into showing how big, strong and heavy Sarpedon was. He put into that mighty figure all the anatomical knowledge at his disposal, foreshortening the left foot seen from the front, delineating the musculature either with bold or with subtle lines, indicating the limpness of the delicately falling fingers. He drew two soldiers, one at each side of the central group of three, run-of-the-mill warriors who

125. Sleep and Death with the body of Sarpedon. Attic red-figure calyx krater, late 6th century BC, by Euphronios. Metropolitan Museum, New York.

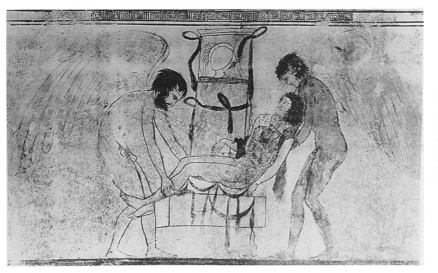

126. Sleep and Death with an Athenian warrior. Attic white-ground lekythos, c. 450 BC, by the Sabouroff Painter. British Museum, London.

could claim nothing of the stature of Sarpedon, as the comparison makes clear. Sleep and Death have to struggle to lift the magnificent body.

Tragic dignity of much the same quality could be imparted to real Athenians who died for their country (Fig. 126). By showing the winged gods, bearded Death and here beardless Sleep, solemnly lifting the body of a fallen Athenian, the vase painter has endowed an ordinary human being with heroic status, for the scene is set beside a normal Athenian gravestone.

The fact that the Greeks could readily envision their myths in terms of everyday life lent depth and immediacy to illustrations of myths; transferring some of that imagery to their portrayals of mortals' experiences graced real life with an aura of mythic glamour.

PROBLEMS

THIRTEEN

Showing What Cannot
Be Seen

Words can sometimes conjure up images that defy visual representation. Things that are hidden can be revealed in words; private emotions can be expressed in words; things in the very process of transformation can have their progress traced by words. The Roman poet Ovid was particularly brilliant in delineating metamorphoses. Take, for instance, his description of how Daphne, fleeing from the unwanted embraces of Apollo, was turned into a laurel tree by her father, a river god:

> "O Father," she cried, "help me! If you rivers really have divine powers, work some transformation, and destroy this beauty which makes me please all too well!" Her prayer was scarcely ended when a deep languor took hold on her limbs, her soft breast was enclosed in thin bark, her hair grew into leaves, her arms into branches, and her feet that were lately so swift were held fast by sluggish roots, while her face became the treetop. Nothing of her was left, except her shining loveliness.
>
> Even as a tree, Phoebus [Apollo] loved her. He placed his hand against the trunk and felt her heart still beating under the new bark. Embracing the branches as if they were limbs, he kissed the wood; but, even as a tree she shrank from his kisses. . . .
>
> *Metamorphoses* 1, lines 545–556 (trans. Mary M. Innes)

How can a static image capture the delicacy of this metamorphosis? A Roman mosaicist (Fig. 127) has tried to convey the essence of the

127. Daphne and Apollo. Roman mosaic from Antioch, late 3rd century AD. The Art Museum, Princeton University. Gift of the Committee for the Excavation of Antioch. Photo: Bruce M. White.

story – Daphne's fear and loathing as she flees from the radiant Apollo, whose eager, outstretched hand is about to grasp her shoulder. At the crucial moment, just before he actually touches her, the girl is transformed into a laurel. But the artist's hint of this outcome seems hopelessly unsubtle, and it looks more as if Daphne has run into the bush than that she has turned into it. The task, however, is not an easy one. Other artists coped with illustrating metamorphoses in different ways, sometimes avoiding the actual event and only suggesting it obliquely. This was the approach of the vase painter who illustrated the metamorphoses of Thetis in Figure 128. As Thetis was a Nereid, a sea goddess, she was reluctant to be married to Peleus, a mere mortal, and so she did what she could to prevent the alliance, which she considered rather beneath her.

Being a sea creature, Thetis had the ability to change her shape into anything she chose. When Peleus came to woo her she resisted him by turning herself first into a roaring lion, then into a hissing snake and finally into flowing water and burning fire. These last two were

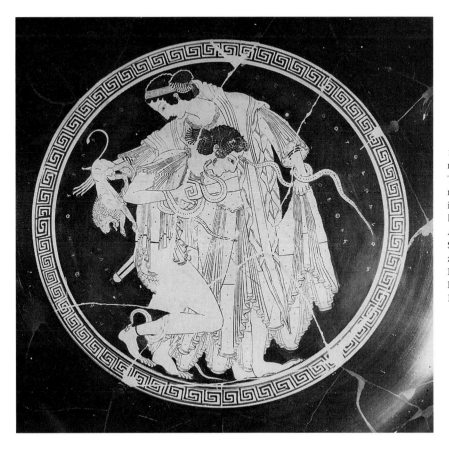

128. Peleus and
metamorphising
Thetis. Attic
red-figure cup
interior, c. 500 BC,
by Peithinos.
Antikensammlung,
Staatliche Museen
zu Berlin –
Preussischer
Kulturbesitz,
Berlin.

especially difficult to get a grip on, but Peleus held fast undeterred, showing himself to be a man of great determination, and in the end Thetis relented, resumed her normal shape and consented to marry him.

The transformations of Thetis were easily evoked by poets, but they were difficult for an artist to convey in a single picture. One artist's way of dealing with the problem was to depict Thetis in her true form, that is, as a lovely sea nymph, but at the same time to suggest her transformations by means of subsidiary figures. Thus in Figure 128 Peleus grasps Thetis firmly around the waist. Three snakes (one held by Thetis, another wound about Peleus' arms and a third looped around one calf and nipping his heel) and a small lion (which appears to be climbing down Pelcus' back) symbolise Thetis' metamorphoses. Peleus' tenacity is revealed in the way his hands are clasped together: so firmly are his fingers intertwined that they are locked into a geometric pattern.

Another way of illustrating a metamorphosis is to allude to it by showing something of the consequences. The hunter Actaeon had the

bad luck to glimpse Diana (the Roman equivalent of the Greek Artemis) naked in a pool. The outraged goddess, unable to reach either her clothes or her weapons, hurled a handful of water into his face and then challenged him to tell that he had seen her undressed. In Ovid's words:

> She uttered no more threats, but made the horns of a long-lived stag sprout where she had scattered water on his brow. She lengthened his neck, brought the tips of his ears to a point, changed his hands to feet, his arms to long legs, and covered his body with a dappled skin. Then she put panic fear in his heart as well. The hero fled, and even as he ran, marvelled to find himself so swift. . . . his hounds caught sight of him. . . . Actaeon fled, where he had himself so often pursued his quarry, fled, alas before his own faithful hounds. He longed to cry out: "I am Actaeon! Don't you know your own master?" but the words he wanted to utter would not come – the air echoed with barking. . . . While they held their master down, the rest of the pack gathered, and sank their teeth in his body, till there was no place left for tearing. Actaeon groaned, uttering a sound which, though not human, was yet such as no stag could produce
>
> *Metamorphoses* 3.193–239 (trans. Mary M. Innes)

Thus Actaeon, still a man in all his thoughts and emotions, locked within the inarticulate body of a stag, met a terrible fate: his very own dogs, not recognising him in his changed shape, tore him to pieces. Unable to speak, unable to call for help or defend himself, he was doomed.

For an artist merely to show a stag being attacked by dogs would not do; it would look like an ordinary hunting scene. A man attacked by dogs would be more unusual (Fig. 129), but only when one spies the pair of horns sprouting from his forehead does the story become clear. The sculptor was not able to capture the distress of a human spirit trapped in the body of a stag, but he could at least convey the story itself by showing the horrible consequences brought about by the transformation.

The problem of how to reveal the feelings and thoughts of a man captive within an alien form also confronted artists who illustrated the story of Odysseus and Circe. The sorceress Circe had an irresistible urge to transform any visitors she might receive into animals. She did this by offering them a drink and then touching them with her wand, after which, according to the *Odyssey*, they were turned into pigs and could be driven into the pigsties that were suitable homes for them in their new condition. The hero Odysseus thwarted Circe. He had eaten a

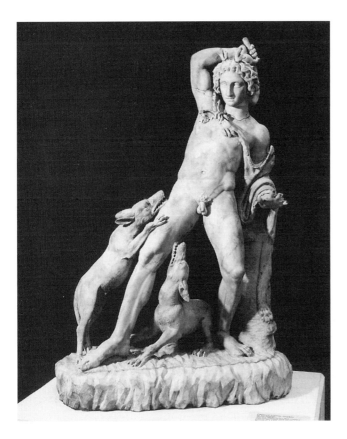

129. Actaeon
being attacked by
his own dogs.
Roman statue, 2nd
century AD. British
Museum, London.

special herb before arriving and was unaffected by her potion; he was
therefore able to threaten her while retaining his own shape and force
her to turn his companions (who had arrived previously and suffered
the customary transformation) back into men.

One vase painter chose to illustrate the dramatic moment when
Odysseus draws his sword on the startled Circe, who drops her cup and
wand and flees for safety (Fig. 130). Two of Odysseus' men, transformed

130. Circe,
Odysseus and
some of Odysseus'
transformed men.
Detail from Attic
red-figure calyx
krater, c. 440 BC,
attributed to the
Persephone
Painter.
Metropolitan
Museum of Art,
New York.

KIRKA

131. Odysseus and
Circe and a
transformed man.
Boeotian black-
figure skyphos,
Cabirian, early 4th
century BC, by the
Mystes Painter.
British Museum,
London.

into animals, rush up joyously behind Odysseus, delighted with what he has done.

The painter, who did not follow the text of the *Odyssey* exactly, decided to depict the men with various animal heads and tails, one with a boar's head and tail, the other with a horse's head and tail, as if the process of metamorphosis has been caught midway to completion. This sounds a good idea, but in a static image there can be little hint of what came before or what will come next. There is no clue, therefore, that these are men in the process of turning into beasts: to look at them, they might just as well be complete and immutable monsters, rather like the Minotaur. The Minotaur had a man's body but a bull's head and tail; Odysseus' men seem to have men's bodies but a boar's or a horse's head and tail. If one knows the story – and the discomfiture of Circe helps to recall it – it is easy to recognise what they are, but the artist has hardly succeeded in suggesting the human spirit imprisoned within an animal body.

Another artist succeeded far better (Fig. 131). His vase is one of a series of mythological parodies that were a speciality of a certain cult. To the left, Circe (inscribed) offers a huge cup full of her magic potion to a greedy Odysseus, who holds out eager hands to receive it. To the right is Circe's loom, which she was working at before Odysseus and his comrades arrived. On the other side of the loom sits the anguished figure of one of Odysseus' men transformed into a boar. The head and most of the body are boar-like, but the front haunch resembles a tensed shoulder and the hind leg is more human than animal, the foot is wholly human. The uncomfortable pose, the awkwardly placed leg, the pathetic upturned snout, all these features suggest the misery of the human being confined within the animal's form. The incompleteness of the physical transformation hints at the lack of spiritual transformation. The artist

has been remarkably successful in revealing what is hidden: the nature of the man inside the body of an animal.

Strong emotions and disturbing states of mind can be dramatically described in words but are less easy to depict. Discord, desire and persuasion are eloquent abstractions and often powerful motivations that propel myths to their conclusion. To show such invisible forces at work artists would sometimes resort to personifications (human figures supposed to embody an emotion or state of mind and labelled in order to make the point clear) to convey ideas that could not otherwise be seen by the naked eye. Vase painters occasionally used them to great effect.

The Trojan War began as a result of the rivalry of three goddesses for the sake of a Golden Apple, the prize for beauty that Paris was charged to award to one of them (see Figs. 61–64). Though the discord among the goddesses was basically an emotional state, the Greeks tried to make it manifest by creating a personification of Eris (Discord) herself. She appears right in the centre of Figure 132, just above Paris, her lower

132. The Judgement of Paris. Attic red-figure hydria, c. 420–400 BC, by the painter of the Carlsruhe Paris. Badisches Landesmuseum, Karlsruhe (drawing of Figure 63).

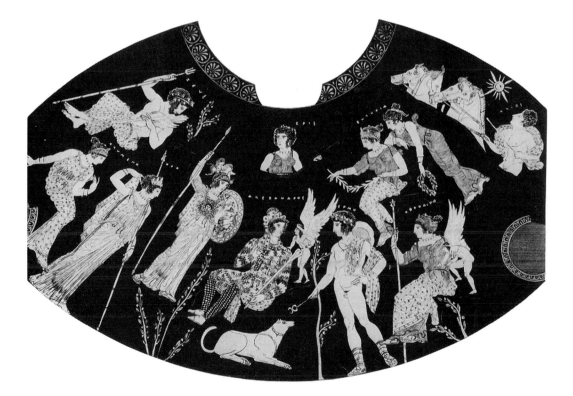

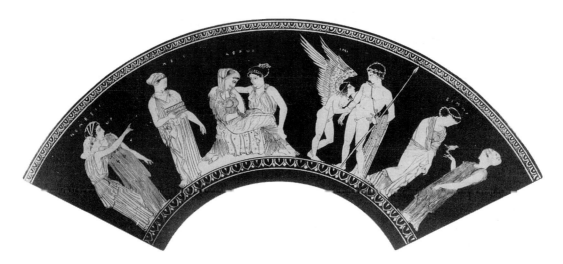

133. Aphrodite, accompanied by some powerful personifications, persuades Helen to elope with Paris. Attic red-figure pointed amphoriskos, c. 430 BC, by the Heimarmene Painter. Antiken-sammlung, Staatliche Museen zu Berlin – Preussischer Kulturbesitz, Berlin.

body concealed behind a hillock, her identity assured by the inscription beside her head.

Aphrodite, who received the Golden Apple, had bribed Paris to give it to her with the promise that she would arrange to have him gain the love of Helen, the most beautiful woman in the world. Now she had to make good her word. Helen at the time was married to Menelaus, and though she may have virtuously tried to resist the pleas of Paris, the odds were stacked against her. How could she withstand the blandish-ments of Aphrodite, who was ready to plead in person for Paris? This point is made by a 5th-century BC vase painter (Fig. 133). Aphrodite is shown holding Helen on her lap. Helen, chin in hand, is pensive and withdrawn. Paris stands to the right with a winged boy beside him. The youth looks like Eros, the god of love, but he is labelled "Himeros" (Desire). Another of Aphrodite's attendants stands to the left, carry-ing a jewel box. She is labelled "Peitho" (Persuasion). Firmly held by Aphrodite, caught between Desire and Persuasion, Helen has little hope of escaping her fate. The point is underlined by the inclusion of two further personifications: Heimarmene (Destiny) is present to the right, turning her back on Paris to address an unidentified woman with a bird perched on one hand, while Nemesis (Retribution), at the far left, leans on the shoulder of a woman whose label is no longer intelligible, and points a finger at the lovers-to-be. The subtle emotional trap (and its dire consequences) have been made manifest through the personifications.

The fall of Troy was finally achieved thanks to a trick, an innocent-seeming device that concealed the forces for destruction within. The

Greeks besieging Troy had constructed a huge, hollow wooden horse. This they left outside the walls of Troy while they led the Trojans to believe that it was an offering to Athena to assure their safe return home. Then they pretended to raise the siege and sail away. The Trojans, unwilling to let the Greeks get off unscathed, decided to drag the horse inside their walls so that they might profit from its protection and the Greeks suffer without it. In order to get the huge thing in, the Trojans widened their gates and tore down part of their walls, then rejoiced and revelled in what they thought was their first night of peace in many years. But their pleasure was short-lived, for the Greeks had concealed the best men in their army within the hollow horse, and when the celebrating Trojans had fallen into drunken sleep, the Greek warriors descended from the horse, summoned back the rest of the army, which had sailed only a short distance away, and sacked the dazed city.

As with the image of Circe's victims, the artist's problem was how to reveal what was concealed. To the Trojans, the horse was a harmless thing, an offering made of wood, but in fact it was a fearful bane, with picked warriors hidden inside it.

One artist solved the problem with naive simplicity (Fig. 134). He made the horse huge, occupying almost all the space available. He indicated that it was a wooden horse, not a real one, by fitting its feet with wheels, like a child's pull-toy. Much of the remaining space he filled with warriors, but just in case an observer should miss the point, he cut "windows" in the side and the neck of the horse, through which more

134. The Wooden Horse with warriors inside. Greek clay relief storage vessel, c. 670–650 BC. Myconos Museum, Myconos.

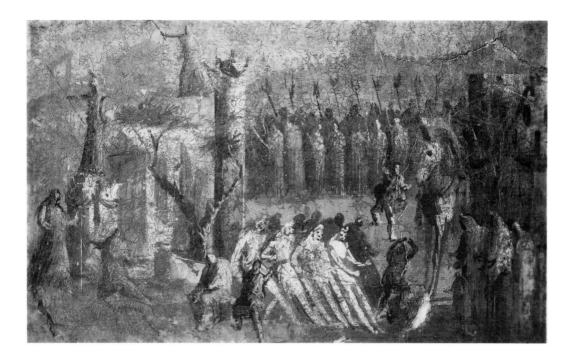

135. The Wooden Horse being hauled into Troy. Roman wall painting, c. AD 50–79 (from Pompeii). Museo Nazionale, Naples.

Greek warriors can be seen, like passengers in an aeroplane. In this way he clearly revealed what was concealed, telling his story eloquently enough, but forfeiting any illusion that the Trojans might have been fooled.

A Roman painter (Fig. 135), like the poet Virgil, sought instead to tell the story from the Trojans' point of view. In the *Aeneid*, Virgil chillingly recounted how the Trojans decided that it might well be worth their while enlarging their gates or even tearing down their walls in order to bring the huge horse, a lucky talisman as they believed, over to their side. This is how the Trojan hero Aeneas describes the event:

> We cut through our walls and threw our defences open. All set to work with zest. Rollers for smooth running were placed under the horse's feet and hempen ropes tied round its neck. That engine of doom, pregnant with armed men, mounted our walls. Boys and unwedded girls sang hymns around it, happy in the hope that the very touch of the ropes would bring them luck. The brute climbed on; then sank menacingly to rest right inside Troy. . . . Four times the horse halted in the gateway, and each time weapons clanged within it. But we remained witless, and blind, and mad; we pressed ahead and stationed the malignant horror within our consecrated citadel. Cassandra, whom her own god

had ruled that no Trojan should believe, let her lips utter once again the truth of what destiny had in store. We, poor fools, spent this our last day decorating with festal greenery every temple in our town.

Virgil, *Aeneid* 2.234–249 (trans. Jackson Knight)

It would be difficult for a painter to evoke as powerfully as this passage the misguided joy of the benighted Trojans as they drew the doom-laden creation within their walls.

One Roman painter, nevertheless, boldly chose to portray the moment when the Trojans began the fearful act of hauling the horse into the city (Fig. 135). The wooden horse, at the right, though bigger than an ordinary horse, seems a rather modest construction, not very much larger than the humans who tug at it, dragging it inevitably towards the city. It is equipped with a tower-like howdah on its back and is shown to be a *wooden* horse by the fact that its feet rest on a wheeled platform.

Quick, almost impressionistic brush-strokes capture the sense of excitement that pervades the scene. Dramatic light brightly illuminates the men pulling the horse but throws others into shadow, cleverly suggesting the nocturnal setting. A statue of Athena can be glimpsed within the city to the left. Elsewhere, orderly groups are contrasted with wildly energetic individuals. Two such agitated figures converge on the space in front of the horse, a third rushes away in the distance, a fourth falls to her knees before the statue and a fifth, at the far left, strides out of the picture towards us. Battlemented walls loom in the background.

The scene is animated but filled with a certain uneasiness. The eerie light falls most strongly on the vigorous diagonals of the men tugging at the monstrous horse, a stubborn vertical resisting their efforts; it is more muted as it falls on the stolid figures grouped together toward the back and glancingly hits the rushing figures scattered about. Though the picture is sketchy, it effectively hints at the disaster lurking beneath the bustling surface.

FOURTEEN

Distinguishing One Myth from Another

Some motifs occur over and over again in myths, often associated with the same characters. The problem for artists is to ensure that one myth can be distinguished from another. Herakles' encounters with multiheaded dogs present a case in point.

The two dogs in question were Cerberus, who belonged to the gods of the Underworld and guarded their gates (see Fig. 12, no. 11), and Orthros, who belonged to triple-bodied Geryon (see Fig. 12, no. 9) and the herdsman who tended his cattle. In literature there was no problem about distinguishing between these dogs: Cerberus was generally supposed to have three heads (though an occasional hyperbole might give him a hundred) and Orthros had two. In Attic art, however, these distinctions were not observed, and both dogs were normally portrayed with two heads. Nevertheless, there was little confusion, as the contexts usually sufficed to establish which dog was which.

Herakles was charged to fetch Cerberus, who was immortal, and show him to Eurystheus, the tyrannical master who imposed Herakles' deeds upon him. Thus when Herakles is depicted either capturing (Fig. 136) a two-headed dog in Attic vase painting or leading one (Fig. 137), it is clear that the dog is Cerberus. In Figure 136 Herakles cautiously approaches the double-headed, snake-tailed dog, his club by his side, a chain held at the ready. Athena stands behind him making a gesture of support. Cerberus is half in and half out of a building, which is indicated by a single column and part of the superstructure. This, presumably, is meant

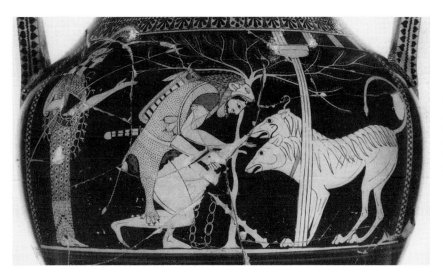

136. Herakles capturing Cerberus. Attic red-figure amphora, c. 525–510 BC, by the Andokides Painter. Louvre, Paris.

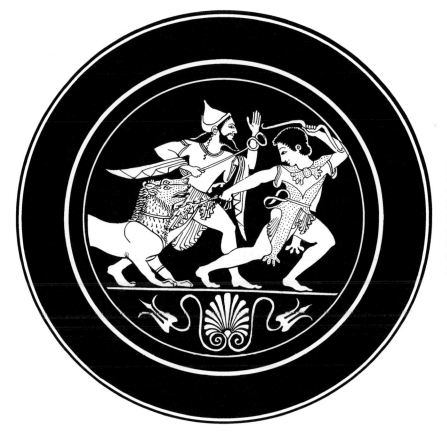

137. Herakles leading Cerberus, accompanied by Hermes. Attic red-figure plate, c. 520–510 BC, by Paseas. Museum of Fine Arts, Boston (H. L. Pierce Fund).

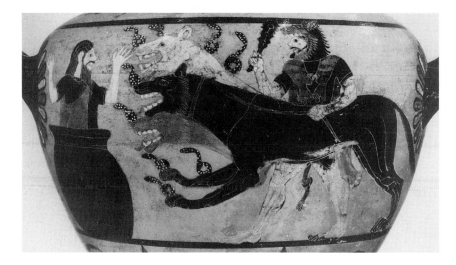

138. Herakles
introduces
Cerberus to
Eurystheus.
Caeretan black-
figure hydria,
c. 530–520 BC.
Louvre, Paris.

to represent the entrance to the Underworld that he is supposed to guard, preventing anyone who enters from ever leaving.

Once the monstrous hound had been captured, Herakles could lead him off, as in Figure 137, where he is accompanied by Hermes, as he drags along the recalcitrant two-headed hound. (As Hermes is the conductor of souls of the dead to the Underworld [see Fig. 125], he is a suitable guide in this context.) Cerberus' heads look rather leonine and he seems to have a mane, but such variations are only to be expected, for there is, of course, no model in nature for the monsters of myth.

Outside Attica, Cerberus was often given his full complement of three heads, as in Figure 138, in which Herakles presents the slavering monster to the cowardly Eurystheus, who has taken refuge in a gigantic storage jar. Herakles, his club in his raised hand, his lion skin over his head, holds Cerberus on a loose lead, while the dog with three differently coloured heads, bristling with snakes on noses, paws and neck, jaws gaping to show polished white teeth, bounds eagerly forward. Eurystheus in his jar throws up his hands in horror.

Orthros, unlike his brother, did not do so well in his encounter with Herakles. Though belonging to the same family of monsters as Cerberus, Orthros did not share Cerberus' immortality. According to the most prevalent form of the myth, he died along with his triple-bodied master, Geryon, and the single-bodied herdsman assisting him (Fig. 139). On the exterior of a cup, Herakles' exploit is portrayed in full. At the far left the dying herdsman collapses. Above him stands Herakles' nephew Iolaos, outfitted as a warrior, conversing with Athena, Herakles' patron, while in the centre Herakles attacks his triple-bodied foe, brandishing

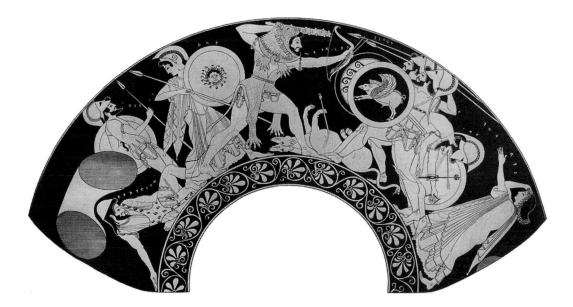

his club in one hand and holding out his bow ineffectually in the other. One of Geryon's three bodies, already out of commission, has fallen backwards, and a woman (at the far right) strikes her forehead in distress. Between Herakles and Geryon lies Orthros, double-headed, snake-tailed, an arrow in his belly and most certainly dead. The fact that he is dead is the one feature that distinguishes him with absolute certainty from his immortal brother, Cerberus.

Greek artists were never rigid in their portrayals, nor did they always feel obliged to show Orthros only after he had been killed. One of the most endearing images (Fig. 140) shows Orthros, at the far right, alive

139. Orthros lying dead as Herakles fights Geryon. Attic red-figure cup, c. 510 BC, by Euphronios. Antikensammlungen, Munich.

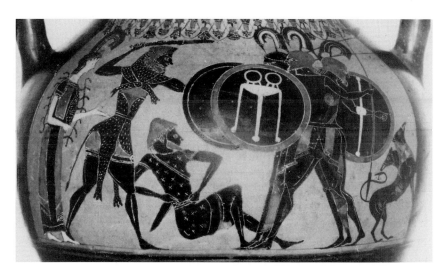

140. Orthros trying to escape from Herakles' onslaught. Attic black-figure amphora, mid-6th century BC. Musei Vaticani, Vatican City.

and intelligent, prudently trying to climb out of the frame of the picture while Geryon meets his come-uppance at the hands of Herakles. Orthros here is identified by his association with Geryon, the association which is his defining characteristic.

While non-Attic artists sometimes depict Cerberus and even Orthros with three heads, occasionally they show either dog with only one. For the artists it was the story that counted most, not the number of heads on the dogs, and so Cerberus could appear in any kind of canine guise, either in association with Herakles (attempting to or succeeding in carrying him off, Figs. 136, 137 and 138) or with his masters, the rulers of the Underworld, while Orthros appears only with Geryon (Figs. 139 and 140) and not always then. Geryon, after all, was Herakles' primary adversary, whereas Orthros and the herdsman were only optional extras in the myth and therefore readily omitted (as in Fig. 12, no. 9). During the Roman period, artists concentrated on the two protagonists, and images of Orthros disappeared entirely. Cerberus, by contrast, remained an interesting figure in Roman art with an increasingly varied assortment of heads: sometimes three equal-sized canine heads, at other times a large central one with two

141. Cerberus with unusual types of heads, held by Herakles. Roman sarcophagus, AD 160–170 (detail of an Alcestis sarcophagus). Musei Vaticani, Vatican City.

smaller flanking ones, and occasionally, oddly, three different kinds of animal heads and even a rather leonine central head (Fig. 141). Usually he appears in association with Herakles, the gods of the Underworld, or the Alexandrian deity Serapis, who resembled the king of the Underworld.

We have already seen centaurs, either as individuals like Nessos, the ferryman, who attempted to rape Herakles' wife Deianeira (Figs. 29 and 30), or as a group, like the centaurs who ran amok at the wedding feast (Figs. 69–71 and 73). We have even seen centaurs with wives and children (Figs. 102 and 103), but there are still more episodes in which centaurs are involved, usually misbehaving in one way or another or fighting.

After the Lapiths had driven the centaurs away from the women and guests at the wedding, they fetched their armour and continued the fight out in the open. Scenes of armed men fighting centaurs (Fig. 142) illustrate this phase of the conflict. Notice how the men use manufactured weapons while the centaurs fight with trees and boulders – even their names reflect this dichotomy, as one of the centaurs is called Petraios (boulder wielder) and one of the men Hoplon (hoplite or heavily armed foot soldier). To the left, three centaurs (much of their horse bodies lost) converge on an armed man who is being driven into the ground. He is visible only from the waist up, holding his shield out to the right; his helmet can still be seen with its high crest standing proudly vertical, though most of his head has been destroyed. This is Kaineus. Kaineus was originally a girl, but after being raped by Poseidon chose to be turned into a man and made invulnerable as her reward for services rendered. It was in this new guise that she (now a he) fought beside the Lapiths in their battle against the centaurs. The centaurs soon realised

142. Centaurs fighting Lapiths; Kaineus pummelled into the ground. Attic black-figure volute krater (François vase), c. 570 BC, by Kleitias. Museo Archeologico, Florence.

143. Herakles with Pholos and other centaurs at the centaurs' communal wine jar. Attic red-figure column krater neck, c. 460 BC, by the Niobid Painter. Museo Nazionale, Palermo.

that it was impossible to wound Kaineus and so, instead, hammered him into the ground. The composition, with centaurs on either side looming over their armed, partially submerged, adversary, proved attractive in its own right and was often portrayed (see Fig. 113), sometimes by itself as an excerpt from this conflict.

It was not only the Lapiths who had to fight a whole group of centaurs; Herakles, single-handed, was once forced to confront a large number of them. When the tired hero was passing through Arcadia, he stopped off with the friendly centaur Pholos, who was in charge of the centaurs' communal wine store. Pholos was obliged to offer Herakles some of the wine, and as he lifted the cover off the wine jar and the delicious aroma escaped, centaurs from all around scented the wine and came rushing up (Fig. 143). In Figure 143 the great storage jar partially sunk into the ground occupies the centre of the image. (It is this very kind of storage jar in which Eurystheus has taken refuge in Figure 138.) Herakles, lion skin over his head, stands to the left, his cup held out ready to be filled; Pholos stands to the right, holding a drinking horn. Another centaur approaches from the right and two more from the left, all attracted by the smell of the wine.

144. Herakles chasing the centaurs away from the communal wine jar. Corinthian black-figure skyphos, c. 580 BC. Louvre, Paris.

Soon matters got out of hand and Herakles was forced to chase the unruly creatures away, wounding some and killing others (Fig. 144). The dismayed Pholos stands at the far right, behind Herakles, holding a cup, while Herakles drives four centaurs away. Herakles needs

145. The centaur Eurytion dining with Dexamenos and his intended bride, the daughter of Dexamenos. Attic red-figure fragment, c. 475–450 BC, by the Nausikaa Painter. Louvre, Paris.

no special attributes in this scene to make the story recognisable, as this is the only myth in which a single man has to fight many centaurs.

Notice that the centaurs have human front legs (like Nessos in Fig. 29), but despite the unlikelihood of human front legs keeping up with equine back legs, they seem to run well enough. In archaic art this can be made to seem plausible, but as art became more naturalistic such inconsistencies became disturbing and all centaurs were eventually shown as human only down to the waist and fully horse below that.

Herakles' encounters with centaurs did not end here. When Herakles was visiting his friend Dexamenos, he arrived just as the centaur Eurytion had come to claim his unwilling bride, the daughter of Dexamenos. One brave vase painter has shown the prospective bride-groom reclining on a couch along with the father of the bride, while the girl herself, her white veil hanging down behind her, sits demurely at one side (Fig. 145). The centaur has his horse body discreetly covered, but his tail is clearly visible to the left of the bride and his haunch and hooves can just be made out to the right of her. This gracious reception of a centaur as a suitor no doubt required some strengthening of the furniture! Another vase painter, only a fragment of whose ambitious work exists, explored in more detail exactly how a centaur can accommodate himself to the civilised dining customs of the Greeks (Fig. 146). Herakles, naturally, disposed of the unwanted suitor.

There was one centaur who differed from all the others in everything but his anatomy. The wise Cheiron had different parents from the rest of the centaurs, a different character, and different qualities. Learned and benign, Cheiron lived in a cave with a wife and mother who were wholly human in form and devoted much of his time to educating

146. The centaur
Eurytion and his
intended bride.
Attic red-figure
fragment,
c. 475–450 BC.
Museum für Kunst
und Gewerbe,
Hamburg.

young heroes like Jason and Achilles in the arts of hunting, fighting, music and medicine. Artists often portrayed the young Achilles with his unusual tutor, either at their first meeting (preferred by vase painters) or undergoing instruction (preferred by Romans). A Roman painting (Fig. 147), probably copied from a Greek prototype, shows Cheiron seated rather clumsily on the ground in an elaborate interior setting teaching the youthful Achilles some of the finer points of lyre playing.

We can now appreciate something of the variety of myths in which centaurs were involved and begin to analyse which factors distinguish one from another. Thus, a scene that shows one man and a number of centaurs should be a representation of Herakles and the centaurs who got intoxicated at the wine jar. This story is recognisable even when Herakles has no identifying attributes, just from the personnel involved (Figs. 143 and 144).

Herakles (suitably equipped with attributes or an inscription) in combat with a single centaur might be a representation of Herakles with Nessos (Fig. 31) or with Eurytion in the sequel to the banqueting scene we have just been looking at (Figs. 145 and 146). If a woman is also present, she could either be the daughter of Dexamenos or Herakles' own wife, Deianeira (Figs. 29 and 179). Inscriptions can clarify identities, but if the woman is seated on the centaur's back, there is little doubt that she is Deianeira (Fig. 160), as Nessos was acting as ferryman when he attempted to violate her.

When more women or more men are present (Figs. 68, 71 and 73) along with one or more centaurs, some aspect of the battle of the Lapiths

147. The centaur Cheiron instructs Achilles in playing the lyre. Roman wall painting (presumably a copy of a Greek prototype), 1st century AD (from the Basilica at Herculaneum). Museo Nazionale, Naples.

and the centaurs is probably intended; if the men who are fighting are unarmed (Figs. 68–71 and 177) the wedding feast would be the implied setting, as the men would not come armed to that sort of celebration. Armed men (Fig. 142), or even just a single armed man, fighting a centaur represent the aftermath of the fight that began at the wedding, the battle of the Lapiths out in the open, in which the incident of the centaurs hammering Kaineus into the ground is one episode. Finally, a single centaur graciously receiving a small boy or gently instructing a youth must be Cheiron (Fig. 147).

Analyses along these lines ought to ensure that, with luck, when we see images of centaurs, we can usually recognise who is doing what with whom and why; but variations, complications and simple confusions on the part of the artists can never be entirely ruled out.

Certain themes had a particular appeal to the carvers (and purchasers) of Roman sarcophagi. Hunting was one such subject. A dangerous and demanding activity, it provided a subject which Romans apparently felt imparted an aura of bravery and heroic dignity to the departed. Boar hunting was particularly challenging because boars are powerful, fast and unpredictable. Not surprisingly, three myths (Meleager and the Calydonian boar, Venus and Adonis, Phaedra and Hippolytus) that all include a boar hunt were popular for the decoration of sarcophagi. The

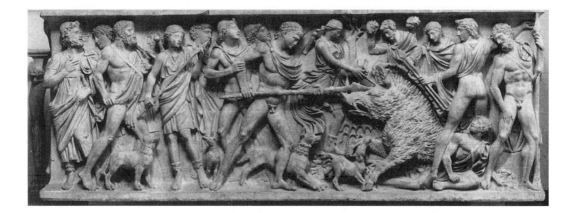

148a. Meleager hunts the Caly-donian boar with a spear while Atalanta shoots it with an arrow. Roman sarco-phagus, 180–200 AD. Palazzo Doria, Rome.

significance of the hunt in the story and the outcome were different in the three myths, but they had enough elements in common to encourage artists to find ways to distinguish one from another.

The stories are the following: Meleager was the leading hero and or-ganiser of the hunt of the Calydonian boar. This monstrous boar had been sent by Diana (the Greek Artemis) to ravage the land because Meleager's father had forgotten to make a sacrifice to her. Diana was a touchy goddess, as the stories of Actaeon (see Chapter 13) and Iphi-geneia (see Chapter 1) reveal, although, in rescuing Iphigeneia at the last moment, she did show a more compassionate side. Meleager invited most of the celebrated heroes of his generation to partake in the hunt. Not all the participants were male: Atalanta, a bold huntress, also joined in, and she was the first to wound the boar with an arrow, while it fell to Meleager to finish the beast off.

In representations of the hunt of the Calydonian boar (Figs. 148a and 148b), Meleager is the most prominent figure; he is shown nude and on foot and is not overlapped by any other figure as he spears the boar

148b. Drawing of Figure 148a.

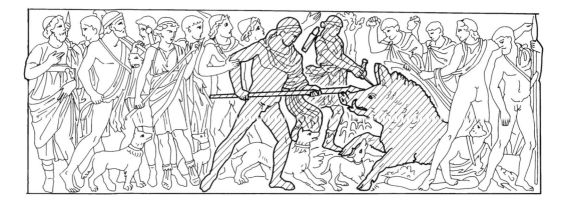

who rushes towards him from the right. Atalanta, shooting her bow, appears between Meleager and the boar. Even though the whole of the available space is filled with figures, some of greater significance than others, when one's eyes become adjusted to the bustle and confusion, the three main actors can be clearly descried: the boar at the right, Meleager confronting it, and Atalanta between the two.

149a. Venus and Adonis: departure of Adonis for the hunt; Adonis injured; Adonis hunting. Roman sarcophagus, c. AD 220. Musei Vaticani, Vatican City.

Adonis' confrontation with a boar did not have such a happy outcome. The goddess Venus (the Greek Aphrodite) loved the youth Adonis and was reluctant to have him engage in so dangerous a sport as boar hunting; and she was right. The bold boy nevertheless could not be restrained, and Venus was forced to let him go (Fig. 149a and 149b). At the far left, Venus reluctantly bids Adonis farewell. His horse stands ready behind him. At the far right, the boar charges and Adonis falls before it, fatally wounded. In the centre, Venus sits disconsolately beside her beloved, while a physician and a little love god try, to no avail, to assuage his wound.

The order of presentation may at first glance be puzzling, as the last episode in the story occupies the centre. Although one can often read the narrative presented on sarcophagi in a coherent manner from left to

149b. Drawing of Figure 149a.

150a. Phaedra and Hippolytus: Phaedra confronts Hippolytus; Hippolytus attacks a boar on horseback. Roman sarcophagus, 180–190 AD. Campo Santo, Pisa.

right, this is not always the case, and episodes may be distributed in a seemingly arbitrary order. The Romans apparently had no objection to this sort of temporal rearrangement of a story and might actually have valued it, as the educator Quintilian recommends:

> It is useful at first ... when a child has just begun to speak, to make him repeat what he has heard with a view to improving his powers of speech, and for the same purpose, and with good reason, I would make him tell his story from the end back to the beginning or start in the middle and go backwards or forwards. ...
>
> Quintilian 2.4.15 (trans. H. E. Butler)

The amorous relationship between Phaedra and Hippolytus was very different from that of Venus and Adonis and had nothing of their tender mutuality. Phaedra fell in love with her stepson, Hippolytus, a disgraceful passion. At first she tried to hide her real feelings, but as she sickened and seemed almost at death's door (though with her honour intact), her affectionate nurse persuaded her to tell Hippolytus of her passion. She

150b. Drawing of Figure 150a.

finally did so, and in doing so, deeply shocked the innocent youth. He left her to go hunting, for he was devoted to the hunt and to the chaste goddess Diana (Figs. 150a and 150b). At the far left, Phaedra, seated, declares her passion. Hippolytus, holding his horse, listens with horror; then he leaves, exiting from the interior of the house (indicated by an arch) into the open country. As in illustrations of the other two myths, a boar charges him from the right; he attacks it from horseback.

In all three cases the front of the sarcophagus is entirely filled with figures, some important to the story and to whom a name can be attached, others personifications (representing the courage involved in boar hunting), and still others just anonymous participants whose presence prevents any nasty gaps appearing in the overall decoration. In all three cases a boar (or, at least the front part of a boar) is normally shown charging from the right.

The three myths, as represented on Roman sarcophagi, can be distinguished because Meleager fights successfully on foot with Atalanta between him and the charging boar (Figs. 148a and 148b), while Adonis, who also hunts on foot, has fallen before the boar's onslaught (Figs. 149a and 149b). Hippolytus, by contrast with the other two, hunts on horseback (Figs. 150a and 150b).

151a. Venus and Adonis: Departure of Adonis; death of Adonis. Roman sarcophagus, 2nd century AD. Palazzo Giusti-niani, Rome.

151b. Drawing of Figure 151a.

What is surprising is how much some of the scenes of Adonis depart-
ing from Venus and Hippolytus leaving Phaedra resemble each other. In
Figures 149a and 149b, Venus embraces Adonis with her right hand, but
in Figures 151a and 151b, another rendering of the Venus and Adonis
myth, she is fully as reserved as Phaedra. A puzzling feature in both
of these Adonis sarcophagi is that Adonis is shown with a horse be-
hind him as he prepares to leave, even though he ultimately seems to
have hunted on foot. Scholars have suggested that the imagery used for
scenes of Hippolytus and Phaedra has been taken over here to show
Adonis' farewell to Venus.

The way such elements from one story can wander into images of
another and the confusion they can sometimes produce is the subject
of the next chapter.

Confusing One Myth
with Another

We have already seen examples of images of one man carrying another: Ajax carries the dead body of his comrade, Achilles, out of the battle raging around Troy (Fig. 50, shown here again as Fig. 152), and Aeneas carries the live body of his father, Anchises, away from the fallen city (Fig. 59 [shown here again as Fig. 154] and Fig. 60). The stories, of course, are different, though both belong to the tale of the Trojan War: Achilles is dead and Ajax soon will be; Aeneas and Anchises escape and survive. The visual parallels, however, are notable and can lead to confusion.

Images of Ajax with the body of Achilles began to appear in the first half of the 6th century BC. The earliest example clearly identified by inscriptions was painted by Kleitias on the handle of a vase (Fig. 152). Ajax moves to the right. His arms are fully occupied in coping with the huge bulk of Achilles and he has abandoned his shield in order to rescue the corpse of his friend from the turmoil of the battle.

A little after the middle of the century, another vase painter, Exekias, painted the same two figures, but reversed the direction and showed Ajax moving to the left (Fig. 153). The warriors are not labelled, but their identity can be established by the presence of the woman who stands at the far left, receiving the burdened warrior weighed down by his lifeless companion. This woman, so inappropriate in the context of a battle scene, must be Achilles' mother, Thetis, she who so often solaced her son during his trials and now is obliged to arrange for his

152. Ajax with the body of Achilles. Attic black-figure volute krater handle, c. 570 BC, by Kleitias (François vase). Museo Archeologico, Florence.

funeral. Reversing the direction so that Ajax moves to the left enabled the painter to give prominence to Ajax's shield, which he carries on his left arm. Homer often commented on this huge shield, unusual for its size, and Exekias may have considered it a sort of attribute belonging to the hero.

Exekias depicted Ajax partly obscured by his large shield, his head appearing just above the rim, while the dead Achilles' head, still in its elegant helmet decorated with a wreath, falls forward, the crest dipping toward the ground. Achilles' body is draped over Ajax's back and falls behind him; the dead man's limp left leg is almost parallel to Ajax's energetic left leg, while the right foot dangles between Ajax's legs. Achilles' shield, seen in profile, is tied to his back.

Reversing the direction had an additional advantage: it helped Exekias to distinguish between images of Ajax carrying the body of Achilles and Aeneas carrying Anchises, for he painted images of both. He depicted Aeneas moving to the right. Showing one group going to the left and the other going to the right was a good way of keeping the two very similar-seeming motifs from getting mixed up with one another.

Exekias' rendering of Aeneas carrying Anchises survives only as a fragment, but another artist's depiction clearly shows how different a

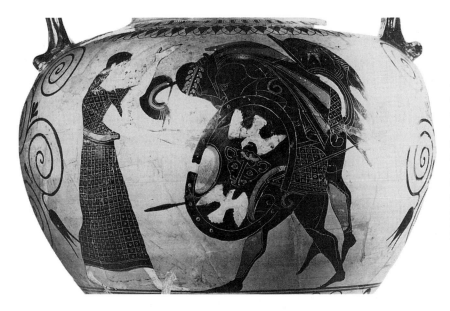

153. Ajax with the body of Achilles being received by Thetis. Attic black-figure amphora, c. 540 BC, by Exekias. Antikensammlung, Staatliche Museen zu Berlin – Preussischer Kulturbesitz, Berlin.

live old man being carried by a warrior looks from a dead warrior being carried by his comrade. This artist (Fig. 154) shows Anchises crouching as he clings on to his son's shoulder, his knees bent, craning his head forward. Aeneas grasps his father's shins with his right hand, the left holds his shield. Anchises looks ahead eagerly, his head overlapping that of Aeneas, the crest of whose helmet appears vertical behind him. Note the different spatial arrangement of the carriers and the carried in the two scenes: in Figure 153 Ajax's shield is closest to us, behind it is

154. Aeneas escapes from Troy with the blessing of his mother, accompanied by his wife and child, carrying his father. Attic black-figure amphora, c. 520– 510 BC, by the Antimenes Painter. Museo Nazionale, Tarquinia.

Ajax, and furthest away, the body of Achilles; in Figure 154 Anchises is closest to us, overlapping his son, who in turn overlaps his shield (which is furthest away from us). Note the intensity of the crouching Anchises with his lower legs held horizontally, as opposed to the limp body of Achilles with its pathetically dangling feet. Both the contrast in the characterisations and the opposite directions of movement help to distinguish the two scenes. But there are also many elements that they share, including, most important, supplementary figures. Two women and an archer are shown along with Aeneas and Anchises in Figure 154. The woman at the far left, waving the group off, is Aphrodite, the concerned mother of Aeneas and one-time lover of his aged father. The woman at the right, preceding the group and looking back while carrying a baby, is Aeneas' wife. The archer ahead of her could be any Trojan – and indeed fighting men are entirely appropriate in both scenes.

In Figure 153 the woman at the left is, like Aphrodite, also a mother. She is Thetis preparing to receive the dead body of her son. Other artists show Thetis performing another function (Fig. 155); they show her leading the group off the field of battle, looking back to make sure Ajax is following, and so functioning much like the wife in Figure 154.

155. Thetis leads Ajax carrying the body of Achilles. Attic black-figure amphora, c. 500 BC. British Museum, London.

While two women, wife and mother, both have a place in images of Aeneas' escape, only one woman, Thetis, has a role in the scenes involving Ajax with the body of Achilles. Thetis can, however, either appear as she does in Figure 153, receiving her son's body, or as she does in Figure 155, leading the rescuer of his corpse off the field of battle. She can, therefore, be depicted either like Aphrodite in Figure 154, sending her mortal family off to safety, or like Aeneas' wife in Figure 154, moving ahead of the burdened warrior. Within this flexibility lurk the seeds of confusion. One can see the seeds beginning to burgeon already in Figure 156, an 18th-century drawing of a vase now lost.

The central group of Figure 156 clearly shows Ajax with the body of Achilles: Ajax moves to the left, his shield is prominent, Achilles' lifeless legs dangle, and his hanging head is hidden behind Ajax's shield, while the crest of Ajax's helmet stands proudly vertical above the drooping body.

The identity of the accompanying women, however, is more problematic. (What look like inscriptions appear to be no more than meaningless letters.) The woman at the left leads (as Thetis does in Fig. 155), the one at the right seems to wave off the group in a pose resembling Thetis in Figure 153, but also resembling Aphrodite in Figure 154. The fact that there are *two* women is odd in itself. Only one woman ought to be associated with Ajax carrying the body of Achilles: Thetis. But Thetis cannot be both leading Ajax *and* sending him off at the same time.

The poses and positions of the women in Figure 156 are strangely similar to those of the two well-differentiated women in the scene of Aeneas and Anchises (Fig. 154). There one woman stands behind the

156. Two women with Ajax carrying the body of Achilles. 18th-century drawing after a lost Attic black-figure vase, probably late 6th century BC. Ex-Hamilton Collection, Tischbein IV, 53.

157. Ajax carrying the body of Achilles accompanied by two women and the spirit of a warrior. Attic black-figure amphora, late 6th century BC. National Museum of Ireland, Dublin.

group, sending them off (Aphrodite), while the other woman precedes the group (Aeneas' wife). The framing figures in Figure 156 are the same as those in Figure 154 (though in mirror image), but the central group is the wrong one!

Matters can become still more complicated if the usual direction of one or other of the themes is reversed. Thus when Ajax and Achilles are shown moving to the right, as on the vase in Figure 157, there is a good chance of muddle, despite the fact that this was the direction in which the group was portrayed in early representations (Fig. 152), before the Aeneas theme was tackled in art.

Besides showing Ajax moving to the right, the vase painter has also revived one of the most poignant elements in the older image: the pathetically hanging hair of the dead Achilles. The central scene is framed by two women; they flee in opposite directions, like the framing women in Figure 60 (or those framing Menelaus in Fig. 58). Why are there two of them, when only Thetis should be present? Are they a pair simply to serve as balancing decorative elements? Does the woman at the right have a closer, more meaningful relationship to the central group? She looks much like Thetis when she leads (Fig. 155), but equally like the wife of Aeneas (Fig. 154).

In some images (Fig. 158) the family group of Aeneas, his father, his wife and his son, are tightly bonded together, with the son shown between his parents. Here, too, a second woman (at the left) moves

158. Aeneas
carrying Anchises
accompanied by
two women and a
child. Attic
black-figure
amphora, late 6th
century BC. Musée
des Beaux-Arts,
Boulogne-sur-Mer.

away from the central group. Like so many others, she may have been
introduced as nothing more than a figure designed to balance the woman
at the right (the wife).

The compositions of Figures 157 and 158 are disconcertingly similar;
even the small running figure between Ajax with the body of Achilles
and the woman who walks in front of them in Figure 157 is very like
the son in Figure 158. But this is no child. The small running figure in
Figure 157 is helmeted and wears a breast plate and so is a miniature

159. Ajax with the
body of Achilles
accompanied by a
woman, an archer
and a child. Attic
black-figure
amphora, late
6th–early 5th
century BC.
Collection Abbé
Mignot, Louvain.

warrior. Surely it must represent the spirit of the warrior departing from his body, lamenting, as Homer says, and "weeping for its fate and the youth and manhood it must leave".

In both Figures 157 and 158 the central motif is one man carrying another; in both the carrier moves to the right; in both women move away from the centre but look back; in both a small figure runs between the carriers and the woman to the right. The potential for confusion is high. Were the small figure in Figure 157 a child (instead of the spirit of a warrior), the confusion would be complete. And so it seems to be in Figure 159, in which Ajax carrying the body of Achilles moves to the right. A woman is in front of him, an archer behind. Between the burdened warrior and the woman runs a child – a fugitive, it seems, from the other, visually very similar story, the story of Aeneas and Anchises. No child is associated with Ajax and the body of Achilles.

What is perhaps most surprising about this mix-up of two easily confused and conflated themes is not that it has happened, but rather that it happened so seldom!

Misunderstandings and Muddles

N ot every problem can be solved; not every contradiction can be resolved. Sometimes this is because an artist is referring to some myth or variant of a myth that has not come down to us. At other times it may be because an artist has made a mistake. Artists in antiquity were just as human as viewers in modern times, and just as fallible. Mistakes, muddles and confusions were part of life then as they are now, and often the best we can do is to recognise them for what they are.

We have seen that five devices could be used by artists to make their images of myths recognisable:

Inscriptions (providing identifying names)
Attributes (like the lion skin of Herakles)
Unique adversaries (monsters associated with particular heroes)
Unusual situations (for instance, men riding sheep upside-down)
Context (association of one incident with others from the same cycle).

All can be helpful and each sometimes decisive, but none can be relied on absolutely.

Take inscriptions: at first glance, inscriptions should be wonderfully reliable in economically specifying a particular person or situation seemingly indisputably – but this is not always so.

Sometimes inscriptions are used when no inscription is really necessary, for instance, the image of a centaur carrying a woman on his

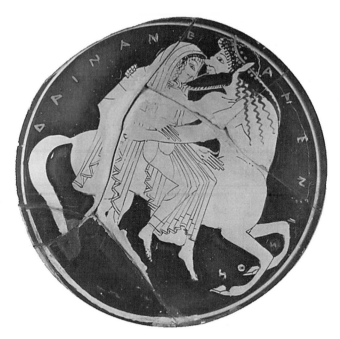

160. Nessos carrying off Deianeira. Attic red-figure cup interior, c. 520 BC, by the Ambrosios Painter. British Museum, London.

161. Theseus and the Minotaur accompanied by Ariadne and Athena and six youths and seven maidens. Attic black-figure cup, c. 550–540 BC, signed by Archikles and Glaukytes. Antikensammlungen, Munich.

back could only be Nessos carrying Deianeira (Fig. 160). The centaur is clearly a centaur, the only centaur who uses his anatomy for transport is the centaur Nessos, and the only passenger of note that he carries is Herakles' wife, Deianeira. The identity of the characters is made clear by their specific characteristics and the situation: the inscriptions are superfluous.

Sometimes inscriptions are used more lavishly than is strictly necessary: thus, Kleitias, in depicting Achilles' pursuit of Troilos (Fig. 26), not only labelled all the figures but even attached inscriptions to the fountain-house and the water jar.

An abundance of inscriptions, only some of them really informative, is employed in a detailed portrayal of Theseus killing the Minotaur

(Fig. 161). The climax of the story is shown in the midst of a veritable snowstorm of inscriptions (Fig. 9 is a detail of this frieze). The central scene is flanked by eight figures to the left and seven to the right. Athena (somewhat surprisingly unarmed and holding a lyre – the lyre also labelled) stands to the left, Ariadne with her ball of thread and a wreath to the right, and they are flanked by the full complement of seven maidens and six youths (Theseus was the seventh). It is helpful of the artist to give names to all the youths and maidens, but the central figures actually required no inscriptions: the anatomy of the Minotaur is distinctive enough in itself and the situation in which he is killed serves to identify Theseus, who killed him.

The ornamental quality of inscriptions as space fillers may have contributed to their attraction. Occasionally an illiterate artist, appreciating the decorative potential of scattered letters, would decorate his vase with a nonsense inscription (Fig. 162). Here Herakles, immediately recognisable by his lion skin, is attacking a centaur, while a woman, clearly Herakles' wife Deianeira, hastily dismounts. The central scene is unmistakable, even if the three human figures on the right and the two centaurs on the left are harder to explain. No inscription is necessary, and the supposed inscriptions are no more than a meaningless assortment of letters.

In Figure 163 Nessos and Deianeira are paired in the centre of a plate, an image that but for its abominable execution is very much like Figure 160. In this case the black marks surrounding the figures are not even letters, but mere imitations of letters.

By contrast, the inscriptions on a red-figure vase (Fig. 164) are entirely legible and intelligible (on the original vase), but all the more puzzling for that. In the centre Herakles (identified by his attribute of a club) attacks a centaur inscribed Dexamenos, while a woman

162. Herakles, Nessos and Deianeira, flanked by humans and centaurs and enhanced by nonsense inscriptions. "Tyrrhenian" Attic black-figure amphora, 565–550 BC. Antikensammlungen, Munich.

163. Nessos and Deianeira. Attic black-figure plate, late 6th century BC. National Archaeological Museum, Athens.

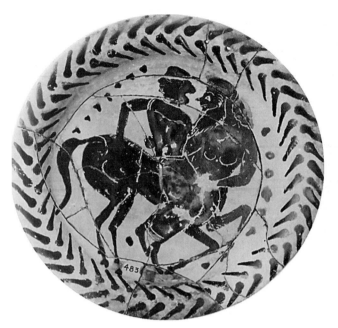

164. Herakles with a centaur called Dexamenos, Oineus and Deianeira. Attic red-figure stamnos, 450–440 BC, by a painter in the Group of Polygnotos. Museo Nazionale, Naples.

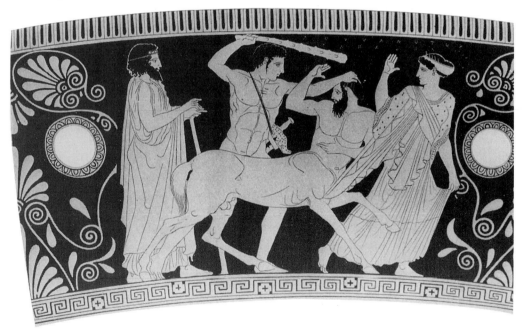

(inscribed Deianeira) flees, and a man, at the far left (labelled Oineus), looks on. Oineus was the name of the father of Deianeira, Herakles' bride who was attacked by Nessos. Dexamenos (the name attached to the centaur here) was the name of the father of the girl whom the

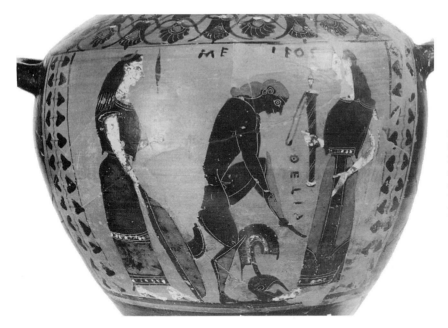

165. Thetis helping Menelaus to arm. Attic black-figure hydria, c. 540 BC. Antikenmuseum der Universität Leipzig, Leipzig.

centaur Eurytion was all set to marry before Herakles appeared on the scene. To fit one story, the centaur's name ought to be Nessos, but to fit the other, the centaur's name should be Eurytion and the father's name Dexamenos.

A more straightforward and unambiguous instance of what is probably just a simple case of mistaken identity occurs on a black-figure vase (Fig. 165) on which Thetis (inscribed) to the right, is helping Menelaus (inscribed) to arm himself. Some of the letters in Menelaus' name have been lost, but the spacing of those which remain makes it clear that he is meant. But why?

Thetis was Achilles' mother, and it was well known that she supplied her son with new armour made by Hephaistos when his own armour, which he had lent to his friend Patroklos, was lost. There are many images of Thetis bringing the new armour to Achilles, but none which show her performing the same service for Menelaus, with whom she had no particular relationship in mythology. The most likely answer to this puzzle is that the artist just got the names wrong. Such lapses occur to this day, even among scholars with a special interest in mythology. To err is human – and not confined to the modern era.

Surprisingly easy to explain is the case of three names (unsuitable for the myth depicted) inscribed on a Roman copy of a 5th-century BC

166. Hermes, Orpheus and Eurydike. Roman copy of a "Three-Figure Relief" originally made in the 5th century BC and mislabelled, at some time after the 16th century AD, as Zetus, Antiope, Amphion. Louvre, Paris.

relief (Fig. 166). The touching scene shows Orpheus, the legendary Thracian musician (he wears a Thracian hat), who so charmed the gods of the Underworld that they allowed him to bring his beloved wife, Eurydike, out of the realm of the dead on the condition that he did not turn to look at her as he led her back up to life. The condition seemed reasonable and all went well to begin with, but human curiosity, anxiety about any possible substitutions and general insecurity made Orpheus finally, fatally, turn his head. He then beheld his dear wife, but not for long, as Hermes, the messenger in charge of conducting the souls of the dead to the Underworld, immediately took her hand and led her away. The image is subtly eloquent as Orpheus (far right) turns to look tenderly at his wife and she, sadly, returns his glance, one hand still resting on his shoulder; at the same moment Hermes (far left) gently takes hold of her other hand in order to turn her and lead her back again. The names that should be attached are obviously Hermes, Eurydike and Orpheus, but they read: ZETUS, ANTIOPE, AMPHION – participants in quite another story. For once, the explanation

is straightforward: the erroneous inscriptions were added long after the
end of antiquity, at some time after the 16th century AD: the mistake is a
modern one.

* * *

Attributes are often almost as useful as inscriptions, particularly for
identifying famous figures like Herakles. What then does it mean if one
youth is carrying the hero's trademark lion skin and another holding
Herakles' club (Fig. 167)? Or, even odder, if a woman wears Herakles'
lion skin and carries his club (Fig. 168)? The answers to these two conun-
drums are mercifully simple: the youths are the Kerkopes, mischievous
creatures who stole Herakles' equipment while he slept and whose

167L. Kerkopes having stolen the attributes of Herakles. Attic
red-figure pelike, 430–420 BC, in the manner of the Washing
Painter. Antikensammlung, Staatliche Museen zu Berlin –
Preussischer Kulturbesitz, Berlin.

168R. Portrait statue of a Roman woman in the guise of
Omphale dressed as Herakles. 1st half of the 3rd century AD.
Musei Vaticani, Vatican City.

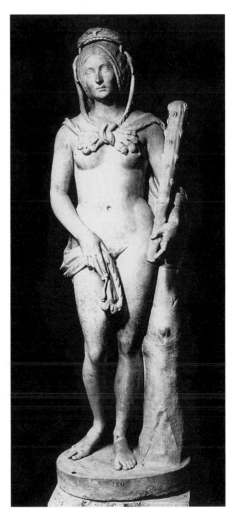

169. Herakles and the Kerkopes. Metope from Temple C at Selinus (Limestone), c. 575–550 BC. Museo Nazionale, Palermo.

story we know from literature. Other representations usually show a later phase in the story, when Herakles had caught the Kerkopes and hung them upside-down on a pole that he carried over his shoulders (Fig. 169). This gave them a unique opportunity to observe Herakles' spectacularly black and hairy bottom, and the jokes they made on the subject so amused the good-natured hero that he let them go.

The explanation of the woman dressed in attributes that rightly belong to Herakles (Fig. 168) is equally easy to explain – if one knows the story. The woman is Omphale, the queen of Lydia. Herakles, who suffered from sudden murderous rages, once requested purification from the oracle at Delphi. He was told that he had to be sold into slavery for three years. His purchaser was Omphale, who amused herself swaggering around dressed like Herakles while the humiliated hero had to wear women's clothes and perform women's tasks.

The point to remember is that attributes by themselves are not always enough to identify a figure. They may temporarily be in someone else's possession, and one should never jump to conclusions on the basis of attributes alone.

170. Hermes weighing the destinies of Memnon and Achilles in the presence of their anxious mothers, Eos and Thetis. Attic red-figure cup, c. 450 BC. Louvre, Paris.

Finally, attributes such as wings can sometimes be added or at other times omitted according to need and context. We can see how this happens in images of Thetis (normally wingless) and Eos (normally winged). These two goddesses each had a son, and tension was high when the two sons fought each other to the death. On the exterior of a cup (Fig. 170), Hermes is shown in the centre weighing the fates of the two contenders. The goddess-mothers, having learned the result, rush away from him, eager to support their sons, who are shown fighting on the other side of the cup (not illustrated). Eos, the dawn goddess who needs wings to propel her through the sky, speeds away to the left. Thetis, a sea goddess who needs no wings, hurries off to the right. The two deities are properly distinguished by their attributes here, but when the two mothers are shown actually anxiously watching their sons engaged in combat, the symmetry of their positions and of their emotional states often seems to overwhelm the distinctions in their appearance. Thus in Figure 171 both mothers (both inscribed) are shown as wingless, while

171. Achilles and Memnon fight while their anxious mothers, Thetis and Eos (both wingless), look on. Attic red-figure volute krater, c. 490 BC, by the Berlin Painter. British Museum, London.

172. Achilles and Memnon fight while their anxious mothers, Thetis and Eos (both winged) look on. Attic red-figure cup, 490–480 BC, by the Castelgiorgio Painter. British Museum, London.

in Figure 172 both are winged. From the point of view of attaching the correct attributes to a mythological figure, these representations are not quite right, but from an emotional point of view, and even a compositional one, they are excellent.

* * *

The unusual forms possessed by monsters are normally sufficient to allow for identification, but sometimes it took a little while before a conventional form was arrived at. Thus an early (7th-century BC) image of what looks for all the world like a lady centaur (Fig. 173) appears baffling. Some clue to what is meant may, however, be gleaned from the man who purposefully saws off her head while determinedly looking the other way. This is exactly what Perseus does in Figure 95 when he decapitates Medusa while avoiding any kind of eye contact. Some scholars have suggested that what appears to be a female centaur really is not a lady centaur before her time, but that when the standard type of the Gorgon Medusa had not yet been formulated, a centaur served as an all-purpose type of monster. It was here shown as female (because Medusa was female), and Perseus behaves as would be prudent were he to confront a Gorgon. A similar argument is offered to explain why in a very early image Zeus is shown fighting with what looks like a centaur, but what, in the context of the image, ought to be Typhon, a monster who eventually came to be represented as human on top with snake legs below, a type that later probably inspired the snake-legged images

173. Perseus
beheads Medusa
(in the guise of a
female centaur).
Boeotian relief
amphora, c. 660
BC. Louvre, Paris.

174. Three "Mino-
taurs". Attic
black-figure
hydria shoulder,
c. 520–510 BC.
British Museum,
London.

of giants (see Chapter 9). In this early period Typhon was considered to
be a monster in some way combining human and animal forms, but no
visual equivalent had yet been formulated, so once again the centaur
served as the all-purpose form of man-animal mix.

Another problem is presented when what ought to be a unique
monster is multiplied (Fig. 174). We know of only one mythological
Minotaur, the one that lived in the labyrinth and was killed by Theseus,

so it is surprising to see no fewer than three Minotaurs dancing along. There is no myth that would explain the cloning of a Minotaur, so some other explanation has to be sought. The bulls' heads on the human bodies might easily be masks (tails are easily attached) and the repetitive dancing poses of the three "minotaurs" suggests a theatrical chorus. It seems likely, therefore, that these three minotaurs are not minotaurs at all, but actors in costume. One theory is that they represent river gods. River gods were generally portrayed in art as bulls with horned men's heads. Such creatures would be difficult to manage in a theatre, but reversing the parts, putting bulls' heads on men's bodies, would make matters much easier.

∗ ∗ ∗

A different sort of problem is presented by a perfectly recognisable monster – the Chimaera – in an unrecognisable situation. The Chimaera was a most unusual combination of beasts, predominantly lion, but with a fire-breathing goat emerging from the middle of its back and a snake for a tail. It could hardly be mistaken for anything else. The fate of the

175. Bellerophon riding Pegasus attacks the Chimaera. Floor mosaic from Hinton St. Mary, 4th century AD. British Museum, London.

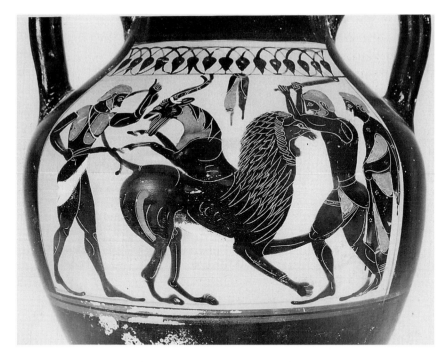

176. Two men attack the Chimaera. Attic black-figure amphora, c. 540 BC, by the Swing Painter. British Museum, London.

Chimaera was to be killed by the hero Bellerophon, who performed this feat while riding on the winged horse Pegasos, offspring of Medusa, as in this late Roman mosaic (Fig. 175). Despite the damage to Pegasos' wings and the centre of Bellerophon's body, there is little doubt that the conventional image is presented: a single hero, mounted, is dealing with the triple-bodied monster. A 6th-century BC black-figure vase, by contrast, has a most unconventional representation of an attack on the Chimaera (Fig. 176). The beast in the centre of the image is indubitably the Chimaera, gallantly fighting on two fronts, attacked by two men, while a draped civilian watches from the right. Who are the men? The one on the right wields a club – a weapon often used by Herakles and sometimes by Theseus – but neither Herakles nor Theseus have anything to do with the Chimaera, nor was the beast slain by a pair of heroes, but by Bellerophon alone. Has the artist invented the image just for the sake of decoration? Or did he know something that we don't?

* * *

Clearly, many of the clues normally relied upon to decode images can be baffling at times; even context can not always be relied upon.

We have learned a lot about centaurs and the different fights in which they were involved. Some tangled with Herakles, others with

Theseus. The rule of thumb for identifying which episode is intended (if there are no inscriptions) is the following:

177. The battle of the Lapiths and centaurs at the wedding feast. Attic red-figure cup exterior, 410–400 BC, by Aristophanes. Boston, Museum of Fine Arts, MFA 00.345. H. L. Pierce Fund purchased by E. P. Warren.

> One man, many centaurs: Herakles and the battle at the wine jar
> One man, one centaur, one woman: Herakles, either with Nessos and Deianeira or with Eurytion and the daughter of Dexamenos
> One or more men (unarmed) and one or more centaurs and/or one or more women: the battle of the Lapiths at the wedding feast
> One or more men (armed) and one or more centaurs: the battle of the Lapiths out of doors following the wedding feast

Thus, the image on the exterior of a cup (Fig. 177) showing several unarmed men fighting several centaurs fits neatly into the category of the battle at the wedding feast. Furthermore, one of the heroes is labelled

178. The outbreak of trouble at the wedding feast: Theseus attacks a centaur who has seized the bride. Apulian red-figure calyx krater, c. 350 BC, by the Laodamia Painter. British Museum, London.

Peirithoos, the host and bridegroom on this unfortunate occasion, and another is inscribed Theseus.

Theseus, the bosom friend of Peirithoos, was prominent in this encounter, as is illustrated on a South Italian vase (Fig. 178). Here the trouble at the wedding feast is just beginning: a centaur has kicked

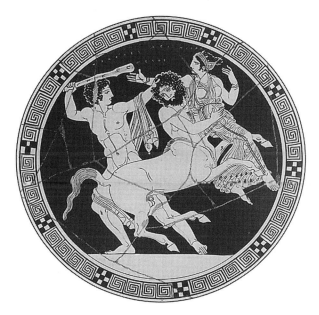

179. Herakles rescuing Deianeira from Nessos. Attic red-figure cup interior of Fig. 177, 410–400 BC, signed by Aristophanes. Boston, Museum of Fine Arts. Boston, MFA 00.345. H. L. Pierce Fund purchased by E. P. Warren.

over a bowl and lays hold of the bride. Theseus (inscribed), to the right, using a slender club, attacks the centaur while another woman flees further right.

The interior of the cup illustrated in Figure 177 shows a man with a similar club attacking a centaur who grasps a woman in his arms (Fig. 179). Instances of centaurs grabbing women in this way abound in images of the battle of the centaurs at the wedding feast (see Figs. 68 and 71), and one might expect, from the context established on the exterior of the cup, that this is an excerpt from the same story.

But one would be wrong. The three figures are inscribed; they are identified as Herakles, Nessos and Deianeira. The context has proved misleading.

⋆ ⋆ ⋆

One can only conclude that endless surprises await the student of mythological illustration in classical antiquity.

Can the Key to an Image Always Be Found?

When the subject of an image is puzzling, scholars search for a key to unlock its secret. If the right key is found, there is a satisfying click of recognition. Such was the case with one South Italian vase (Fig. 180).

At first everyone was baffled as to what it might represent. The centre is occupied by three figures on an altar, a man seated between a standing woman holding a vine rich with grape clusters and a seated woman holding sheaves of grain. There are also numerous subsidiary figures scattered about, none of which seemed to offer any helpful clues. To the left of the central group stands a woman holding some leafy twigs, to the right a dignified man with a sceptre. Higher up, three divinities are represented: to the left, the goddess Artemis, identifiable by the bow she holds, addressing her twin brother Apollo, seated with his attribute of a swan; to the right, a seated figure of Pan, identifiable by his barely visible little white goat horn. No inscriptions give any hint about the identity of the other, more generic figures.

Many such complex scenes with men and women holding rather ordinary objects seem to defy interpretation. Sometimes, luckily, as in this case, somebody who sees the "mystery picture" recalls a story that might be related. If it fits the image, the secret may be unlocked. Thus, once it was suggested that the vase might refer to the daughters of Anios, the elements of the image suddenly arranged themselves into a more intelligible order.

180. The daughters of Anios. Apulian red-figure calyx krater, c. 330 BC, by the Darius Painter. Private Collection, Miami, Florida.

The story is the following: Anios, king of Delos, was aware of a prophecy that the Greeks would not be able to sack Troy until ten years had elapsed. When the Greek expedition first arrived at Delos midway across the Aegean Sea, he ingeniously suggested that the troops stay with him for the nine years' waiting time. He could afford to keep the army because of the marvellous gifts of his three daughters who were able to produce grain, olives and wine at will. At the time his offer was declined, but later, when the troops at Troy found themselves constantly forced to make foraging expeditions while trying to maintain a siege, they thought again. Anios' daughters seemed a general's dream commissariat, and the Greeks decided to send one of the kings who shared the command of the army to demand their services. But by then the girls had become frightened of life with the troops, and they tried to flee. When relentlessly pursued, they prayed to the god Dionysus, who had bestowed their special gifts, and in the nick of time he transformed them into doves and they flew off.

The story of the daughters of Anios was so seldom illustrated in antiquity that it did not readily come to mind, but once suggested it explained the image so satisfactorily that no doubt remained. What had

at first seemed to be a central scene of three figures on an altar, flanked by a standing woman to the left and a standing man to the right, now took on a somewhat different configuration. The rather inconspicuous woman to the left ceased to look as if she were just the symmetrical pendant to the standing man and began to look like one of three sisters, attaching herself, psychologically, to the other two with their more immediately eye-catching crops. At the same time, the leafy twigs she held began to look like sprigs of olive. The regal man standing at the right, instead of reflecting the stance of the olive maiden, began to look as if he were confronting the group of four, and the position of his right hand, which at first had seemed so similar to that of the olive maiden's left hand, now became a gesture suggesting that he was addressing the four figures.

Once the story had been identified, the image became clear: it was a representation of one of the Greek kings coming to Delos to request the services of Anios' daughters. Anios and his offspring, having become reluctant to get involved in the expedition, have taken refuge on or beside an altar. The scene is set at Delos, an island sacred to Apollo, and so the appearance of the god and his sister Artemis (who were born there) seems appropriate. The reason for the presence of Pan is less obvious: possibly he is there merely to indicate that the scene is taking place out of doors. We cannot always understand every detail that appears in ancient representations.

The reading of an image can be radically altered by the interpretation that is imposed on it, and even the composition can assume a different structure once one knows what the story is. This is quite natural and correct. Images on their own are mute. If they are intended to illustrate a story and the right story is identified, the elements will fall into place in accordance with the narrative, as here. The dangers for a modern student are either that a story is *invented* to account for a picture, which would then have nothing to do with the original intentions of the artist, or that the wrong story is seized on and the elements are *forced* to conform with it.

Artists sometimes ensure against errors of interpretation by labelling their figures or choosing situations that are quite unmistakable, but when they are just straightforwardly illustrating a story that *they* know, they may offer fewer clues to identification and we, for whom the story is no longer a familiar one, are left mystified.

The identification of the myth on this vase also clarified the subject of another, very similar South Italian vase that had previously

181. Herakles and Apollo struggling for the tripod. Centre of the pediment of the Siphnian Treasury (detail), c. 525 BC. Delphi Museum, Delphi.

defied interpretation. Apparently some South Italian vase painters were more familiar with the story of Anios than modern experts on vase painting.

Even when there is no doubt as to the myth being illustrated, it may still be possible to refine details of the identification. Such refinement was brilliantly demonstrated by Brunilde Sismondo Ridgway in 1965. The centre of the east pediment of the Siphnian Treasury in Delphi had long been recognised as an illustration of the struggle of Herakles and Apollo for the tripod (Fig. 181), the same myth as is illustrated in Fig. 106. The story was extremely popular, particularly among Attic vase painters from the middle of the 6th century BC through the first quarter of the 5th century BC. Dozens of vases illustrating it still survive. The most popular schema (Fig. 182) showed four figures: Herakles trying to carry the tripod off while Apollo clings on to it, flanked by Artemis standing behind her brother and Athena behind her protégé, Herakles. Symmetrically framed by the two flanking figures, the normal composition usually lacks any central accent: the emphasis is on the conflict of the two principals.

Occasionally, however, a figure is introduced as a central feature – most conspicuously on the pediment of the Siphnian Treasury, where the design of the pediment demands it (Fig. 181). This headless, heavily draped personage, considerably larger than both Herakles and Apollo, was long assumed to be Athena. Apollo (to the left) after all has his supporter, Artemis, holding on to him, while no one stands to the right of Herakles encouraging the hero. Furthermore, the central figure is clearly grasping Apollo's wrist as if to force him to release the coveted object.

The idea that Athena should be so very big, overtopping the two male figures, one a god and the other a hero, puzzled Ridgway. Could the assumption that the central figure on the pediment of the Siphnian Treasury was Athena be the consequence of an Athenian bias among scholars? Would the goddess be so overwhelmingly important in Delphi, or on the Aegean island of the Siphnians, whose city paid for the Treasury?

Ridgway turned to the literary sources that described the myth. The two that were most detailed were much later than the Siphnian Treasury, which was built shortly before 525 BC, but relied on earlier traditions. Both related that Zeus intervened to settle the dispute. Could Zeus, she wondered, then be the central figure? He would logically be taller than his two less magnificent sons and the most appropriate person to mediate between them.

Once her inspired questioning reached this conclusion, more and more details became apparent that confirmed it. The dignified long garment worn by the central figure would have been suitable for either Zeus or Athena, but if Athena had been intended some hint might have been given of her characteristic snake-fringed aegis. There was no hint. Furthermore, the long garment only reaches to the ankles of the central figure, while the robes of the indisputably female figures to the left trail on the ground. Finally, the trace of a beard, very similar to Herakles'

182. Herakles and Apollo struggling for the tripod, with Herakles supported by Athena and Apollo by Artemis. Attic red-figure amphora, c. 530–520 BC, by the Andokides Painter. Louvre, Paris.

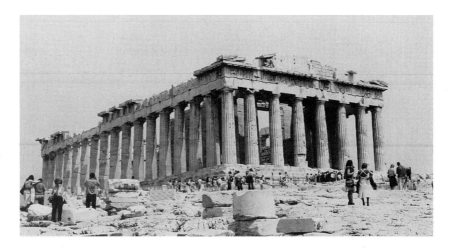

183. Parthenon, temple dedicated to Athena, 447–432 BC. Acropolis, Athens.

well-preserved beard, can be detected just to the left of the locks falling on that side.

The new identification of the central figure was thus convincingly confirmed.

Such neat solutions are very satisfying; unfortunately they cannot always be found. Sometimes a universally acceptable interpretation remains stubbornly elusive. This appears to be the case with two of the most famous, widely discussed and greatly admired of all works to survive from classical antiquity: the frieze of the Parthenon and the Portland Vase.

The Parthenon frieze (Figs. 184–191) was part of a large public monument, a marble temple, built in Athens in the 5th century BC. By contrast, the Portland Vase (Figs. 192–194) (so named after its one-time owner, the Duchess of Portland) was a private possession, an exquisite glass vessel originally seen only by a select few, made by a Roman craftsman in the early years of the Roman Empire. Though dramatically different in size, material and function, both of these celebrated works pose formidable problems in interpretation, problems that many still consider unresolved.

The frieze of the Parthenon itself was an unexpected element in the rich sculptural decoration of the temple, the largest dedicated to Athena in Athens (Fig. 183). Doric temples like the Parthenon normally had sculptures with mythological subjects filling front and back pediments and often also some metopes carved in relief. An immensely long sculpted Ionic frieze – the Parthenon frieze originally stretched

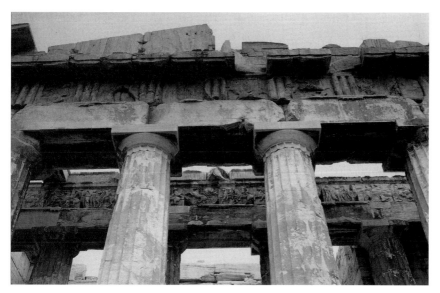

184. View of the
frieze of the
Parthenon through
the external
colonnade. Photo:
Hirmer Verlag
München,
Munich.

for 160 metres (524 feet) – was a surprising innovation. In its original
position (Fig. 184), the frieze ran above the exterior of the side walls
and above the front and back porches of the inner core of the temple.
It was high up on the building, visible only at intervals behind the
external colonnade, and neither so accessible nor so conspicuous as
it now is in the various museums where about two-thirds of it is still
preserved. It was an intimate part of the decoration; one could not see
it from a great distance but had to stand rather close to the temple and
look up at it between the outer columns.

No ancient author says anything at all about it. Pausanias, who saw
the Parthenon complete and undamaged in the second century AD,
noted the myths illustrated on the front and back pediments (the
birth of Athena and the contest of Athena and Poseidon for the
patronage of Athens, respectively), but he did not even mention
the metopes or the frieze. There are sufficient clues in the sur-
viving metopes to satisfy most scholars as to what they represent
(see Chapter 11). But the subject of the frieze continues to challenge
scholarly unanimity.

All interpretations – and all evaluations of the validity of inter-
pretations – have to begin with a study of the material. Inspecting the
original reliefs is best, but failing that, there are a number of well-
illustrated books (see p. 236), for instance those by Martin Robertson
and Ian Jenkins, and a CD-ROM included in Jenifer Neils' book which
can be consulted. An admirable publication recording a collection

gathered in Basel of all the casts ever made of the frieze (including casts of pieces now lost) and such drawings from the seventeenth to the nineteenth century as are illuminating, appeared in 1996 (in German). As a compendium of visual material it is superb.

Long narrow friezes like that of the Parthenon (which was only about a metre high) present artists with considerable problems of design. A suitable subject is the first step to a solution. A procession could serve well, since a procession (like a battle, cf. Figs. 68 and 72) could be extended indefinitely by adding as many figures as were required to fill out the desired space. It was, therefore, reasonable that most of the Parthenon frieze should be occupied by a procession.

The way the procession was arranged can be understood once one appreciates the position of the Parthenon on the Acropolis of Athens (Fig. 183). The Acropolis itself is a steep rock accessible only from the west. The temple faced east. Worshippers ascending the Acropolis were obliged to approach the Parthenon first from the back and then walk along its length to the front.

The carved procession on the frieze, like any real 5th-century BC procession celebrating a festival in honour of Athena, also moved from the back of the temple to the front (Fig. 185). The carved procession was divided into two unequal branches at the southwest corner. One branch moved along the west end to the north and then proceeded along the north side, as indeed most worshippers did (and visitors do to this day). The other moved along the south side. The two branches converged on the centre of the east end, where twelve seated gods were portrayed (Figs. 186 and 189).

The procession (Fig. 185) was dominated by a cavalcade, which occupied nearly half of the frieze. This was preceded by chariots. The liveliness of the horses and their controlled excitement imparted vitality and a sense of movement to the carved images. Horsemen were shown making preparations, many still unmounted, on the west end (Fig. 184), but moving briskly along the north and south sides headed for the front of the temple (Fig. 191). As the processions neared the east end, the pace slowed down and men on foot were shown carrying trays, musical instruments, water jars or other paraphernalia and leading sacrificial animals. Only on the east end did women appear, virtually at a standstill flanking the stationary groups of men on either side of the seated gods.

As no surviving ancient author explains the meaning of the frieze, it is up to modern scholars to interpret it as best they can. A concise

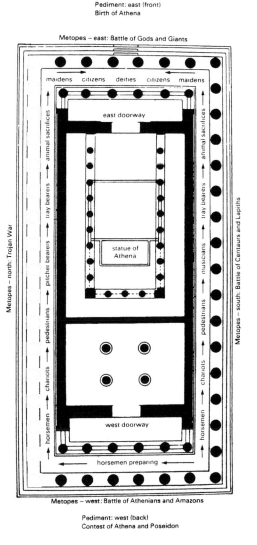

Pediment: east (front)
Birth of Athena

Metopes – east: Battle of Gods and Giants

maidens citizens deities citizens maidens

east doorway

animal sacrifices

tray bearers

pitcher bearers

pedestrians

chariots

horsemen

Metopes – north: Trojan War

statue of
Athena

animal sacrifices

tray bearers

musicians

pedestrians

chariots

horsemen

Metopes – south: Battle of Centaurs and Lapiths

west doorway

horsemen preparing

Metopes – west: Battle of Athenians and Amazons

Pediment: west (back)
Contest of Athena and Poseidon

185. The themes of
the architectural
sculpture decorat-
ing the Parthenon
as indicated on the
plan of the
Parthenon.

summary of several interpretations of its meaning is included in Ian
Jenkins' and Jenifer Neils' books on the Parthenon frieze and Jeffrey
M. Hurwit's on the Athenian Acropolis.

On some points, though far from all, there is general agreement.

The fact that gods are represented is undisputed; their size distin-
guishes them. Though the gods are shown seated (Figs. 187 and 189),
their heads reach up to the top of the frieze just like the heads of the
standing or mounted men. This is a subtle way of indicating the greater
stature of the gods while maintaining an overall decorative pattern
throughout the frieze.

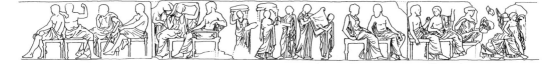

186. Drawing of the centre of the east side of the Parthenon frieze (Figs. 187–189).

The gods are distributed in two groups of six, each group complemented by a small winged attendant. Between the groups of gods are two mortal adults, two girls and a child (Fig. 186). The gods can be identified by means of their attributes, the way they are characterised or the company they keep. The group at the left (Fig. 187), from left to right, consists of Hermes, the messenger god with his traveller's hat in his lap; leaning against Hermes is Dionysus, the jovial god of wine (his upraised hand probably originally held a *thyrsus*, the pine-cone-topped fennel stalk that served as one of his attributes); facing him, chin once resting on her hand, sad and withdrawn, is Demeter, the goddess of grain, grieving over her lost daughter, holding the torches that she will use to seek her out. Although their apparent moods are different, pairing the two agricultural deities, the goddess of grain and the god of wine, is very apt. To the right of Demeter, the restless god of war, Ares, nurses his knee. Further right is Hera, the wife of Zeus, attended by a small, winged female deity (there is debate as to whether she is the messenger goddess, Iris, the goddess of victory, Nike, or the goddess of youth, Hebe). Hera lifts her veil in a bridal gesture as she turns to face Zeus, chief of the gods and the only one to sit on a throne fully equipped with back and arms.

187. The gods seated to the left of the centre of the east side of the Parthenon frieze. From a cast in the Skulpturhalle, Basel. Photo: Dieter Widmer, Basel.

A gap separates this group of gods from the other group at the right (Fig. 189). The gap (Fig. 188) is occupied by standing figures so much smaller than the gods that they must be seen as humans. Two girls carry what appear to be stools on their heads as they approach a full-grown woman. Back to back with the woman stands a man in priestly garb holding – perhaps folding – a large piece of cloth with the help of a young child. Further right is the second group of seated gods (Fig. 189). Athena sits with her aegis (only traces of which remain) in her lap;

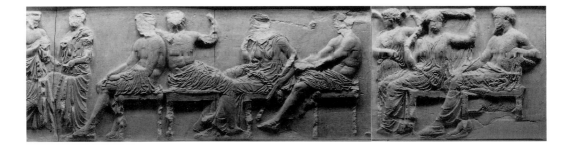

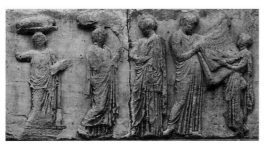

188. A man and a woman with two girls and a child. From the centre of the east side of the Parthenon frieze (peplos incident). British Museum, London.

Hephaistos, the lame god of craftsmen, leans on a crutch and turns around to speak to her. Further right sits Poseidon, the mature god of the sea, apparently engaged in conversation with the youthful Apollo, who may have held a musical instrument in his raised hand. Beside Apollo sits his sister Artemis, and to her right, preserved mostly in casts, Aphrodite, her hand resting on the shoulder of her young son, Eros, the mischievous god of love.

Why is this assembly of gods present? What are the mortal figures between the two groups of gods doing? And why do the gods turn their backs on them?

Since sculpture decorating temples normally illustrates a story concerned with gods or heroes, some scholars have tried to interpret the Parthenon frieze in terms of myth. For instance, in a closely argued article, Joan B. Connelly has suggested that the central scene (Fig. 188) shows Erechtheus, a legendary king of Athens, preparing to sacrifice one of his daughters in order to rescue his city, which is threatened by a military attack.

According to the myth, when Erechtheus inquired of an oracle how the city could be saved, he was told that the sacrifice of a royal princess would ensure victory for the Athenians. Connelly argues that the male figure holding the folded cloth is Erechtheus, that the folded cloth is the funeral shroud of the child assisting him, and that the child is his youngest daughter, the first to be sacrificed. The two girls at the left of the central scene are interpreted as two other daughters of Erechtheus,

189. The gods seated to the right of the centre of the east side of the Parthenon frieze. From a cast in the Skulpturhalle, Basel. Photo: Dieter Widmer, Basel.

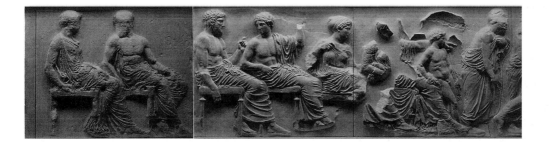

who killed themselves upon the death of their little sister, having taken an oath all to die together. They are supposed to be carrying their own funeral shrouds on top of the stools on their heads. The woman who receives them is assumed to be their mother, a future priestess of Athena. In a speech preserved from an otherwise largely lost play by Euripides (composed shortly after the Parthenon frieze was carved), she patriotically declares that while parents of sons are willing to send their children into battle ready to die to save the city, she has given her daughters for the same cause.

The assembled gods turn their backs on this dramatic central scene, Connelly suggests, because it was believed that gods could not permit themselves to be polluted by contact with death. The numerous other figures on the frieze and the processions of chariots and horsemen are accounted for as participants in the ceremonies that were instituted to commemorate the noble sacrifice of the girls.

This interpretation is in many ways persuasive, but not everybody is persuaded. It is objected that the calm mood of the central scene hardly accords with such a tragic scenario. Furthermore, as the interpretation moves further from the centre the arguments become increasingly tenuous. Particularly elusive is an explanation of the splendid cavalcade of horsemen who compose the bulk of the back and sides of the frieze. Finally, many scholars argue that the child at the far right of the central scene is a boy not a girl, and if that is so, the whole theory must collapse.

A totally different, non-mythological, interpretation has been more generally accepted for over two centuries.

One of the earliest modern observers, James Stuart, who visited Athens in the later 18th century, suggested that the frieze represented the Great Panathenaia. This festival honouring Athena was celebrated every four years with athletic contests and sacrifices and concluded with a procession culminating in the presentation of a new, elaborately woven robe (a peplos) to an old, highly venerated statue of the goddess. Stuart related some of the figures carrying equipment suitable for the occasion to texts describing the ceremony and, above all, identified the scene at the centre of the east frieze as having to do with the peplos presented to Athena at the climax of the festival.

As Athena was the goddess to whom the Parthenon was dedicated, the idea had considerable merit. The validity of the interpretation appeared to be strengthened when a man wearing a helmet and carrying a shield riding in a racing chariot beside the tense driver (Fig. 190) was recognised to be an *apobates*, someone who participated in a competition

190. Man with a shield and helmet leaping off (and on) a racing chariot (*Apobates*). From the south side of the Parthenon frieze. British Museum, London.

that involved leaping off (and, perhaps, on) a speeding chariot, one of the distinctive events in the games that were part of the Great Panathenaia. That a ritual rather than a myth could provide the subject of a frieze decorating a temple was an unusual suggestion, but the figured frieze itself was an unusual feature on this sort of temple.

A number of other theories refine or elaborate this approach. For instance, A. W. Lawrence accepted the idea that the Parthenon frieze was a (perhaps idealised) representation of the the Panathenaic festival and sought to explain its presence on the temple as the Athenian response to analogous friezes carved for Athens' powerful but recently defeated enemy, the king of Persia. The Persian friezes showed carved processions accompanying the route of the real processions that brought annual tribute to the king, just as the carved processions on the Parthenon mirrored the ritual procession of the Athenians bringing gifts – not to a king, but to their own goddess; the divergences from the putative Persian model would have been just as significant as the similarities, particularly if the comparison were intended to point up the contrasts. The Persian wars (see Chapter 11) were a live issue in the mid-5th century BC and the Athenians, pondering their extraordinary victory at Marathon when confronted with the overwhelmingly superior numbers of the Persians, attributed much of their success to being free men beholden to no king, paying no tribute, owing homage to no man but only to their divine patron, Athena. Thus, the Athenians, while adopting a theme from the Persians, could use it, subtly modified, to demonstrate how signally they differed from their erstwhile enemy.

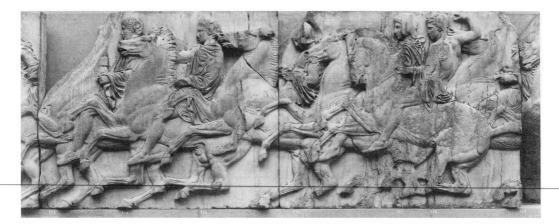

191. Part of the cavalcade on the north side of the Parthenon frieze. British Museum, London.

Reconciling the texts that describe the procession in honour of Athena with the details of the frieze has been a challenge for the many scholars who believe in a connection between the Parthenon frieze and the Great Panathenaia. Among the most troublesome elements are the numerous horsemen (Fig. 191), which, according to such fragmentary and late texts as describe the procession, would have taken no part in it.

In 1977 John Boardman proposed an intriguing solution. He suggested that the horsemen were a heroised transformation of the heavily armed foot soldiers (hoplites) who had given their lives to protect Athens in the battle of Marathon. These very men had celebrated the Great Panathenaia shortly before the battle, and honouring them in the frieze might have seemed an appropriate tribute to those who died at Marathon and who were revered ever after in Athens. Hoplites, like the men who fought and died at Marathon, were present in the real Panathenaia. Their absence from the frieze was puzzling. Boardman felt he had solved the puzzle by suggesting that, as heroes were associated with horses and as the Marathon fighters were heroes, they were shown not in the armour in which they had actually fought but in glorious apotheosis riding upon horses. Along the way he also explained why the gods were turned towards the processions (rather than the activity concerned with the peplos); they were welcoming the deified warriors into their own realm. In a sly afterword, Boardman suggested that the number of men portrayed associated with horses was the very same number as the men who had fallen at Marathon – 192. This clever idea does not, as it seems to, clinch the argument, for Boardman's method of counting was rather arbitrary: he included boyish servants but excluded charioteers. It is a sleight of hand, but the main argument stands or falls without it.

Although regrettably brief, these summaries of just four interpre-
tations of the Parthenon frieze – as an illustration of the myth of
Erechtheus, an image of the Great Panathenaia, a procession to rival
those represented on monuments in Persia, or a commemoration of the
gallant men who fought and died at Marathon – are intended to give
a flavour of the variety of ways in which an awkward problem can be
approached. None of the solutions suggested is universally accepted
and none is without its difficulties. Sculpted decoration on a temple is
usually mythological, but can we be sure a myth was the subject of the
Parthenon frieze?

To many it must seem as if the key is lost forever – or is yet to be
found.

* * *

In contrast to the dozens of figures decorating the Parthenon frieze,
only seven figures are represented on the Portland Vase, four on one
side (Fig. 192), three on the other (Fig. 193). In contrast to the virtual
absence of any hint of a setting in the Parthenon frieze, trees, rocks
and architectural features are prominent on the Portland Vase. But, as
with the Parthenon frieze, the meaning of the images remains elusive
and hotly debated. Since its discovery in about 1600, more than fifty
interpretations (some hardly more than modifications of others) have
been published. A summary of those proposed up to 1967, several with
brief explanations, can be found at the end of D. E. L. Haynes' 1975
book *The Portland Vase* (see p. 237).

The Portland Vase was made of two layers of coloured glass, the
inner one very dark blue, the outer one white. Parts of the white layer
were carefully cut away to reveal the underlying blue layer so that
the figures stand out in relief, the highest parts stark white and the
lower parts paler. A pair of handles divide the vase into two sides,
each compositionally self-contained. On one side (Fig. 192) two male
figures turn inward towards the woman in the centre, while a winged
infant flies above her; on the other side (Fig. 193) the outer figures have
their backs to the woman in the centre but their heads turned towards
her.

Both sides are shown continuously in a periphery photograph shot as
the vessel is rotated before the camera (Fig. 194). At the far left a nude
youth (A) steps forward, his left hand grasping the arm of a seated,
half-draped woman (C). Behind him is a gateway. In front of him a small
winged boy (B) holding a torch in one hand and a bow in the other

192. The Portland Vase: two men, a woman and Eros. Roman cameo-glass Augustan or Julio-Claudian, late 1st century BC or early 1st century AD. British Museum, London.

193. The Portland Vase: two women and a man. Roman cameo-glass. The other side of Figure 191.

A B C D E F G

looks back at the youth as he hovers over the head of the woman. The
woman is seated on the ground (C), legs to the right, but upper body
turned to the left to look at the youth and to link her right arm with his.
Her other arm appears to embrace a snaky creature emerging from her
lap. Behind her there is a tree. To the right of the scene, a nude bearded
man (D) stands with one foot raised on a rock, looking intently to the
left. There is another tree to the right of him. A handle separates this
side of the vase from the other, and below it is the carving of a bearded
(perhaps horned) head.

194. Periphery
photograph of
both sides of the
Portland Vase,
Roman cameo-
glass. British
Museum, London.

On the other side of the vase, at the left a nude youth (E) sits on a pile
of rocks in front of an isolated column, his body facing left but his head
turned to the right. In the centre, a half-draped woman (F) reclines on a
pile of rocks, her right arm thrown over her head, her lowered left hand
holding an inverted torch. A rectangular object (perhaps the capital of
a column) lies on the ground in front of the rocks. A leafy tree rises
behind the woman.

To the far right, a half-draped woman (G) sits upright on a separate
pile of rocks, her body facing right but her head turned back. She holds
a staff in her raised left hand. There is a bush to the right. Under the
other handle is another bearded head.

Who are these figures? What stories are they illustrating? How
important are the elements in the setting to decoding the images?

The Portland Vase was probably created during the reign of the emperor Augustus (27 BC–14 AD) or a little later, a period of great artistic vitality in Rome. It was a luxury item made for a cultivated elite, educated to know as much about Greek culture as about their own native tradition. Any number of complex, sophisticated ideas and allusions might have been woven into its decoration, and a wide range of ingenious solutions have been proposed.

On almost all points there is disagreement – except for the identity of the small flying figure (B). He is generally recognised as Cupid (the Greek Eros), the god of love.

Is the subject historical, mythological or allegorical? Opinions differ as to the nature of the trees, the one behind the seated woman (C) being identified either as a laurel or an oleander, the one behind the reclining woman (F) as either a fig, a plane or a white poplar. Even the clue that might come from the creature in the lap of the seated woman (C) is disputed, some interpreters considering it a snake and others a sea monster. Finally, there is disagreement as to whether each side of the vase is a separate entity or whether both ought to be read together as a continuous narrative, with Cupid (B) leading the youth (A) along to the reclining woman (F) on the other side of the vase, while the seated woman (C) next to him is just encouraging him by taking his arm, as D. E. L. Haynes argued.

Erika Simon, unlike Haynes, interpreted the two sides as two stages – each an independent composition – in the same story. She suggested that the vase illustrates a legend about the emperor Augustus. A rumour was put about that Augustus' mother, Atia, was loved by the god Apollo, who, mating with her in the form of a snake, fathered the future emperor. According to this view, the side with E to G (Fig. 193) shows Apollo (E) first catching sight of Atia (F) under the influence of Venus (the Greek Aphrodite) (G). Atia's pose with one arm thrown over her head, the other holding the down-turned torch dropping by her side, is explained as her taking a rest from the exhausting celebration of a night-time festival (hence the torch). Venus (G), seated at the far right, looks over her head meaningfully at Apollo (E) so that as his gaze falls on the reclining woman, he becomes enamoured of her. The outdoor setting is indicated by the fig tree (growing in the wild), the rocky seats and the isolated column that indicates a rural shrine.

The other side of the vase (A to D) (Fig. 192) shows the consummation of Apollo's passion for Atia. Apollo (A) advances out of the gateway of his sanctuary, in the pose later used for divine lovers on sarcophagi (for instance, Luna [Selene] on Fig. 39 or Mars on Fig. 40), to find his

ardour reciprocated by Atia (C), who extends her arm to link with his. The snake in her lap alludes to Apollo's disguise in the story, the laurel tree in the background is sacred to him, and the little flying Cupid assures the union of god and mortal. At the right, Romulus (D) (the legendary founder of the city of Rome who was deified under the name Quirinus) observes with satisfaction the engendering of Augustus, who was to be considered "a second Romulus".

Some scholars accepted parts of this interpretation; others rejected it entirely. Many did so because they maintained that the supposed "snake" held by C is really a sea monster and so must belong to a sea deity, not to Augustus' mother. Thus, Evelyn B. Harrison argued that the images on the Portland Vase are purely mythological and that they refer to the hero Theseus, one side (Fig. 192) illustrating Theseus' adventure under the sea and the other (Fig. 193) his abandonment of Ariadne.

There were two traditions about the paternity of Theseus. One said that he was the son of the mortal king of Athens, the other that he was the son of the sea god Poseidon. It was on his way from the Peloponnese to Athens to meet his mortal father that Theseus performed his notable deeds (Fig. 11). But it was on his way to Crete to kill the Minotaur that he was obliged to invoke his divine father. While sailing to Crete with the Athenian youths and maidens destined to be devoured by the Minotaur, the Cretan king, Minos, who was escorting them, taunted Theseus with his mortal parentage. When Theseus defended himself, asserting that he was the son of Poseidon, Minos threw a ring into the sea and challenged Theseus to authenticate his claim by retrieving it. Theseus gamely leapt overboard and was graciously received by Poseidon's wife, Amphitrite (who was not his mother), at the bottom of the sea. Thus, according to Harrison, Figure 192 shows Theseus (A) departing from the gates of Athens to descend into the sea, where Amphitrite (C) (identified by the sea monster in her lap) gently guides the hero into the unfamiliar element. The laurel tree behind alludes to the coming victory of the hero. To the right, his proud father, Poseidon (D), observes the scene.

The other side of the vase (Fig. 193) is supposed to illustrate Theseus' abandonment of Ariadne. Here Theseus (E) is seated on an island (represented by the pile of rocks), close to Ariadne (F), who reclines on another pile of rocks. Ariadne is falling asleep as Theseus prepares to leave her. Aphrodite (G), who has guided Theseus so far, sits on a separate island and glares imperiously at Theseus ordering him to depart, perhaps preparing Ariadne for the arrival of Dionysus, which is heralded by the fig tree (often associated with Dionysus) in the background.

Identifying as Ariadne the woman (F), who indeed resembles Ariadne on the sarcophagi in Figures 38 and 42, makes it possible to relate the ill-omened inverted torch to Ariadne's imminent abandonment (though Harrison interprets it as a sign that Ariadne is falling asleep). Despite strong points in favour of this reading of one side of the vase, too little significance seems to have been attributed to the flying Eros on the other side.

Quite another mythological interpretation was proposed by Bernard Ashmole. He suggested that one side of the vase (Fig. 192) alludes to Peleus' marriage to Thetis and the other (Fig. 193) to their son, Achilles. The mortal Peleus (A) is shown entering the world of the gods through the gateway, to be warmly received by Thetis (C), a sea goddess, whose nature is indicated by the sea monster in her lap. Here Eros (B) plays a crucial role in conducting Peleus to his bride. The bearded man (D) is identified as Poseidon, one of the gods who had been a suitor for Thetis' hand before it became known that her son was destined to be greater than his father, a prophecy that instantly cooled any god's ardour.

In this interpretation Achilles, the fruit of this marriage, appears on the other side of the vase (Fig. 193). Achilles fought bravely in the Trojan War, but eventually was killed. According to one tradition, after his death prospects brightened for Achilles, for his divine mother carried him away to the White Island (in the Black Sea) where his soul lived on married to the beautiful Helen, who, as the daughter of Zeus, also enjoyed a most agreeable afterlife. Ashmole contended that Achilles (E) is shown beside his grave monument, Helen (F) in front of the plane tree that was particularly associated with her, and Aphrodite (G), at a little distance, presides over this final, happy marriage. The inverted torch held by Helen is considered indicative of death, and thus shows that the scene is situated on the White Island.

John Hind, in 1979, accepted Ashmole's identification of Peleus and Thetis, but suggested that the scene on the other side (Fig. 193) dealt with a Roman rather than a Greek myth. He identified the youth (E) with Aeneas, the Trojan hero who fled Troy after its sack and went on to Italy to become the ultimate ancestor of the Romans. On the way Aeneas came to Carthage, where Queen Dido, received him kindly and, cunningly influenced by Venus, fell in love with him. Aeneas' destiny, however, did not allow him to linger long with the besotted Dido, and under divine orders he was forced to depart. The abandoned queen in a passion of grief killed herself, leaving a lasting (historical) legacy of enmity between Rome and Carthage. Hind, thus, proposed that the reclining woman with the inverted torch

(F) is Dido and the goddess (G) set a little bit apart from the couple is Venus (Aphrodite) or Juno (Hera), one or the other of whom was deeply concerned that Aeneas should relinquish his love for Dido and get on with the tasks destiny had set for him. This, Hind thought, would well explain the stern look that the goddess darts at the seated man.

In 1995 Hind revised his ideas about the vase, having discovered what he considered to be new clues. These lay mainly in his having a different identification of the trees verified by an expert at Kew Gardens. He now came to consider the bearded man (D) not to be Poseidon but Nereus, the father of Thetis (perfectly appropriate in a scene where Peleus and Thetis are the main players), because the tree before him is a kind of oleander, known to the Greeks as a *nerion*, and thus a pun on the name of Nereus. Hind also re-identified the tree behind the reclining woman (F) as a white poplar, in Greek a *leuke*. As *leuke* means "white" in Greek, the tree was taken to be a punning device to locate the scene on the White Island (as Ashmole had suggested). Finally, to clinch the argument, Hind pointed out that "torch" in Greek is *helene*, a pun on the name of the lady who holds it.

The intellectual world of the Romans in the late 1st century BC and early 1st century AD was highly complex and sophisticated. Upper-class aristocrats who might commission or own a luxury item like the Portland Vase were all bilingual in Latin and Greek and well acquainted with Greek myths. Punning allusions offering clues to an interpretation might well have appealed to them.

The simplified summaries of various scholars' ideas given above do not do justice to the subtlety and learning that has informed them, the rich layers of meaning detected in the choices of subjects, the wide-ranging analogies invoked to comparable works of art or the depth and breadth of research.

Yet none of them is final, none universally accepted. There is still work to be done; interpretations to be evaluated, puzzles to be solved.

Reading the articles and books referred to in this chapter, listed below, provides a starting point.

There is no stopping point.

Books and Articles Cited in This Chapter

The Daughters of Anios

Trendall, A. D. "The Daughters of Anios". *Studien zur Mythologie und Vasenmalerei: Konrad Schauenburg zum 65. Geburtstag am*

16. April 1986, ed. Elke Böhr and Wolfram Martini, pp. 165–168. Mainz, 1986.

The Siphnian Treasury

Ridgway, Brunilde Sismondo. "The East Pediment of the Siphnian Treasury: A Reinterpretation". *American Journal of Archaeology* 69 (1965): 1–5.

The Parthenon Frieze

PHOTOGRAPHIC RECORDS

Jenkins, Ian. *The Parthenon Frieze*. London: British Museum Press, 1994. Robertson, Martin. *The Parthenon Frieze*. London: Phaidon, 1975. Both include photographs of all the known fragments of the frieze in the British Museum and elsewhere and reconstruction drawings of missing parts. Jenkins is more complete and up-to-date and uses the current numbering of the frieze panels in the British Museum.

Berger, Ernst, and Madeleine Gisler-Huwiler. *Der Parthenon in Basel: Dokumentation zum Fries*. Mainz: Philipp von Zabern, 1996. This is a complete record of all casts ever made of fragments from the Parthenon frieze, including some that have since been lost, and relevant drawings from the 17th through the 19th centuries (text in German).

CD-ROM

The Parthenon Frieze CD-ROM by Rachel Rosenzweig, in Jenifer Neils, *The Parthenon Frieze* (New York: Cambridge University Press, 2001), is based on the casts in the Skulpturhalle, Basel.

SUMMARIES OF INTERPRETATIONS

Hurwit, Jeffrey M. *The Athenian Acropolis*, pp. 222 228. New York: Cambridge University Press, 1999.

Jenkins, Ian. *The Parthenon Frieze*, especially pp. 24–42. London: British Museum Press, 1994.

Neils, Jenifer. *The Parthenon Frieze*, pp. 173–201. New York: Cambridge University Press, 2001.

ARTICLES PROPOSING INTERPRETATIONS

Boardman, John. "The Parthenon Frieze – Another View". In *Festschrift für Frank Brommer*, pp. 39–49. Mainz am Rhein: Philipp von Zabern, 1977.

Connelly, Joan B. "Parthenon and *Parthenoi*: A Mythological Interpretation of the Parthenon Frieze". *American Journal of Archaeology* 100 (1996): 53–80.

Lawrence, A. W. "The Acropolis and Persepolis". *Journal of Hellenic Studies* 71 (1951): 111–119. The thesis is further developed by Margaret Cool Root, "The Parthenon Frieze and the Apadana Reliefs at Persepolis: Reassessing a Programmatic Relationship", *American Journal of Archaeology* 89 (1985): 103–120.

Rotroff, Susan. "The Parthenon Frieze and the Sacrifice to Athena". *American Journal of Archaeology* 81 (1977): 379–382.

Simon, Erika. *Festivals of Attica: An Archaeological Commentary* chap. 4, "Panathenaia and Parthenon", pp. 55–72. Madison: University of Wisconsin Press, 1983.

Stuart, James, and Nicholas Revett. *The Antiquities of Athens*, vol. 2, p. 12. London, 1787; published 1789. Reprinted by Arno Press, New York, 1980.

The Portland Vase

INTERPRETATIONS OF THE PORTLAND VASE

Ashmole, Bernard. "A New Interpretation of the Portland Vase". *Journal of Hellenic Studies* 87 (1967): 1–17.

Harrison, Evelyn B. "The Portland Vase: Thinking It Over". In *Memoriam Otto J. Brendel: Essays in Archaeology and the Humanities*, pp. 131–142. Mainz: Verlag Philipp von Zabern, 1976.

Haynes, D. E. L. *The Portland Vase*. London: British Museum Publications, 1975.

Hind, John. "Greek and Roman Epic Scenes on the Portland Vase". *Journal of Hellenic Studies* 99 (1979): 20–25.
"The Portland Vase: New Clues towards Old Solutions". *Journal of Hellenic Studies* 115 (1995): 153–155.

Simon, Erika. *Die Portlandvase*. Mainz: Verlag des Römisch-Germanischen Zentralmuseum, 1957. Text in German.

Glossary

The Glossary is restricted to characters and events discussed Chapters 1–17 in this book. When the Greek and Latin spellings or names differ, the alternative form is given in parentheses.

Mythological Characters

Achilles (Greek: Achilleus). Son of the mortal Peleus and the Nereid Thetis. When he was a baby Thetis dipped him in the river Styx to make him invulnerable, with only partial success. Hero of the *Iliad*, he became the foremost warrior of the Greeks against the Trojans. Angered when Agamemnon took away his prize-of-honour, Briseis, he withdrew from the fighting, but rejoined to avenge his friend Patroklos. He killed Troilos, Hector and Penthesilea, among others. When he died, his friend Ajax carried his body out of battle. His ghost demanded the sacrifice of Polyxena before the Greeks could sail home. According to one tradition, his afterlife was spent on the White Island married to Helen.

Actaeon (Greek: Aktaion). Greek hunter, turned into a stag and attacked by his own hounds when he offended the goddess Artemis.

Adonis. Beautiful youth loved by Aphrodite, fatally gored by a boar when out hunting.

Adrastos (Latin: Adrastus). King of Argos, brother of Eriphyle, father-in-law of Polyneikes. To help Polyneikes regain his throne, he led the Seven against Thebes.

Aegisthus (Greek: Aigisthos). Son of Thyestes. He became the lover of Clytemnestra while Agamemnon was fighting at Troy and helped her murder her husband on his return. He was later killed by Orestes.

Aeneas (Greek: Aineias). Son of the goddess Aphrodite and the Trojan prince Anchises, valiant fighter who escaped from Troy after its fall, carrying his father on his shoulders and accompanied by his wife and son. Hero of Virgil's *Aeneid*, he eventually came to Italy and became the ancestor of the Romans.

Aeson (Greek: Aison). Father of Jason, rightful king of Iolkos, deposed by Pelias.

Agamemnon. King of Mycenae, brother of Menelaus, husband of Clytemnestra, and father of Iphigeneia, Electra and Orestes. Leader of the Greek armies against Troy, he was forced to sacrifice Iphigeneia so that the troops could set sail. On his return home, his wife murdered him.

Ajax (Greek: Aias). Son of Telamon, Greek hero in the war against Troy, said by Homer to be second only to Achilles as a warrior. He rescued Achilles' body when Achilles was killed and expected to be awarded his armour as a prize. When the armour went to Odysseus instead, humiliated beyond endurance, Ajax killed himself.

Alkmaion (Latin: Alcmaeon). Son of the seer Amphiaraos and Eriphyle, he avenged his father by killing his mother.

Amazons. A tribe of eastern warrior women. Herakles had to obtain the belt of the queen (Hippolyta) and this led to a battle. Theseus, who accompanied Herakles, carried off an Amazon, and in revenge the Amazons attacked Athens. The Amazons were allies of the Trojans, and their queen at the time, Penthesilea, came to the aid of the Trojans but was killed by Achilles.

Amphiaraos (Latin: Amphiaraus). Greek seer, husband of Eriphyle and father of Alkmaion. Reluctant to join the Seven against Thebes, knowing that he would not return, he was forced to go by his wife, who had been bribed by Polyneikes. He charged his son Alkmaion to avenge him.

Amphitrite. A sea goddess, daughter of Nereus, wife of Poseidon.

Anchises. Trojan prince, loved by Aphrodite by whom he fathered Aeneas. Aeneas carried him out of Troy on his back after the city was captured.

Andromache. Wife of the Trojan hero Hector and mother of Astyanax.

Andromeda. Daughter of the king of Ethiopia, exposed to a sea monster because of her mother's bragging, but rescued by Perseus, who married her.

Anios (Latin: Anius). King of Delos, whose three daughters could produce wine, olives and grain at will.

Antenor. Trojan elder, friend of Priam.

Aphrodite (identified with the Roman goddess Venus). Goddess of love, lover of Adonis and Anchises, mother of Aeneas. She won the Golden Apple in the Judgement of Paris and induced Helen to run away with Paris, thus causing the Trojan War.

Apollo. God of prophecy, archery and music, son of Zeus, twin brother of Artemis. He was forced to struggle to retain his tripod when Herakles tried to wrest it from him. One Roman tradition claimed he was the father of the emperor Augustus.

Ares (identified with the Roman god Mars). God of war.

Argonauts. A group of Greek heroes who sailed on the ship *Argo* with Jason to the far eastern end of the Black Sea to fetch the Golden Fleece.

Ariadne. Daughter of Minos, king of Crete, and half-sister of the Minotaur. She gave Theseus a ball of thread to help him find his way out of the labyrinth after he had killed the Minotaur. She escaped from Crete with him only to be abandoned on Naxos, where Dionysus found her and married her.

Artemis (identified with the Roman goddess Diana). Goddess of the hunt, daughter of Zeus, twin sister of Apollo. Easily offended, she demanded the sacrifice of Iphigeneia, sent the monstrous boar to ravage Calydon, and turned Actaeon into a stag to be destroyed by his own hounds.

Astyanax. Infant son of the Trojan hero Hector and Andromache. According to the literary tradition, he was thrown to his death from the walls when Troy was captured, but according to the artistic tradition, he was killed by being hurled against his grandfather, Priam.

Atalanta. Greek heroine, who joined in the hunt of the Calydonian boar and was first to wound the beast with an arrow.

Athena (identified with the Roman goddess Minerva). Goddess, born from the head of Zeus, patroness of Greek heroes, usually depicted armed and wearing a snake-fringed aegis. She was one of the unsuccessful contenders for the Golden Apple in the Judgement of Paris.

Atreus. King of Mycenae, brother of Thyestes, with whom he carried on a bloody feud, and father of Agamemnon and Menelaus.

Augias (Greek: Augeias). King of Elis, whose filthy stables (or cattle yard) Herakles was obliged to clean out in a single day.

Bellerophon (Greek: Bellerophontes). Greek hero who rode on Pegasos to kill the Chimaera.

Boreades (Greek: Boreadai). The two sons of Boreas. As Argonauts, they chased the Harpies away from Phineus.

Boreas. God of the north wind, who carried off and married the Athenian princess Oreithyia.

Busiris (Greek: Bousiris). Mythical Egyptian king who thought it wise to sacrifice all foreigners – until he tried to sacrifice Herakles.

Cassandra (Greek: Kassandra). Trojan princess, daughter of Priam, whose true prophecies were never believed; she was raped by a Greek named Ajax (the son of Oileus – not Ajax the son of Telamon, second only to Achilles, who had already committed suicide before Troy fell) on the night Troy was sacked, despite her having taken sanctuary at the statue of Athena. She became the captive slave of Agamemnon and was killed with him.

Centaurs. A group of monsters, part horse and part man, the upper part man and the rest horse. Cheiron, whose parents were different from the others, was highly civilised and an educator of heroes like Achilles and Jason. Most of the others were wild and barbaric, though Pholos, in charge of the communal wine store, had different parents and a better character. Centaurs attacked Herakles when Pholos offered him wine, and Herakles had to drive them off. Herakles also fought individual centaurs (Nessos and Eurytion). The centaurs were invited to the wedding of the Lapith king, Peirithoos, their neighbour, but misbehaved. The Lapiths defended their womenfolk on the spot and then, having driven the centaurs out into the open, collected their armour and defeated them in an all-out battle. Zeuxis painted a "centaur family", thereby inventing the female centaur and centaur babies, which flourished in later art and literature.

Cerberus (Greek: Kerberos). Multiheaded dog that guarded the entrance to the Underworld, ensuring that those who entered did not leave. Herakles had to fetch him to show him to Eurystheus.

Ceres (Roman goddess identified with the Greek Demeter). Goddess of grain.

Cheiron (Latin: Chiron). Gentle and learned centaur, educator of Achilles and other heroes.

Chimaera (Greek: Chimaira). Fire-breathing monster, composed of parts of a lion, a goat and a snake, killed by Bellerophon.

Chrysaor. Son of the Gorgon Medusa, father of triple-bodied Geryon.

Circe (Greek: Kirke). Sorceress, daughter of the sun, who turned Odysseus' men into animals.

Clytemnestra (Greek: Klytaimnestra). Queen of Mycenae, sister of Helen, mother of Iphigeneia, Electra and Orestes, and wife of Agamemnon, whom she murdered on his return home from Troy with the assistance of her lover, Aegisthus.

Cupid. *See* Eros.

Cyclopes (Greek: Kyklopes). A tribe of one-eyed giants. Odysseus blinded the Cyclops Polyphemus on his way home from Troy.

Daidalos (Latin: Daedalus). Athenian craftsman who fled to Crete after committing a murder and there created a wooden cow to satisfy Pasiphae's lust for a bull and built a labyrinth to keep the Minotaur safe in.

Daphne. Nymph who, fleeing from the love of Apollo, was transformed into a laurel tree.

Deianeira. Wife of Herakles, attacked by the ferryman centaur Nessos.

Demeter (identified with the Roman goddess Ceres). Goddess of grain, who used torches to search for her daughter who had been abducted by the god of the Underworld.

Dexamenos (Latin: Dexamenus). Father of a girl forcibly betrothed to the centaur Eurytion. Herakles rescued her at the last moment.

Diana. *See* Artemis.

Dido. Queen of Carthage, who fell in love with Aeneas but was abandoned by him.

Diomedes. Thracian king who owned man-eating horses. Herakles was required to capture them.

Dionysus (Greek: Dionysos). God of wine, who fell in love with Ariadne when he discovered her abandoned on Naxos.

Electra (Greek: Elektra). Daughter of Clytemnestra and Agamemnon, who helped her brother Orestes avenge the murder of their father.

Endymion. Shepherd who was loved by the goddess of the moon (Selene in Greek; Luna in Latin) as he slept.

Eos (identified with the Roman goddess Aurora). Goddess of the dawn, lover of Kephalos and Tithonos, by whom she had a son, who was an ally of the Trojans, killed by Achilles.

Erechtheus. King of Athens who sacrificed his daughter to save the city.

Eriphyle. Sister of Adrastos and wife of Amphiaraos, who, bribed by Polyneikes, sent her husband to join the Seven against Thebes.

Eris. Personification of discord, who produced the Golden Apple inscribed "For the Fairest" and thus initiated the Judgement of Paris and consequently the Trojan War.

Eros (identified with the Roman god Cupid). God of love, often depicted as a winged youth or child.

Eurydike (Latin: Eurydice). Wife of the musician Orpheus. Orpheus tried to rescue her from the dead, but lost her again when he looked back at her as he led her out of the Underworld.

Eurystheus. King of Mycenae who set twelve labours for Herakles to perform.

Eurytion. Centaur who wanted to marry the daughter of Dexamenos but was prevented by Herakles.

Gaia (Ge). The goddess Earth, mother of the Giants.

Ganymede (Greek: Ganymedes). Member of the Trojan royal house whose boyish beauty so charmed Zeus that he carried him off to be his cupbearer.

Geryon (Greek: Geryoneus). Triple-bodied son of Chrysaor, owner of cattle that Herakles was compelled to steal. The cattle were tended by a single-bodied herdsman and the double-headed dog, Orthros.

Giants (Greek: Gigantes). Children of the goddess Earth who challenged the gods and were defeated in a great battle.

Gorgons (Greek: Gorgones). Three monstrous sisters, so awful in appearance that those who looked at them were turned to stone. Two of them were immortal, but the third, Medusa, was slain by Perseus.

Harpies (Greek: Harpyiai). "Snatchers", winged demons who carried off what they could of Phineus' food and fouled what remained. They were driven away by the sons of Boreas when the Argonauts visited Phineus.

Hebe. Daughter of Hera and personification of youth.

Hector (Greek: Hektor). Son of Priam, king of Troy, and Hecuba; husband of Andromache and father of Astyanax. The most valiant of the Trojan heroes, he killed Achilles' friend Patroklos and was in turn killed by Achilles.

Hecuba (Greek: Hekabe). Wife of Priam, king of Troy, and mother of Hector, Paris, Troilos, Cassandra, Polyxena and others.

Hekate (Latin: Hecate). Triple-bodied Greek goddess.

Helen (Greek: Helene; Latin: Helena). Daughter of Zeus and Leda, half-sister of Clytemnestra, married to Menelaus, king of Sparta. The most beautiful woman in the world, she ran away with the Trojan prince Paris and thus ignited the Trojan War, which was fought to recover her. Her afterlife was spent on the White Island married to Achilles.

Hephaistos (identified with the Roman god Vulcan). Greek god of smiths and other craftsmen. He made the necklace that Polyneikes used to bribe Eriphyle and produced new armour for Achilles at Thetis' request.

Hera (identified with the Roman goddess Juno). Goddess of marriage, wife of Zeus, one of the unsuccessful contenders for the Golden Apple in the Judgement of Paris.

Herakles (Latin: Hercules). Son of Zeus and Alkmena, educated in music by Linos. He performed twelve arduous labours on orders from Eurystheus. He also had several encounters with centaurs (Nessos, who wanted to ravish his wife; Eurytion, who wanted to marry the daughter of Dexamenos; and a group of centaurs who attacked him while he was being entertained by Pholos). When denied an oracle from Apollo, he tried to carry off the god's tripod, but was eventually constrained to release it and advised that he

should be sold into slavery for a certain period. He was purchased by Omphale.

Hercules. *See* Herakles.

Hermes (identified with the Roman god Mercury). Son of Zeus, messenger god, conductor of souls to the Underworld, frequent companion to heroes, especially when they confronted monsters (e.g., Perseus and Medusa, Herakles and Cerberus).

Hippolytus (Greek: Hippolytos). Son of Theseus and stepson of Phaedra, who fell in love with him. Chaste Hippolytus rejected her, preferring to worship Artemis and delight in hunting.

Hoplon. The name of a Lapith fighting centaurs on a vase painting.

Hydra. Many-headed monster that lived in swampy Lerna. Herakles was ordered to destroy it but was hampered by the fact that whenever one head was lopped off, two new ones grew to replace it. He finally succeeded when his nephew Iolaos cauterised each stump with a burning torch.

Iolaos (Latin: Iolaus). Nephew of Herakles and companion of the hero on many of his labours. Iolaos is often seen holding Herakles' weapons when the hero is otherwise engaged.

Iphigeneia (Latin: Iphigenia). Daughter of Clytemnestra and Agamemnon. Her father was forced to sacrifice her to Artemis before the Greek troops could sail to Troy. At the last moment (but unbeknownst to her parents), Artemis rescued her and took her off to the land of the Taurians.

Iphikles (Latin: Iphicles). Half-brother of Herakles who, like Herakles, was taught music by Linos. His son, Iolaos, accompanied Herakles on many of his labours.

Iris. Messenger goddess, personification of the rainbow.

Jason (Greek: Iason). Son of Aeson, whose throne was usurped by Pelias. Pelias challenged Jason to fetch the Golden Fleece from Colchis, at the far eastern end of the Black Sea. Jason assembled a crew (the Argonauts) to join in the adventure. At Colchis, Jason was aided by Medea, who fled her home with him. When Jason proposed to abandon Medea and make a more glamorous marriage, Medea slew the prospective bride and her father, and slaughtered the children she had borne Jason, leaving him a broken man.

Juno. *See* Hera.

Jupiter. *See* Zeus.

Kaineus (Latin: Caeneus). Originally a girl raped by Poseidon, who chose to become an invulnerable man as a reward for her favours and, in this new form, fought beside the Lapiths against the centaurs.

Kastor (Latin: Castor). Son of Leda, twin brother of Polydeukes.

Kebriones. Brother of Hector, who once acted as his charioteer.

Kephalos (Latin: Cephalus). Athenian hunter, loved by the goddess Eos.

Kerkopes (Latin: Cercopes). Mischievous, apelike creatures who once stole Herakles' equipment.

Kerkyon (Latin: Cercyon). Bandit who used to force passersby to engage in a fatal fight with him, until he got a dose of his own medicine from Theseus.

Lapiths. Human neighbours of the centaurs. The centaurs behaved badly at the wedding of the Lapith king, Peirithoos, and after they had been driven away, the Lapiths fetched their arms and fought them in a pitched battle out of doors.

Leda. Mother by Zeus of Helen and Polydeukes, and by her mortal husband, Tyndareus, of Clytemnestra and Kastor.

Linos (Latin: Linus). Music master of Iphikles and Herakles.

Luna. *See* Selene.

Lycomedes (Greek: Lykomedes). King of Skyros, where Achilles, disguised as a girl, stayed in his youth.

Mars (identified with the Greek god Ares). Roman god of war, seducer of Rhea Silvia, who bore him Romulus and Remus, founders of Rome.

Medea (Greek: Medeia). Barbarian sorceress who fell in love with Jason and helped him obtain the Golden Fleece, after which she fled with him from her homeland. To avenge Pelias' having usurped the kingdom from Jason's father, she contrived to have the daughters of Pelias unwittingly murder their father. When Jason proposed to abandon Medea in favour of a more advantageous alliance, she sent a poisoned robe to his prospective bride and finally killed her own children by him in order to punish her faithless husband.

Medusa. Mortal member of the three Gorgon sisters whose terrible faces turned men to stone. When Medusa was beheaded by Perseus, she gave birth, through her neck, to Chrysaor, the father of Geryon, and Pegasos, the winged horse.

Meleager (Greek: Meleagros). Organiser of the hunt of the Calydonian boar. He slew the boar after it had been wounded by Atalanta.

Menelaus (Greek: Menelaos). King of Sparta, brother of Agamemnon and aggrieved husband of Helen. His brother, Agamemnon, led the Greek armies to Troy to recover Helen after she had run off with Paris. When the city was captured, Menelaus intended to kill his errant wife but, under the influence of Aphrodite, was deterred.

Minos. King of Crete, husband of Pasiphae, father of Ariadne and Phaedra, stepfather of the Minotaur, for whom he had the labyrinth built and a supply of Athenian youths and maidens imported to feed the monster.

Minotaur (Greek: Minotauros). Bull-headed monster, the son of Pasiphae, queen of Crete, and an attractive bull. He was confined in the

labyrinth, fed on imported Athenian youths and maidens and finally killed by Theseus.

Neoptolemos (Latin: Neoptolemus). Son of Achilles, conceived when Achilles was disguised as a girl on the island of Skyros, brutal killer of Priam (and, according to the vase painters, also of Astyanax) at the sack of Troy. Later he sacrificed Polyxena to the ghost of his father.

Neptune. *See* Poseidon.

Nereids (Greek: Nereides). Sea deities, daughters of Nereus, one of whom was Thetis.

Nereus. Father of the Nereids.

Nessos (Latin: Nessus). Centaur who worked as a ferryman and attempted to rape Herakles' wife Deianeira when carrying her across the river, for which misdeed he was slain by Herakles.

Nike (identified with the Roman goddess Victoria). Goddess (or personification) of victory.

Odysseus (Latin: Ulysses). King of Ithaca and clever Greek warrior who fought the Trojans, hero of the *Odyssey*. After Achilles' death, he was awarded the hero's armour in preference to Ajax. On his way home from the war, he encountered the Cyclops Polyphemus and ingeniously escaped from his cave, and also met and mastered Circe, who had turned his men into animals.

Oineus (Latin: Oeneus). King of Calydon, father of Deianeira and Meleager, who omitted Artemis from a sacrifice and was punished by her sending an enormous boar that ravaged the countryside.

Oinomaos (Latin: Oenomaus). King of Pisa (a city near Olympia) who challenged suitors for his daughter's hand to a chariot race, which he expected to win because of his wind-swift horses. He was defeated by Pelops, who won the bride.

Omphale. Queen of Lydia who bought Herakles to serve as her slave for a limited period and enjoyed dressing up in his regalia while he was forced to wear women's clothes and perform women's tasks.

Oreithyia (Latin: Orithyia). Athenian princess abducted and married by the god of the north wind, Boreas.

Orestes. Son of Agamemnon and Clytemnestra, brother of Iphigeneia and Electra. As a baby he was used as a hostage by Telephos. When his father was murdered, he was sent out of the country, but returned later to help Electra avenge their father by killing his mother and her paramour, Aegisthus.

Orpheus. Thracian musician who could charm even the rocks and trees with his music. After his wife Eurydike died, he persuaded the gods of the Underworld to let him lead her back to life. However, they stipulated

that he must not look at her while leaving the underworld, and when he did so, she sank back into it. After this, Orpheus antagonised the Thracian women (various explanations are given as to how) and they killed him.

Orthros. Multiheaded dog belonging to triple-bodied Geryon. Unlike his brother Cerberus, he was not immortal and was killed by Herakles.

Pan. Minor deity of the outdoors, goat-legged with goat's ears and horns (or sometimes only goat's horns), often a companion of Dionysus.

Paris. Trojan prince who, while acting as a shepherd, was called upon to judge which of three goddesses (Hera, Athena or Aphrodite) was the most beautiful and should be awarded the Golden Apple. Aphrodite bribed him with the offer of the most beautiful woman in the world, Helen. With Aphrodite's help, Paris carried Helen off to Troy, thus causing the Trojan War.

Pasiphae. Wife of Minos, king of Crete, and mother of Ariadne and Phaedra by Minos and of the Minotaur by a bull that she found irresistible.

Patroklos (Latin: Patroclus). Greek warrior, friend of Achilles, killed by Hector, who then confiscated the armour that Achilles had lent him.

Pegasos (Latin: Pegasus). Winged horse, son of Medusa, ridden by Bellerophon in his fight against the Chimaera.

Peirithoos (Latin: Pirithous). King of the Lapiths, whose wedding was disrupted by the bad behaviour of the centaurs.

Peitho. Greek personification of persuasion (an ally of Aphrodite).

Peleus. King of Phthia, suitor for the hand of the Nereid Thetis, whom he captured despite her many metamorphoses and on whom he fathered Achilles.

Pelias. King of Iolcos, who usurped the throne from Aeson. He sent Jason, Aeson's son, to fetch the Golden Fleece (hoping he would die in the attempt). When Jason returned with the fleece and Medea, Medea took vengeance on Pelias by persuading his daughters to cut him up and boil him in a kettle with the promise that this would rejuvenate him. It did not.

Pelops. Adventurer who raced with Oinomaos for the hand of his daughter and won, becoming a king in the Peloponnese.

Penthesilea (Greek: Penthesileia). Amazon queen and ally of the Trojans, killed by Achilles, who fell in love with her as she expired.

Perseus. Hero who slew the Gorgon Medusa and later rescued Andromeda, who had been exposed on a rock as food for a sea monster.

Petraios. The name of a centaur fighting a Lapith on a vase.

Phaedra (Greek: Phaidra). Daughter of Minos, king of Crete, and Pasiphae. She was married to Theseus but fell in love with her stepson, Hippolytus.

Phineus. Blind king of Thrace, plagued by the Harpies, who stole most of his food and fouled the rest. In exchange for Phineus' providing information to the Argonauts, the Boreades chased the Harpies away.

Pholos (Latin: Pholus). Centaur whose parents were different from the rest of the centaurs and who was in charge of the centaurs' communal wine store. When he offered Herakles some wine, the other centaurs rampaged.

Polydeukes (Latin: Pollux). Son of Leda, twin brother of Kastor.

Polyneikes (Latin: Polynices). Exiled from Thebes by his brother, he married one of the daughters of Adrastos and persuaded his father-in-law to raise an army (the Seven against Thebes) to reinstate him. He bribed Eriphyle to force her husband, Amphiaraos, to join.

Polyphemos (Latin: Polyphemus). One-eyed giant Cyclops, who devoured half a dozen of Odysseus' comrades before being blinded by Odysseus and his remaining men. They escaped from his cave clinging on to the undersides of sheep when he let his flocks out to pasture.

Polyxena. Daughter of the Trojan king, Priam, and of Hecuba. She accompanied her brother Troilos when he went outside the protective walls of Troy to water his horses and he was killed by Achilles. After the fall of Troy, Polyxena was sacrificed to the ghost of Achilles.

Poseidon (identified with the Roman god Neptune). God of the sea, divine father of Theseus.

Priam (Greek: Priamos; Latin: Priamus). King of Troy, husband of Hecuba, father of Hector, Paris, Troilos, Cassandra, Polyxena and others. He was killed by Neoptolemos despite having taken sanctuary on an altar.

Procrustes (Greek: Prokroustes). Bandit who used to adjust passersby to his bed, stretching the short, lopping off limbs of the tall, until Theseus gave him a dose of his own medicine.

Pylades. Friend of Orestes, who accompanied Orestes when he went to Mycenae to avenge the death of his father.

Quirinus. Roman god with whom Romulus was identified after his death.

Remus. Son of Mars and Rhea Silvia, twin brother of Romulus.

Rhea Silvia. Roman Vestal Virgin, raped by Mars. She became the mother of Romulus and Remus.

Romulus. Son of Mars and Rhea Silvia, twin brother of Remus, founder of Rome. He was assimilated to the god Quirinus after his death.

Sarpedon. Son of Zeus, ally of the Trojans, killed by Patroklos. Zeus instructed Sleep and Death to carry his body home after the wounds had been washed by Apollo.

Satyrs. Horse-tailed, horse-eared semibestial followers of Dionysus.

Selene (identified with the Roman goddess Luna). Goddess of the moon, who fell in love with the shepherd Endymion and visited him while he slept.

Serapis. Alexandrian god portrayed with a triple-headed dog.

Silenus (Greek: Silenos). An old satyr.

Sinis. Bandit who used to kill passersby by tying them to a tree that he had previously bent down, until he got a dose of his own medicine from Theseus.

Skiron (Latin: Sciron). Bandit who used to force passersby to wash his feet and then kicked them off a cliff to their deaths, until he got a dose of his own medicine from Theseus.

Telephos (Latin: Telephus). Son of Herakles. He was king of Mysia, near Troy, when his country was accidentally attacked by the Greeks looking for Troy. Unable to cure a wound inflicted by Achilles, he went to Greece to seek help. According to some sources, he used the infant Orestes as an aid to his supplication, but according to others he used the child as a hostage to defend himself. In the end he obtained the cure he desired and helped the Greeks find the true location of Troy.

Theseus. Son of Poseidon or of the king of Athens. Born in the Peloponnese, Theseus courageously took the land route on his voyage to Athens, killing bandits and a wild sow on his way; later on he captured and sacrificed the bull that was ravaging Marathon. He accompanied the Athenian youths and maidens sent to Crete and destined to be devoured by the Minotaur, and with the help of Ariadne, daughter of the Cretan king, killed the monster. He fled Crete with Ariadne, but abandoned her on Naxos, continuing to Athens with her sister Phaedra. Theseus helped his friend Peirithoos fight the centaurs who disrupted his wedding, and joined Herakles in his battle against the Amazons. He abducted an Amazon and carried her off to become the mother of his son Hippolytus; to recover her, the Amazons attacked Athens.

Thetis. A Nereid, sea goddess. It was prophesied that her son would be greater than his father, and so Zeus and Poseidon, who had been in love with her, married her off to the mortal Peleus. He proved determined enough to keep hold of her despite her many metamorphoses. She bore him Achilles and tried to make the infant invulnerable by dipping him in the waters of the river Styx. She obtained new armour for Achilles from Hephaistos when the armour he had lent to Patroklos was taken by Hector. After Achilles' death she offered his armour to the best of the Greeks after Achilles.

Thyestes. Brother of Atreus, with whom he had a catastrophic feud, and father of Aegisthus.

Tithonos (Latin: Tithonus). Trojan prince who, while acting as a shepherd, was loved by the goddess of dawn, Eos, who procured immortality for him but forgot to ask for eternal youth. Eos bore him a son, who became an ally of the Trojans and was killed by Achilles.

Troilos (Latin: Troilus). Son of the Trojan king Priam and Hecuba, killed by Achilles when he left the safety of Troy to take his horses outside the walls to water them.

Tyndareus (Greek: Tyndareos). King of Sparta, husband of Leda.

Typhon. Youngest son of Gaia, a huge, snake-legged monster brought forth to challenge Zeus after the defeat of the giants.

Venus. *See* Aphrodite.

Zeus (identified with the Roman god Jupiter). Chief of the Greek Olympian gods, husband of Hera, father of Athena, Apollo, Artemis, Ares, Dionysus and Hermes, and by mortal mothers of Herakles, Sarpedon, Helen and many others.

For further information about these mythological characters and their adventures, of which only the aspects relevant to this book are mentioned above, the reader is advised to consult some of the many excellent mythological dictionaries available, especially: Jenny March, *Dictionary of Classical Mythology* (London: Cassell, 1998); and Pierre Grimal, *The Dictionary of Classical Mythology* (Oxford: Blackwell Reference, 1986).

Historical Figures

Admetus (late 6th–early 5th century BC). King of Molossia, with whom Themistokles sought sanctuary for a time when he was fleeing for his life.

Aeschylus (525/4–456 BC). Athenian tragic playwright, whose works were so appreciated that the city provided funds to produce them again after his death.

Alexander the Great (356–323 BC). King of Macedonia from 336 BC, who led the Greeks to conquer the whole of the Persian Empire and even beyond. His empire was divided up by his successors, under whom Hellenistic culture flourished.

Antony (c. 82–30 BC). Roman general and politician during the Late Republic, he was at first an ally of Octavian (before he became the emperor Augustus), but ultimately came into conflict with him. He was finally defeated at the Battle of Actium in 31 BC.

Apelles (4th century BC). Distinguished painter of panels, favoured by Alexander the Great. His works are discussed by ancient authors.

Aristeides (c. 520–c. 468 BC). Athenian statesman and soldier, renowned for his honesty.

Aristogeiton (6th century BC). Older of the two Tyrannicides who attempted to assassinate the Athenian tyrant Hippias in 514 BC.

Aristophanes (c. 450–c. 385 BC). Athenian comic playwright.

Atia (d. 43 BC). Mother of the Roman emperor Augustus.

Augustus (63 BC–AD 14). Honorary title given to Octavian, the first Roman emperor, who reigned from 27 BC to AD 14.

Claudius (10 BC–AD 54). Roman emperor who reigned from AD 41 to 54.

Commodus (AD 161–192). Roman emperor who reigned from AD 180 to 192.

Euripides (485?–406? BC). Athenian tragic playwright.

Exekias (6th century BC). Athenian black-figure vase painter who signed his works as both painter and potter.

Hadrian (AD 76–138). Roman emperor who reigned from AD 117 to 138.

Harmodios (6th century BC). Younger of the two Tyrannicides who attempted to assassinate the Athenian tyrant Hippias in 514 BC.

Hippias (late 6th century BC–early 5th century BC). Tyrant of Athens in the second half of the 6th century BC, the object of an assassination attempt by the Tyrannicides, Harmodios and Aristogeiton.

Homer (8th century BC). Poet who composed the *Iliad* and the *Odyssey*.

Julia Domna (d. AD 217). Wife of the Roman emperor Septimius Severus.

Kleitias (early 6th century BC). Athenian black-figure vase painter who signed his works as painter.

Leochares (4th century BC). Athenian sculptor whose works are discussed by ancient authors.

Lucian (c. AD 120–200). Greek satirist and rhetorician from Samosata on the Euphrates who described works of art, among other things.

Lysippos (4th–3rd century BC). Prolific sculptor in bronze, favoured by Alexander the Great, whose works are discussed by ancient authors.

Pausanias (2nd century AD). Greek traveller and antiquarian who wrote about the sites and shrines in Greece and described many works of art, sometimes in considerable detail.

Phidias (5th century BC). Athenian sculptor who made the huge and costly statue of Athena inside the Parthenon and was supposed to be the overseer of the whole project; much praised by ancient authors.

Phrynichos (late 6th–early 5th century BC). One of the earliest Athenian tragedians, none of whose works survive.

Pliny the Elder (c. AD 27–79). Roman polymath who included discussions of sculpture and painting in his encyclopaedic *Natural History*.

Plutarch (c. AD 46–c. 120). Greek biographer, essayist and moralist.

Polygnotos of Thasos (5th century BC). Celebrated painter of murals, whose works are known only from descriptions by ancient authors.

Quintilian (1st century AD). Roman rhetorician and educator.

Sabina (1st–2nd century AD). Wife of the Roman emperor Hadrian.

Septimius Severus (late 2nd–3rd century AD). Roman emperor who reigned from AD 193 to 211.

Sophocles (c. 496–406 BC). Athenian tragic playwright.

Themistokles (c. 528–c. 462 BC). Athenian statesman and general, responsible for the Greek victory over the Persians at Salamis (480 BC), but finally forced to flee from Athens.

Thucydides (5th century BC). Athenian historian who wrote a history of the Peloponnesian War.

Timanthes (late 5th–early 4th century BC). Painter of panels, famed for his ingenuity, praised by ancient authors for his *Iphigeneia*.

Timomachos of Byzantium (1st century BC). Painter of panels, praised by ancient authors for his *Medea*, among other works.

Virgil (70–19 BC). Roman poet, author of the *Aeneid*.

Zeuxis of Herakleia (late 5th–early 4th century BC). Painter of panels, whose ingenious works are discussed by ancient authors.

The Survival of Greek Myths in Art and Literature

Images of Myths Surviving from Antiquity

In antiquity, the most prized and notable works of art were free-standing statues, cult images, paintings on panels and walls, expensive dedications in sanctuaries and luxury items owned by the rich. This, at least, is the impression given by Greek and Roman writers (Pliny the Elder, Pausanias and the poems about art works in the Greek Anthology). Many of these works bore images of myths; almost without exception, they have been lost.

Occasionally we have copies or reflections of celebrated works. Most of these are either wall paintings from provincial centres like the Campanian cities of Pompeii and Herculaneum, which were inspired by famous paintings in Greece or Rome, or marble statues that were copied or adapted from statues originally cast in bronze or made of wood and veneered in gold and ivory. Even these constitute only a small sample of what once existed.

What has survived in some quantity are paintings on pots, carved marble sarcophagi, sculpture decorating architecture, murals from the Campanian cities buried by the eruption of Mount Vesuvius in 79 AD and mosaics on floors.

Pottery has survived in the greatest abundance. It can be broken but is seldom entirely destroyed and, unlike bronze, cannot be reused for other purposes. Much ancient pottery was simply serviceable and

plain, but many Greek vases (including those made in South Italy) were decorated, often with mythological subjects. Vase painters were great experimenters in the representation of myths, and their lucid images are usually easy to understand. This explains why so many appear in books dealing with images of myths in classical antiquity.

Although tens of thousands of painted vases are still extant, they represent a minuscule fraction of those originally produced; a survival rate of about 1 percent has been estimated by T. B. L. Webster (*Potter and Patron in Classical Athens* [London: Methuen, 1972], p. 3), while John H. Oakley ("An Athenian Red-figure Workshop," *Bulletin de Correspondance Hellénique*, suppl. 23 (1992), pp. 199–200) believes that no more than one-fifth of a percent has survived. Certain inferences can, however, be made on the basis of what has been preserved. For instance, we may surmise that if we can still account for several hundred examples of Herakles and the Nemean lion, many thousands must have been made. When the numbers are lower, conclusions must be more tentative: whether nearly twenty examples of Orestes killing Aegisthus means that thousands, or at least hundreds, were painted is likely but far from certain, and a single example (for instance, Exekias' Ajax preparing to kill himself) may be unique, just a lucky chance survival.

Less abundant than vases, but still preserved in large numbers, are Roman sarcophagi. These carved marble coffins became popular from the early 2nd century AD and continued to be made well into the 4th century. Some thousands of them still survive, many decorated with mythological subjects.

Architectural sculpture used by the Greeks to decorate temples and treasuries usually depicted the deeds of gods and heroes. A considerable number of carved metopes from mainland Greece, Sicily and South Italy have survived. The themes of a handful of sculptures decorating pediments mostly in mainland Greece are known either from literary descriptions or in preserved fragments, while substantial sections of sculpted friezes, several portraying myths, survive from Asia Minor as well as mainland Greece.

Roman wall paintings, many in domestic dwellings, often illustrated Greek myths. Some of these are preserved in Rome, and more in Pompeii, Herculaneum and other Campanian cities.

Mosaics (made out of small coloured squared stones) began to be used as decorations on floors from the 3rd century BC in Greek lands and became popular throughout the Roman Empire right up to the

triumph of Christianity and beyond. Although they survive in considerable quantity, only a small proportion are devoted to illustrating myths.

How We Know about Greek Myths

While the images that survive from antiquity represent only a fragment of what once existed, the same is true of the myths they illustrate. The myths themselves were traditional tales, told and retold for centuries in a lively oral tradition that is impossible to recover. They were constantly modified, developed, elaborated and reworked. Some that were written down, for instance Homer's *Iliad* and *Odyssey*, have fortunately survived to our day; many others in prose and poetry, much admired in their time and providing much inspiration to artists, have not. What remains is a very small sample of the grand legacy of ancient art and literature.

For instance, out of the hundreds of tragedies dramatising myths that were produced in the 5th century BC, we have only thirty-one, the rest having been lost when neglected books ceased to be copied, old manuscripts disintegrated and precious libraries were destroyed.

Nevertheless, we still know a good deal about tragedies that have not actually come down to us. We have lists of titles in inscriptions and in texts; we have fragments preserved either on scraps of papyrus or in quotations and allusions in surviving literature. Ancient scholarly commentaries, particularly those on Aristophanes' comedies that parodied tragedies, illuminate various aspects of lost plays. By means of subtle detective work, combining a variety of sources, we can even claim that one or another image reflects a lost tragedy, for many tragedies are not lost without a trace.

Much information about myths and the way they were treated in lost works of literature in other genres (epic or lyric poems, local or universal histories and such like) can be recovered by similar, seemingly indirect, methods. Many cultivated Roman writers adopted or adapted Greek myths. Virgil did so in parts of the *Aeneid* and Seneca in his tragedies. Ovid retold Greek myths with great sensitivity and charm in his *Metamorphoses*. Myths that became a fundamental part of Roman civilisation also pervaded many works of which only traces have survived.

Despite the loss of so much Greek and Latin literature, the bare bones of many myths, the story lines without any poetic elaboration, have been preserved in a number of mythological compendia. An outstanding

example is the *Library*, written in Greek probably in the 1st or 2nd century AD and wrongly attributed to Apollodorus, a learned scholar in the 2nd century BC. Less impressive, but still interesting, is the *Fabulae*, a collection of myths written in Latin, probably in the 2nd century AD, and erroneously attached to the name of Hyginus, who lived earlier. Numerous fragments, quotations and allusions also provide chunks or bits of information about various myths, so that by collating all the sources available, our stock of knowledge, though still full of gaps, is considerable.

The Illustrations in the
Context of Art History

Although many examples of Greek and Roman art have been discussed in this book, there has been no attempt to put them into chronological order or to trace the development of art in classical antiquity. The works themselves are hardly representative, since some media lent themselves better than others to the portrayal of myths and some periods encouraged the depiction of myths more than others. The purpose of this appendix is to sketch in the main lines of artistic development so that this heterogeneous collection of objects can be placed within an art-historical perspective.

Vase Painting, Painting and Mosaics

Only a small percentage survives of the immense quantity of Greek pottery and Roman wall painting that was produced in classical antiquity, while Greek mural and panel paintings, once highly influential, have disappeared virtually without trace.

Vase Painting from the Time of Homer to the End of the Persian Wars

The earliest surviving examples of Greek paintings are on vases. At first the decoration of vases consisted only of abstract, geometric patterns. During the 8th century BC human figures and even whole scenes began to appear. These were painted in dark silhouette on the lighter surface of

the vase. It is not certain whether such early figured scenes were simply generic or whether some of them were intended to illustrate myths.

In the course of the 7th century BC many artists found ways to make mythological illustrations unambiguous, either by selecting unique and unmistakable events for representation or by adding explanatory inscriptions. Increased trade and foreign contacts helped them enlarge their vocabulary of monsters, suggesting types for Gorgons, chimaeras and various creatures that combined parts of animals and human beings. At this point, too, the technique of vase painting became more complex, some figures being drawn partially in outline and others articulated by incisions scratched into the painted silhouette before firing (Fig. 29a).

The application of incisions to the black silhouettes was the decisive factor in the creation of the "black-figure technique" (Chapter 2, p. 16), which was invented in Corinth at the beginning of the 7th century BC and was soon adopted by the rest of the Greek world. It flourished particularly in Athens during the 6th century BC.

The use of incision was important because it allowed figures on vases to remain decoratively effective while at the same time taking on subtler expressions and engaging in more complex interactions. Incisions gave definition to eyes and mouths within faces, muscles on nude bodies and clothing on draped figures (e.g., Figs. 23, 27, 31, 83, 84, 118). They could also be used to distinguish overlapping figures from one another (Fig. 50). The figures themselves were flat, with parts usually shown either in full profile or full front view – heads and legs normally in profile, chests and eyes in front view; transitions were largely ignored.

Although the essence of the black-figure technique resided in silhouettes articulated by incision, the technique also allowed the addition of some colours, at first a dark purplish-red and later also white. Such added colours could make black-figure vases surprisingly cheerful in appearance (Fig. 61). The colours were limited, however, to those which could be made out of clay slips suitable for firing.

During the last third of the 6th century BC, Athenian vase painters began to experiment with new techniques; they began to make use of a white ground (a white slip painted over the natural orange colour of the vase) decorated either in normal black-figure or in outline (Figs. 25, 62, 121, 126). Some also experimented with a reversal of the black-figure technique, painting the background black and leaving the figures in the natural red-orange of the clay, thus creating the "red-figure technique" (Chapter 2, p. 20).

The red-figure technique developed into something that was not simply a negative image of black-figure, for the internal markings on figures could no longer be made by means of incisions scratched into the wet paint but had to be painted on with the aid of a flexible brush. This encouraged (or was encouraged by) a new interest in details of anatomy (Figs. 13, 87, 125) and in more dramatic foreshortenings (Fig. 92). Twists and turns of the body and intermediate angles were investigated and represented with increasing plausibility; drapery could be shown with an abundance of soft folds (Figs. 74, 86, 91, 120) and could also be used to suggest movement (Figs. 34–37, 87). The addition of purplish-red gradually went out of fashion and white almost disappeared, only to be reintroduced with some enthusiasm in the 4th century BC along with touches of gilding and some more fragile colours added after firing.

In red-figure, facial expression could be refined, and the drawing of an eye in profile could give direction to a glance (Fig. 33). Of course, great expressiveness could be obtained in black-figure by outstanding artists like Kleitias and Exekias by means of actions and poses (e.g., Figs. 20, 27 and 50), but emotional subtlety was generally easier to achieve in red-figure vase painting.

*Major Paintings and Their Relationship to Vase Paintings
in the 5th Century BC*

Hardly any Greek painting on walls and panels has been preserved because the paint was generally applied to a wooden ground, and wood does not survive well in Greece. Such fragments as we have from the archaic period suggest that figures were drawn in outline, in style much like contemporary figures in black-figure vase painting, and stood on a single ground line against a light (probably white) background. The colour range was much wider than was possible in vase painting. The use of solid blues, greens, yellows, reds and violets, in addition to black and white, must have made for a lively effect, even if the figures remained flat, without any shading or foreshortening.

Up until the second quarter of the 5th century, vase painting and painting on walls and panels seem to have differed only in scale and in the greater variety of colours always available to painters on walls and panels.

Shortly after the end of the Persian wars (in 479 BC), literary sources record revolutionary new developments in mural painting. Many of these appear to have been stimulated by Polygnotos of Thasos, no

fragment of whose work survives. In his famous murals, so writers who saw them say, Polygnotos excelled in the portrayal of character, temperament and mood. Internal motivation rather than external activity intrigued him, and he often avoided painting the obvious moment of climax. Thus, for instance, instead of depicting the raging night of the sack of Troy, as had been usual (Figs. 44, 52, 82), he painted the scene on the following day, so that he could explore the movement of the mind when that of the body had been stilled.

In his two great paintings at Delphi, of which we have extensive descriptions by Pausanias (10.15,1–10.31,12), Polygnotos appears to have been less interested in telling the story (one dealt with the sack of Troy, the other showed Odysseus in the Underworld) than in revealing the characters of the participants. His genius allowed him to endow his quiet figures with hitherto unknown intensity; his achievement is probably best reflected in the design of the east pediment of the Temple of Zeus at Olympia (Figs. 21a and 21b).

While the expressive inwardness that could be imparted to figures in actionless scenes was a great achievement, it was not without its drawbacks. The greatest of these was that such scenes became difficult to identify – indeed, it would be impossible to say who the figures standing around in the east pediment of the Temple of Zeus at Olympia (Fig. 21b) were or what story they were involved in were it not for the fact that Pausanias tells us who is who and what is going on.

This sort of difficulty also would have applied to individual figures. Pausanias was greatly impressed by the image of "a man . . . sitting in an attitude of deepest dejection" and claimed that one could guess who he was even before reading the inscription (10.15,5). This, however, seems unlikely. A hero fighting a Minotaur or a hero wearing a lion skin is easy to identify without an inscription. Dejected heroes abound in the tragic myths of Greece. We could appreciate how beautifully this one (Helenus) was characterised *once we read the inscription*, but it is doubtful that anyone would recognise this particular hero without it. Polygnotos' innovations in the portrayal of myths deepened some interpretations, but they also introduced images which could be difficult to identify without the help of either inscriptions or some sort of external information.

Polygnotos painted whole walls filled with a multitude of figures, sometimes as many as seventy or more. Making such large assemblages visually interesting without the use of dramatic action presented a considerable problem. In order to solve it, Polygnotos made another

extraordinary break with tradition. Instead of setting all his figures along the same ground line in the usual way, he placed some of them higher up and some lower down, as if they were standing on a sloping hillside. Although the figures themselves were relatively static and seldom interacted, the wall was successfully covered with decoration that filled it from top to bottom.

A result – perhaps unexpected – of this novel arrangement was that some figures appeared to be *further back*, as well as higher up, than others. It must have seemed as if a hole had been cut in the solid wall, suddenly giving a view into the mountainous distance beyond.

It is impossible to know whether Polygnotos was pleased to see the illusion of depth that this distribution of the figures had created, or disappointed to observe that the pattern he had carefully composed on the surface of his painting had been disrupted by the suggestion of space. (His use of inscriptions may not only have been in order to identify figures, but also to reinforce awareness of the surface on which they were painted.) The compelling suggestion of space that emerged may have been unintentional, but once it was produced painters could not resist exploiting the effect. From then on, they became ever more interested in rendering the illusion of depth convincingly and were rarely satisfied with producing merely decorative works.

So impressive were Polygnotos' innovations that some red-figure vase painters were tempted to imitate him. Thus the late 5th-century BC representation of the Judgement of Paris (Fig. 63) shows figures disposed all up and down the surface of the vase, even though the spatial effects that Polygnotos could achieve by using a light background are negated by the conventional black background obligatory in red-figure vase painting. The fact that it is difficult to find and identify the leading figures in the story is also a consequence of Polygnotos' influence.

Etruscan Vase Painting

The Etruscans, who lived in independent cities in Italy between the Arno and Tiber Rivers, developed a lively and individual civilisation that flourished from about 700 BC until they were finally absorbed by the Romans in the 1st century BC. They appreciated Greek art and Greek myths and adapted the things that interested them in highly original ways. The animated illustration of the Judgement of Paris (Fig. 61) is a good example of their use of the black-figure technique that had been developed in Greece. They also produced imaginative vases in the

red-figure technique, including the tender but somewhat unexpected image of the Minotaur as a baby (Fig. 104).

Vase Painting in Athens and South Italy in the Later
5th and 4th Centuries BC

In Athens, red-figure vase painting continued until the end of the 4th century BC – black-figure went on, as a minor trend, even later – but vase painting was no longer representative of the most advanced ideas in painting, though it could sometimes reflect them. Figures were either arranged on a single ground line or on several levels; drawing became increasingly accomplished, and sketchy, broken lines (Figs. 52, 63, 179) replaced the calligraphic continuous lines used in earlier times (Figs. 128, 182).

About the middle of the 5th century BC, Greek vase painters in South Italy and Sicily began to make their own red-figure vase paintings. These local schools flourished in the 4th century BC, sometimes producing somewhat bombastic works, at other times rather sentimental ones, and occasionally delightfully original comic interpretations (Figs. 53 and 80). Simple scenes were often arranged with figures on a single ground line (Fig. 45), more elaborate ones with figures on many different levels (Figs. 3, 81); mythological subjects and theatrical representations were popular, particularly in Apulia.

Some vase painters signed their works, most did not. Many vase painters can, however, be recognised by the style of their drawings. Sometimes this is rather easy, but at other times a trained eye combined with much painstaking labour is required if the works of a single painter are to be gathered into a coherent oeuvre. Sir John Beazley devoted a lifetime to attributing Athenian black-figure and red-figure vases to individual painters, giving names of his own devising (the Kleophrades Painter, the Swing Painter and such like) to those whose real names were not known. A. D. Trendall has performed a similar feat in the colossal task of making order among the Greek painters who worked in South Italy and Sicily.

Later Painting on Walls and Panels

Painting on walls and panels, from about the second quarter of the 5th century BC, had begun to develop faster and along different lines from vase painting. The drive to produce an illusion of reality grew

apace. By the end of the 4th century BC painters of walls and panels had mastered the technique of modelling in light and shadow, had discovered how to indicate the effects of highlights and cast shadows, and were able to produce works of very considerable dramatic power.

Greek painters of walls and panels during the Hellenistic period – the three centuries conventionally dated from the death of Alexander the Great (323 BC) to the final Roman conquest of the Greek-speaking world (31 BC) – had become adept not only in suggesting the massiveness of individual figures and rendering the effects of light accurately but also in placing figures convincingly within a broad landscape setting and creating complex compositions. They were in full possession of a sophisticated naturalistic technique that was gratefully taken over by Roman painters, whose skill (or lack of it) can best be seen in the lavish decoration of houses in the provincial towns destroyed by the eruption of Vesuvius in 79 AD (Figs. 1, 73, 97).

Roman wall painters probably drew most of their mythological illustrations from Greek prototypes from the 4th century BC and the Hellenistic period (Figs. 56, 97). Surviving Roman paintings of Greek mythology often show the same types repeated over and over again, the compositions presumably having been transmitted by means of copybooks. The Romans may, however, have been the inventors of some original and effective landscape settings that are not entirely rationally thought out (Fig. 98), and some impressionistic effects (Fig. (135) that seem to be independent of Greek inspiration.

Mosaics

Tessellated mosaics composed of small, usually four-sided, pieces of coloured stone specially cut for the purpose appear to have been invented in the 3rd century BC either in Sicily, Macedonia or Egypt, though figured mosaics composed of pebbles existed earlier. The new technique proved popular not only in Greece but throughout the Roman world, at first for decorating floors, and then also for walls with curved surfaces or exposed to water (like fountains or public baths).

Some Roman mosaicists imitated illusionistic paintings and appear to have drawn much of their inspiration from sources similar to those which inspired Roman paintings (Figs. 64, 103), others simplified images (Fig. 127) or created flat designs (Fig. 105). Copybooks were probably

used as guidance for many popular narrative designs in practically all media, but certainly for mosaics. Some mosaics could be very fine and sensitive (Fig. 103), but others degenerated into rather crude local products (Figs. 46, 175).

Sculpture

There are basically two kinds of sculpture: sculpture in relief and free-standing sculpture. All ancient sculpture was normally painted so that details like eyes, hair and clothing were picked out in colour and the background of reliefs was made to contrast with the figures. Unfortunately, little of the colour that once enlivened these sculptures has survived.

Sculpture in Relief

Sculpture in relief is similar to painting, in that figures are never cut entirely free of the background and so are viewed from the front only. The first step in carving relief sculpture was to draw the figures on the surface of the stone. The background could then be cut back behind them and the figures themselves rounded to indicate modelling.

The development of relief sculpture follows much the same lines as the development of painting. In the 6th century BC, figures were relatively flat and the decoration of the background was negligible (Figs. 90, 169). Over the course of time the advances in naturalism in painting were also applied to reliefs; anatomy was rendered more correctly, and the sense of the massiveness of figures was conveyed more convincingly (Figs. 55, 166). By the Hellenistic period spatial settings could be suggested in relief, though this was not common.

Relief sculpture illustrating mythological subjects was used copiously for architectural decoration in Greece and in the Greek colonies in South Italy and Sicily (particularly for metopes, Figs. 22, 69, 70, 169 and friezes, Figs. 68, 72, 90, 93, 94). Relief sculpture was also used for other decorative purposes in the Greek and Roman worlds (Figs. 55, 166). From early in the 2nd century AD wealthy Romans began to choose to be buried in sarcophagi, carved marble coffins. Mythological subjects were popular on sarcophagi (Figs. 38–43, 148a, 149a, 150a, 151a). Artists decorating sarcophagi were often more interested in producing an overall pattern through the contrast of light and shade than in creating a plausible vision of reality. Thus there is often

no consistency of scale applied to all the figures or any sense of natural space, but the whole surface is covered from top to bottom by the lively interplay of forms with no gaps left unfilled.

Free-standing Sculpture

Most free-standing statues were made either in bronze or marble, and, like sculptures in relief, were enhanced by the addition of colour. Unlike reliefs, however, which are always attached to the background, free-standing statues had to be designed so that they were self-supporting. It is easier to ensure that a free-standing statue is stable in bronze (which has considerable tensile strength) than in marble (where much care has to be taken to be sure that extended limbs are properly supported): Chapter 2, pp. 22–23; Chapter 11, pp. 148–149. When Roman enthusiasts wished to have copies of Greek bronze statues made in marble, they had to include appropriate supports (Fig. 10).

The astonishing development of free-standing sculpture occupies much space in general books on the history of ancient art. Such books trace the development from stiff, rather schematic figures to figures naturalistically modelled and standing in a variety of relaxed or active poses, but, as isolated free-standing sculptures only rarely convey a story – Figures 10 and 129 are exceptional – they are largely absent from this book.

Statuary groups, however, often embody greater narrative content. Groups of statues were used to fill the pediments (the triangular gables) at either end of a classical temple. At first, pedimental sculptures were carved in relief (Fig. 24), but by the end of the 6th century BC, they were normally composed of an assemblage of free-standing statues (Figs. 21a and 21b, 71).

Free-standing sculptural groups, often depicting a myth but independent of temple architecture, were created during the Hellenistic period. The Romans sometimes used huge free-standing statuary groups to serve as decorations in grottoes (Fig. 16) or public baths.

Female Artists

Most artists, like most other craftsmen, in antiquity were male, and for that reason I refer to artists simply as "he" rather than clumsily as "he or she". There were some women artists, however; one appears on

a vase painting, and a few are mentioned by Pliny the Elder (*Natural History* 35.147) primarily because they were so unusual:

> Women, too, have been painters: Timarete, the daughter of Mikon, painted an Artemis at Ephesos in a picture of very archaic style. Eirene, the daughter and pupil of Kratinos, painted a maiden at Eleusis; Kalypso painted portraits of an old man, of the juggler Theodoros, and of the dancer Alkisthenes; Aristarete, the daughter and pupil of Nearchos, painted an Asklepios. Iaia of Kyzikos, who remained single all her life, worked at Rome in the youth of Marcus Varro, both with brush and with cestrum on ivory. She painted chiefly portraits of women and also a large picture of an old woman at Naples and a portrait of herself, executed with a mirror. No artist worked more rapidly than she did, and her pictures had such merit that they sold for higher prices than those of Sopolis and Dionysios, well-known contemporary painters, whose works fill our galleries. Olympias was also a painter; of her we only know that Autoboulos was her pupil.
>
> (trans. K. Jex-Blake)

The Illustrations in the Context of Five Cycles of Myth

Many examples of myths have been used in this book in isolation from the larger cycles of which they form a part. For instance, Medea has appeared engineering the death of Pelias and killing her own children quite apart from the rest of the story – the quest for the Golden Fleece, the adventures of the Argonauts and the history of the hero Jason.

In this appendix, five major cycles are sketched out to provide some idea of the larger picture into which the individual myths fit. The names of the characters who appear in Chapters 1–17 of this book and in the Glossary are shown in boldface.

The cycles were constantly modified and often enlarged, and the outlines that I offer here are a fairly arbitrary choice of alternatives. Those interested in the full range of developments and variations should consult the fascinating and thorough book by Timothy Gantz, *Early Greek Myth: A Guide to Literary and Artistic Sources* (Baltimore and London: Johns Hopkins University Press, 1993; unillustrated).

Jason and the Argonauts

Aeson, the father of **Jason**, should have inherited the kingdom of Iolcos, but his throne was usurped by his half-brother **Pelias**. **Pelias** had been warned to beware of the man wearing only one sandal, and when **Jason**, who had been concealed during his youth and educated by the wise centaur **Cheiron**, appeared at his court with one foot bare,

Pelias was alarmed. In order to get rid of this dangerous youth, **Pelias** sent **Jason** on a quest to fetch the Golden Fleece.

The Golden Fleece was kept, well-guarded, at Colchis, at the eastern end of the Black Sea. The story of how it got there is the following. Athamas, a king in Boeotia, married Nephele and had two children by her: Phrixus and Helle. He later married Ino, who, with a stepmother's malice, tried to arrange the death of the two children. Nephele, however, managed to send a magical ram with golden fleece to their rescue. With the children aboard, the ram flew off. In the course of the flight, Helle fell off and was drowned in the Hellespont (which thenceforth took its name from her), but Phrixus arrived safely at Colchis, where he sacrificed the ram (some authors defend this seemingly ungrateful act by explaining that it was at the ram's own request). The Golden Fleece was hung on a tree guarded by a fierce snake and became part of the national treasure of the Colchian king, Aietes. Aietes married his elder daughter to Phrixus; the younger was the sorceress **Medea**.

In order to fetch the Golden Fleece **Jason** needed a ship and a crew. The ship was built by a man called Argos, and so was named the *Argo*; the crew was recruited from the most notable heroes of that generation, many equipped with special skills that proved useful on the hazardous voyage.

In the course of their travels, the **Argonauts** (as the crew was called) made many stops along the way. In some places, their welcome was warm, as at Lemnos, where the women lived alone (having murdered their menfolk); in others it was hostile, as in the land of the Bebrykes, where Amykos challenged all comers to a boxing match, convinced that he would win. Fortunately, the Argonauts had among their number **Polydeukes**, a champion boxer, who neatly put an end to Amykos' bullying.

In Thrace the Argonauts encountered **Phineus**, a blind seer plagued by **Harpies** who snatched away most of his food and fouled what was left. In exchange for being rid of these horrors, he was willing to advise the Argonauts how they could slip through the Clashing Rocks unharmed. The **Boreades**, sons of the god of the north wind, **Boreas**, who were the crew's specialists in speedy flight, chased the **Harpies** away, and in due course the Argonauts arrived safely at Colchis. Aietes agreed to give **Jason** the Golden Fleece if he would yoke a pair of fire-breathing, brazen-hooved bulls and sow a field with dragon's teeth, a crop that was known to burgeon instantly into a number of armed

men eager to fight. **Jason** accomplished these tasks thanks to the aid and advice provided by **Medea**, who had fallen in love with him. But still Aietes refused to give up the Golden Fleece. Exasperated, **Medea** drugged the guardian snake, helped **Jason** to seize the Golden Fleece and sailed off with him.

Pursued by the angry Colchians, **Medea** chopped up her little brother, whom she had taken with her, and scattered the pieces behind the ship in order to delay the Colchians, who piously stopped to recover the dismembered fragments. This act clearly revealed the determination of **Medea** and the brutal lengths to which she was ready to go once she had decided what she wanted.

On the homeward journey, the Argonauts encountered many of the people and perils that **Odysseus** met later on his travels. **Orpheus**, the supreme musician (another gifted specialist member of the crew) outsang the Sirens and so preserved the **Argonauts** from the fatal allure of their song. Later on, the **Argonauts** avoided the twin menace of Skylla and Charybdis, met the Phaeacian king, Alkinoos, and his wise wife, Arete, and even visited **Medea's** aunt, **Circe**.

Arriving in Iolcos, **Medea** plotted vengeance on **Pelias** on behalf of **Jason**. She persuaded the **daughters of Pelias** that it would be a kindness if they were to rejuvenate their feeble old father. She demonstrated how this could be done using an ancient ram, which, when cut in pieces and boiled up with the right magic herbs, emerged from the cauldron as a frisky young lamb. But when the **daughters of Pelias** tried to produce the same results with their dismembered father, **Medea** withheld the magic herbs. Once it was discovered that the girls had murdered their own father to no purpose, **Medea** and **Jason**, gruesomely revenged on **Pelias** and his innocent daughters, fled to Corinth.

They lived there well enough for several years along with their children until **Jason** spied some advantage in repudiating **Medea** and marrying the daughter of the king of Corinth. **Medea** did not take being scorned lightly. Pretending to acquiesce, she sent the princess a magnificent robe. When the princess donned it, the poisons with which it was imbued set her on fire and burned her, screaming, to death, along with her father who rushed to her rescue.

Believing that **Jason** still had not been sufficiently punished for his ingratitude and betrayal, **Medea** murdered their sons. She was prepared to endure the suffering this would also cause her – for she, too, loved the boys – in order to be avenged on **Jason**. **Jason** was devastated.

Medea escaped to Athens, where she lived comfortably with its king, Aegeus, for some time – till his son **Theseus** arrived. **Medea** plotted against **Theseus**, then was found out and exiled.

Long after the days of his glory, **Jason** was sitting under the *Argo* bemoaning his fate when part of the old ship fell on him and put an end to his suffering.

ANCIENT SOURCES: Apollonios of Rhodes *Argonautica*; Euripides *Medea*; Apollodorus *Library* 1.9.1; 1.9.16–28; Ovid *Metamorphoses*, books 6–7. Diodorus Siculus 4.40.1–4.56.8.

The Seven against Thebes

Oedipus unwittingly killed his father and married his mother, by whom he had four children: his daughters, Antigone and Ismene, and his sons, **Polyneikes** and Eteokles. When the boys offended their father, he cursed them. After Oedipus died and his sons inherited the throne of Thebes, they tried to neutralise the curse by taking turns at being king. Eteokles went first and **Polyneikes** left the city for a year. When **Polyneikes** demanded to have his turn, Eteokles refused.

Polyneikes then went to Argos, where one night he got into an altercation with Tydeus, an exile from Calydon. The king of Argos, **Adrastos**, woken by the scuffle, recognised in the brawling heroes the men destined to be his sons-in-law. He had been told to marry his daughters to a lion and a boar, and as **Polyneikes** carried the insignia of a lion and Tydeus that of a boar, he promptly gave one of his daughters to each of the landless men. He then set about restoring his sons-in-law to their inheritances.

He began with **Polyneikes** and started to assemble seven armies to challenge the mighty city of Thebes with its seven strong gates. He wanted to recruit his brother-in-law, the seer **Amphiaraos**. The two men had often been at odds and had finally resolved to let **Eriphyle**, Adrastos' sister and Amphiaraos' wife, arbitrate between them. **Amphiaraos** was unwilling to participate in the attack on Thebes, as he could foresee that of the leaders only **Adrastos** would return. **Polyneikes** quickly perceived that the decision rested with **Eriphyle**, and so he offered her a precious necklace made by the god **Hephaistos**, part of the Theban royal treasure, as a bribe to persuade her to make her husband join up. **Eriphyle** accepted the bribe and **Amphiaraos**

had no choice but to go. As he left he bade his son, **Alkmaion**, to avenge him.

Adrastos disposed the seven armies he had mustered against the seven gates of Thebes. Eteokles mustered the defenders. The attack was repelled. The two brothers, Eteokles and **Polyneikes**, poised opposite one another, fell by each other's hand, thereby fulfilling their father's curse. **Adrastos** returned alone to Argos.

Alkmaion led an army of the sons of the original Seven against Thebes. These, the Epigoni, were successful and destroyed the city. Then **Alkmaion** murdered his mother to avenge his father. However justifiable his action may have been, he was nevertheless pursued by the Furies who are angered by the shedding of kindred blood, and eventually he was himself killed.

ANCIENT SOURCES: Aeschylus *The Seven against Thebes*; Euripides *The Phoenician Women, Antigone* and *Suppliants*; Apollodorus *Library* 3.5.7—3.7.7; Hyginus *Fabulae* 69 and 70.

Herakles

When **Zeus** became enamoured of Alkmena, he decided to father on her the most glorious hero. In order to do so, he made the night of love three nights long. And, so as not to alarm Alkmena, he disguised himself as her own husband, Amphitryon. Thus was **Herakles** conceived. The next night Alkmena's husband lay with her himself, and Alkmena subsequently gave birth to twins, **Herakles**, the son of **Zeus**, and **Iphikles** the son of Amphitryon.

The birth was not easy. **Zeus**, in the excitement of his impending fatherhood, swore an oath that on that day would be born a descendant of his destined to rule over all the surrounding territory. **Hera**, jealous and angry, profited from the ambiguity of the oath to speed up the delivery of **Eurystheus**, a great-grandson of **Zeus**, and delay that of **Herakles**. **Eurystheus**, therefore, became the overlord and was able to command **Herakles**.

Herakles' trials began when he was still a baby. **Hera** sent serpents to attack the infant twins in their cot. **Iphikles** was terrified, but **Herakles** just grabbed the snakes in his tiny fists and strangled them.

The boys' teachers were chosen with care. **Linos** (according to some, the brother of **Orpheus**) taught them music. Unfortunately, when **Linos**

slapped **Herakles** for striking a wrong note, the enraged hero retaliated and killed the music master.

Herakles married Megara and had several children by her, but, in a fit of madness sent by **Hera**, mistaking them for enemies, he murdered them.

In penance for this terrible deed, **Herakles** undertook to perform twelve labours under orders from **Eurystheus**. The first six were located in the northern Peloponnese.

The first was to kill the **Nemean lion**. A huge beast, it was invulnerable to weapons. **Herakles**, therefore, had to strangle it with his bare hands. He then skinned the animal using its own claws, which could cut through anything, and wore the pelt, using the head as a sort of helmet, as testimony to this, his first major achievement.

The second labour was to kill the **Hydra of Lerna**. This multiheaded monster had the peculiarity of sprouting two new heads whenever one was cut off. As if that were not trouble enough, **Hera** sent a crab to bite **Herakles'** toes as he worked. **Herakles**, exclaiming that "against two even Herakles cannot fight" (a saying that became proverbial), asked his nephew **Iolaos** (the son of his twin brother **Iphikles**) to help him, and as he severed each head, **Iolaos** cauterised the stump with a burning torch. The central (or main) head was immortal, and that one **Herakles** buried, after having dipped his arrows into its venomous blood.

The third labour was to bring the Erymanthian boar back to **Eurystheus** alive. When **Herakles** succeeded in doing so, **Eurystheus** was so alarmed that he hid himself in a huge underground storage jar, an image much appreciated in art.

The fourth labour was to capture the Kerynitian hind with golden horns, an animal sacred to **Artemis**. **Herakles** chased it for a year before succeeding.

The fifth labour was to drive away (or kill – traditions vary) the birds that haunted Lake Stymphalus. They were reputed to be man-eating or to shoot their feathers out like arrows.

The sixth labour was to clean out the filthy **Augean stables** in a single day. This humiliating task required neither bravery nor prowess, and many ancient sources, eager to preserve the dignity of the hero, suggest that he did not simply shovel out the manure but that, with the ingenuity of an engineer, he rerouted the rivers Alpheus and Peneus so that they ran through the cattle yard and did the job for him.

The next four labours took **Herakles** to the four corners of the world; first to the far south to capture the **Cretan bull**. Some claim that this

was the very beast that **Pasiphae** had fallen in love with and that had fathered the **Minotaur** on her. **Herakles** captured the bull, showed it to **Eurystheus** and then let it go. Eventually it roamed as far as Marathon, where it was recaptured by **Theseus** and finally sacrificed by him.

The eighth labour took **Herakles** to the far north, to steal the man-eating **horses of Diomedes**. He appeased their hunger by feeding them their master (or his groom) and was able to lead them peacefully away.

The ninth labour required that **Herakles** travel to the east to fetch the belt of the queen of the **Amazons**. She was happy to oblige the hero, but **Hera** stirred up trouble and there was a pitched battle. Some versions of the story suggest that **Theseus** accompanied **Herakles** on this expedition and carried off the **Amazon** who became the mother of his son, **Hippolytus**.

The tenth labour obliged **Herakles** to steal the cattle of **Geryon**, a triple-bodied monster, who lived far to the west. His herds were guarded by the double-headed dog **Orthros** and a single-headed shepherd. **Herakles** first killed the dog and the shepherd and then disposed of **Geryon**.

The last two labours took **Herakles** beyond the confines of mortality. The eleventh was to fetch **Cerberus**, the triple-headed guard dog of the Underworld – a metaphor, presumably, for overcoming death itself.

The final labour was to acquire the apples of the Hesperides, apples of immortality. As the location of these was obscure, some traditions suggest that **Herakles** was helped in this labour by Atlas.

By completing all these labours, **Herakles** earned the immortality that he was ultimately awarded, but many events intervened before he finally attained it.

The flexibility of myth allowed for a variety of traditions and elaborations. One of the most heart-rending is Euripides' tragedy *The Madness of Herakles*, in which Euripides rearranged the traditional chronology so that **Herakles** did not kill his children before his labours, but came home to his family triumphant after completing them. The children had been under threat from an upstart ruler and **Herakles** rescued them in the nick of time. It seemed as if all **Herakles'** troubles had at last come to an end. But just at that moment, **Hera** afflicted him with madness and he killed his children himself.

Along the way, as **Herakles** was performing his labours, he had a number of awkward encounters: while chasing the boar, he stopped off for a while with the centaur **Pholos**. **Pholos** offered the tired hero some of the wine that had been deposited with him to entertain just

this guest, but the other centaurs, getting wind of it, rushed up and began to attack **Herakles**, who drove them off. After cleaning the Augean stables, **Herakles** visited **Dexamenos**, only to find that the centaur **Eurytion** was courting his host's daughter. **Herakles** swiftly dispatched the unwelcome suitor. While searching for the apples of the Hesperides, **Herakles** landed in Egypt and was in danger of being sacrificed on the orders of the king **Busiris**, but he soon turned the tables on those who were threatening him. When the **Giants** made war on the gods, there was a prophecy that the gods could not win unless they were assisted by a mortal, so **Herakles** helped them out, finishing off disabled **Giants** with a well-aimed arrow.

Even after all this, **Herakles'** troubles still were not over. **Hera** afflicted him with yet another bout of madness and he committed yet another murder. When **Herakles** went to Delphi to find out from the oracle what form his expiation should take, **Apollo** refused to tell him. In anger and frustration, **Herakles** grabbed **Apollo's** tripod (part of the prophetic apparatus of the sanctuary) and tried to carry it off. **Zeus** intervened in this unseemly struggle between his two sons and commanded **Apollo** to give **Herakles** the information he required and **Herakles** to return the tripod. **Apollo** then told **Herakles** that he should be sold into slavery for three years and give the proceeds of the sale to the family of the man he had murdered.

Omphale, queen of Lydia, bought **Herakles** and amused herself by occasionally exchanging clothes with the hero. It was during this period that **Herakles** encountered the mischievous **Kerkopes**, who stole his club and lion skin while he was asleep. To punish them, he tied them by the feet to a pole that he carried over his shoulders. Upside-down, the **Kerkopes** had an unobstructed view of the hero's unusually black and hairy bottom. Their jokes about this noteworthy feature so amused the hero that he let them go.

Some time after **Herakles** had completed his labours, he married **Deianeira**. When they came to a river, the centaur **Nessos**, who worked as a ferryman, offered to carry **Herakles'** bride across. Partway across, he tried to rape her, and when **Deianeira** cried out, **Herakles** shot **Nessos** with one of his arrows dipped in Hydra venom. Before he died, **Nessos** secretly advised **Deianeira** to save some of his blood and, if she ever thought her husband was falling in love with someone else, to use it as a love potion rubbed on **Herakles'** clothing. **Nessos** guaranteed that if this were done, **Herakles** would never love another woman.

Years passed. One day, however, **Deianeira** learned that **Herakles** had conceived a new passion and she thought the moment had come to use **Nessos'** charm. The result was disastrous. When **Herakles** put on the shirt that had been imbued with **Nessos'** blood, the Hydra venom that had been mixed with it began to burn off his skin. Indeed, he never loved another woman; all he wanted to do was die. He climbed upon a pyre and finally persuaded Poeas (or Poeas' son, Philoktetes) to light the pyre. Thus was his human body consumed, while his spirit rose to heaven. He was reconciled with **Hera**, married her daughter **Hebe**, and finally obtained his long-promised immortality.

ANCIENT SOURCES: Sophocles *Trachiniae*; Euripides *Madness of Herakles*; Apollodorus *Library* 2.4.8–2.7.8; Diodorus Siculus 4.7.8–4.39.4.

Theseus

Aegeus, king of Athens, was distressed about his childlessness, especially as his brother had fifty sons only too anxious to take over the throne. He consulted the oracle at Delphi about his problem and was advised, "Loose not the jutting neck of the wineskin, great chief of the people, till you have come once again to the city of Athens", an injunction that he found for some reason difficult to interpret. So, instead of going directly home, he stopped off in Troezen to ask his friend Pittheus for his interpretation.

Pittheus understood at once, got Aegeus drunk and introduced his daughter Aethra. The consequence was that Aethra became pregnant, and when Aegeus realised what had happened, he placed a sword and a pair of sandals beneath a huge stone. He told Aethra that when the son she had conceived was strong enough to move the stone, he should take the sword and sandals and come to his father in Athens. In due course Aethra gave birth to **Theseus**, and though the identity of **Theseus'** mother was never in doubt, a tradition grew up that **Poseidon** had shared her bed and that **Theseus** was the son of the god.

When the time came, **Theseus** removed the stone, took the tokens and set off for Athens. The trip from Troezen to Athens by sea was easy and safe. By land, it was neither. The land route was infested with bandits and wild animals. Theseus chose to follow this dangerous route. The danger actually attracted him, for he wanted to prove his worth before he presented himself in Athens.

His first encounter along the way was with a villain called Periphetes, who used a club to beat unwary travellers to death. **Theseus** gave him a dose of his own medicine and took the club, which served to remind people of this, his first heroic fight, just as **Herakles** recalled his first labour by wearing the skin of the Nemean lion. **Theseus'** use of the club made him resemble **Herakles**, whose heroic deeds he admired and whose characteristic weapon was a club.

Next **Theseus** met cruel **Sinis**, who forced passersby to hold on to a tree that he had bent down. When the tree sprang up again, the victim was tossed in the air and fell to his death. Again, **Theseus** subjected the villain to the very treatment he used to mete out to others. Then **Theseus** made a detour in order to slay the **sow of Krommyon**, an enormous beast that was ravaging the area.

Skiron, who made travellers wash his feet and then kicked them over a cliff to serve as a tasty morsel for his friend the turtle who lurked below, was the next bandit to meet his match in **Theseus**.

As he drew closer to Athens, **Theseus** was forced to fight with the wrestler **Kerkyon**, whom he dispatched like the others.

Theseus' final encounter was with **Procrustes**, who adjusted all comers to the size of his bed, hammering out those who were too small, lopping off limbs of those who were too big. **Theseus** performed a like adjustment on him.

When **Theseus** arrived in Athens, he found that **Medea** was already there. Aegeus, still seemingly without progeny, was increasingly threatened by his fifty nephews, and **Medea** had promised to help him have a child.

Medea recognised Theseus for who he was long before Aegeus did and urged Aegeus to poison the newcomer. But just before Aegeus passed **Theseus** the fatal potion, the young man produced the sword that had been buried with the sandals, and his father, suddenly recognising him, dashed the cup from his hands. **Medea** was hastily sent away and **Theseus** declared the legitimate heir.

The Cretan Bull, which **Herakles** had captured as one of his labours and had then let loose, was roaming around Marathon causing havoc. To benefit his new city, **Theseus** sought it out, mastered it and finally sacrificed it to **Apollo**.

But the Marathonian Bull, as the relocated Cretan Bull had now come to be called, was nothing to the Athenians compared with the terrible tribute of seven youths and seven maidens they were forced to provide periodically to **Minos**, king of Crete, as fodder for the **Minotaur**.

The **Minotaur** was a fierce bull-headed man confined in a complicated labyrinth and occasionally fed on imported Athenians.

Theseus bravely joined the doomed group of young people sailing for Crete. When **Minos** made advances to one of the maidens, Theseus defended her, countering **Minos'** claim to superiority as a son of **Zeus** by declaring that he was in no way inferior, being a son of **Poseidon.** **Minos** immediately validated his own divine parentage by calling upon Zeus and receiving a gratifying clap of thunder; he then challenged **Theseus** to prove his descent by retrieving a ring that he threw into the sea. **Theseus** gamely jumped in and was graciously received by **Poseidon's** wife, **Amphitrite**.

Helped by **Ariadne**, the daughter of **Minos** and **Pasiphae**, who had fallen in love with him, **Theseus** slew the **Minotaur** and with the other youths and maidens escaped from the labyrinth. On the way home, the group stopped off at the island of Naxos, and when they set off again, **Ariadne** was left behind. Various explanations are given for **Theseus'** abandonment of his benefactress, the most creditable suggesting that it was accidental. In the end it turned out well for **Ariadne**, for she was discovered in her lonely plight by the god **Dionysus**, who was so charmed by her that he not only married her but also conferred immortality on her.

In the excitement of his victorious return to Athens, **Theseus** forgot that he had promised his father that if he were successful he would exchange the customary black sails for white (or red) ones. Aegeus, despairing as he spotted the ship with black sails approaching, leapt to his death into the sea, which was henceforth called "Aegean" after him.

Theseus thus became king of Athens. According to later traditions, he unified the whole territory of Attica into a single state, initiated democratic reforms and showed much compassion for suppliants, even if aiding them led to danger. But he was frequently absent from the city. He fought against the **Amazons** in their homeland (possibly along with **Herakles**) and abducted one of their number, who bore him his son **Hippolytus**. To recover her, the **Amazons** came and attacked Athens, where they were eventually defeated.

Some time later, **Theseus** married **Phaedra**, another daughter of **Minos** and **Pasiphae**. She bore him two sons, but during one of his absences she fell hopelessly in love with her stepson, **Hippolytus**. The youth was shocked when he learned of her passion. **Phaedra**, humiliated, hanged herself, but left a note accusing **Hippolytus** of assaulting her. **Theseus**, deceived by this ploy, called down a fatal curse on his son.

Theseus' friendship with the Lapith **Peirithoos** meant that he fought beside the Lapiths when the **centaurs** disrupted **Peirithoos'** wedding. Later the two friends decided that they would each take as bride a daughter of **Zeus**. They therefore abducted **Helen**, though she was still under-age, for **Theseus**, and proposed a harebrained scheme to carry off Persephone, the wife of Hades, god of the Underworld, for **Peirithoos**. They were received courteously by Hades and invited to sit down, but soon found to their dismay that they could not get up again. **Herakles**, when he came to the Underworld to fetch **Cerberus** as one of his last labours, succeeded in saving **Theseus**, but **Peirithoos** had to be abandoned in the Underworld forever. **Helen** was rescued by her brothers, who captured **Theseus'** mother, Aethra, at the same time and took her along to be **Helen's** slave.

Upon his last return to Athens, **Theseus** found that he was no longer welcome and retired to the island of Skyros, where he was either murdered by being pushed off a cliff or accidentally fell to his death.

ANCIENT SOURCES: Bacchylides *Odes* 17, 18; Plutarch *Life of Theseus*, Apollodorus *Library* 3.15.6 – *Epitome* 1.24. Diodorus Siculus 4.59–63; Ovid *Metamorphoses*, book 8.

The Trojan War

There was a prophecy that **Thetis** would bear a son greater than his father. Though **Thetis** was an attractive Nereid, and both **Zeus** and **Poseidon** desired her, they thought it wisest to marry her off to a mortal. They proposed **Peleus** as her husband. **Thetis** was not pleased, and when **Peleus** approached her she did everything in her power to discourage him, changing her shape into that of a lion, a snake, a sea monster, a tree and even blazing fire and running water, but **Peleus** held on to her throughout, proving himself to be a man of exceptional determination. Finally **Thetis** relented and resumed her normal shape.

Perhaps to console **Thetis** for a marriage that she considered beneath her, a magnificent wedding was arranged to which all the gods and goddesses were invited, except **Eris** (Discord), who had been excluded for obvious reasons. But **Eris** came anyway and hurled into the party a Golden Apple upon which the words "For the Fairest" were inscribed. Three major goddesses immediately laid claim to it: **Hera**, the wife of **Zeus**; **Athena**, his daughter; and **Aphrodite**, the goddess of love. **Zeus**

sagely declined to adjudicate and instructed **Hermes** to take the three contending goddesses to **Paris**, a prince of Troy temporarily working as a shepherd, to have him judge which of them was the most beautiful. This was the "Judgement of **Paris**" that inspired many artists. **Paris** gave the Golden Apple to **Aphrodite**, who in return promised him the most beautiful woman in the world (or, according to another tradition, made this offer in advance, as a bribe).

The most beautiful woman in the world was **Helen**, daughter of **Zeus** and **Leda**, wife of **Tyndareus**. Because of her great beauty, **Helen** had had many suitors, and in order to prevent the disappointed candidates from rioting, **Tyndareus** made them all take an oath to support **Helen's** chosen husband should there ever be any trouble and to let **Helen** choose for herself. The suitors took the oath and **Helen** chose **Menelaus**, who ruled Sparta. **Helen** had been married to **Menelaus** for some time when **Paris** came to see her. Under **Aphrodite's** influence she was persuaded to run away with him to Troy.

When **Menelaus** discovered what had happened, he reminded the suitors of their oath. All the leading men in Greece had sued for **Helen's** hand and so a large army was assembled under the leadership of **Menelaus'** brother **Agamemnon,** the wealthy king of Mycenae. They prepared to sail to Troy to recover **Helen**.

Troy itself had long been a rich and powerful city, blessed with men and boys of extraordinary beauty. In fact, some were so beautiful that the gods themselves could not resist them. Thus **Zeus** carried off the young prince **Ganymede** to be his cupbearer, giving his father Tros, the king of Troy, some magnificent horses in compensation. In the next generation, **Eos**, the goddess of dawn, fell in love with **Tithonos** and bore him a son, Memnon, who later fought as an ally of the Trojans against the Greeks and met his death at the hands of **Achilles**. Even **Aphrodite** herself was smitten by a member of the Trojan royal house. She loved **Anchises**, to whom she bore **Aeneas**.

The Trojan king Laomedon, brother of **Tithonos**, was a sly and dishonest character. After the gods **Poseidon** and **Apollo** had helped to build the walls of Troy, he refused to pay them. To punish him the gods sent a flood and a sea monster. The sea monster required Laomedon's daughter, Hesione, as a sacrifice. The girl was exposed by the sea and the sea monster was about to devour her when **Herakles** passed by. He offered to kill the monster and save the girl in exchange for the horses that had been given to Tros in compensation for **Ganymede**. This was

agreed and **Herakles** slew the monster, but Laomedon again refused to pay up. Later, when **Herakles** had completed his labours, he returned to punish the wicked king, sacked the city and installed Laomedon's honest son, **Priam**, as king.

Priam married **Hecuba** and had many children by her, including **Hector**, **Cassandra**, **Polyxena**, **Troilos** and **Paris**. When **Paris** was about to be born, **Hecuba** dreamed that she was giving birth to flames that set the city alight. Seers interpreted this to mean that the child she was bearing would bring destruction to Troy. **Paris** was therefore exposed to die, but was rescued by shepherds. Some time after he had judged the goddesses, he was recognised as a prince of Troy and reinstated in his rightful position. Thus it was that as a member of the Trojan royal family he brought **Helen** to Troy.

Peleus and **Thetis** had a son, **Achilles**. Though **Achilles** had not been one of **Helen's** suitors, **Thetis** knew he might choose to fight in the Trojan War that was impending and so she tried to make him invulnerable by dipping him in the waters of the river Styx. Everywhere the waters touched his body he was made impervious to weapons, but not on the ankle (or heel) by which his mother held him.

Achilles was still very young when the army was mustering to go to Troy, and **Thetis**, always the anxious mother, took her son away from the centaur **Cheiron**, who had been in charge of his education, and hid the beardless boy disguised as a girl among the fifty daughters of **Lycomedes** on the island of Skyros. **Odysseus** cleverly induced the boy to reveal himself by tempting him with a suit of armour and a call to arms. The real girls were frightened, but **Achilles**, his martial spirit roused, fell for the bait and seized the armour, ready to fight. But before he left for Troy, **Achilles** had fathered his son **Neoptolemos** on one of the daughters of **Lycomedes**.

When **Agamemnon** had assembled the necessary Greek troops, they embarked for Troy, but not knowing exactly where it was, they landed too far south, in Mysia. The startled Mysians fought off this unexpected attack bravely, but before the Greeks realised their mistake, the Mysian king, **Telephos**, had been wounded.

After the Greeks had returned to Greece, hoping to acquire some more accurate geographical information, **Telephos** found that his wound refused to heal. He eventually obtained an oracle that explained "He who wounded would cure", and so he went to Greece to find **Achilles** and request the cure. Though **Achilles** denied any knowledge of medicine, **Odysseus** realised that the wound had not been caused so much by

Achilles as by his spear, and when he scraped a little of the rust from the spear into the wound, it healed at once. The grateful **Telephos** then agreed to guide the Greeks to Troy.

But when the Greeks mustered, ready to set sail again, they found that there was no wind. It turned out that **Agamemnon** had offended the goddess **Artemis** and that she could be appeased only if **Agamemnon's** virgin daughter **Iphigeneia** were sacrificed to her. Once this had been done, the fleet delayed no longer.

On the way, they stopped off at Delos. The king, **Anios**, knowing that Troy would not fall before the tenth year of the war, offered nine years' hospitality to the army, ready to supply them with all the wine, olives and grain that they needed thanks to the extraordinary gifts of his daughters, who could produce these staples at will. The Greeks, perhaps unwisely, declined his offer and sailed on. Later, when they realised their error and sent **Menelaus** to request their services, they found that the girls had become frightened and while trying to escape had been turned into doves.

Troy was not a city to be taken easily; it was hedged about with magical conditions. For instance, the Greeks learned that if **Priam's** young son **Troilos** reached the age of twenty, the city could not fall. **Achilles** prepared to remove this impediment. When **Troilos** left the city to water his horses at the fountain-house outside the walls, **Achilles** was lying in wait to ambush him. He chased **Troilos** as far as a sanctuary of **Apollo** and killed him there without difficulty, but he had caught sight of **Troilos'** sister, **Polyxena**, and fallen in love with her, a love he was not able to consummate before his death.

The war dragged on. Nine years had passed when **Agamemnon** offended **Achilles** by taking away his slave girl, Briseis, who had been given to him as a prize of honour. In anger **Achilles** withdrew from the fighting and implored his mother **Thetis** to ask **Zeus** to make things go badly for the Greeks so that they would appreciate what folly it had been on **Agamemnon's** part to have insulted him.

Things went as **Achilles** desired, and eventually the situation so deteriorated that **Patroklos**, **Achilles'** beloved friend, begged **Achilles** to allow him to join the fighting along with **Achilles'** men, even if **Achilles** himself did not wish to. **Achilles** agreed and lent him his own magnificent armour. **Patroklos** fought brilliantly and turned the tide. He killed the Lycian commander, **Sarpedon**, a son of **Zeus** and an ally of the Trojans, but finally he met his match in **Priam's** son Hector, who killed him.

Achilles' grief was unbounded. The removal of Briseis had been a blow to his honour; the death of **Patroklos** was a blow to his heart. He wanted to rush out and fight **Hector** right away, but he had no armour. He therefore summoned his mother and asked **Thetis** to persuade **Hephaistos** to make him some new armour as quickly as possible.

The next morning **Thetis** arrived with the new armour, and **Achilles** returned to the fray full of fighting fury, killing many as he sought out **Hector**. **Hector** was the champion of the Trojans, brave and steadfast, the devoted husband of his wife, **Andromache**, and loving father of his son, **Astyanax**. **Achilles** slew **Hector** and then disgracefully tied his body on to the back of his chariot and drove back to the camp. For several days he continued to outrage the body until **Priam** (aided by the gods) came to the Greek camp to plead for its return. Humanity triumphing over violence, **Achilles** received the bereaved old king kindly and gave the body back to him for burial.

The Trojans still had many allies. **Penthesilea**, queen of the **Amazons**, was one of them. She brought her troops of warrior women with her and drove all before her until she came up against **Achilles**. He slew her, but as he delivered the fatal blow, smitten by her beauty and her bravery, he fell in love with her. It was, of course, too late.

Memnon, son of the dawn goddess **Eos** and the Trojan prince **Tithonos**, came next, bringing his Ethiopians. He, too, initially was wildly successful until he met **Achilles** in battle. Then the two goddess mothers trembled for their sons. **Achilles** won, and **Eos** mourned.

But now **Achilles'** turn came. He was killed by an arrow shot by **Paris** directed into his vulnerable ankle (or heel) by **Apollo**, who had been offended when **Achilles** had killed **Troilos** in his sanctuary.

Ajax carried **Achilles'** body off the field of battle. **Thetis** organised brilliant funeral games in honour of **Achilles** and offered the priceless armour made by **Hephaistos** to the best of the Greek warriors after **Achilles**. **Ajax** assumed the prize would be his, but **Odysseus** argued persuasively that wars are won more by brains than by brawn, and that in that respect he was superior to **Ajax**. When his argument carried the day, **Ajax**, humiliated beyond endurance, committed suicide.

Troy finally fell as a result of a ruse devised by **Odysseus**. (It seems he deserved the arms of **Achilles** after all.) A gigantic hollow wooden horse was constructed, concealing within it the most valiant fighters in the Greek army. It was left before the walls of Troy while the army appeared to sail away. A Greek, pretending to have changed sides, told the Trojans that the Greeks had abandoned the siege, leaving the horse

as a dedication to Athena. If it were brought into the city of Troy, the Greeks at sea would be destroyed. The temptation was too much for the Trojans. They tore down their walls in order to pull the gigantic horse inside – and then they celebrated. In the dead of night, when the Trojans had fallen into a drunken sleep, the Greeks inside the horse crept out, called back their colleagues, who had sailed only a short distance away, and took the city.

Priam could find no protection at the altar where he had taken sanctuary, but was slain by **Achilles'** son **Neoptolemos.** Hector's baby son, **Astyanax,** was ripped from his mother's arms and murdered; **Cassandra,** the prophesying princess whose warnings were never believed, was pulled away from a holy statue of **Athena** and raped. **Aphrodite** persuaded her brave son **Aeneas** to flee, carrying his father, **Anchises,** on his shoulders and accompanied by his wife and son.

Menelaus recovered **Helen.** He had intended to kill her, but **Aphrodite** ensured that her beauty overcame him, and he meekly took her home.

When the fleet was ready to sail, the ghost of **Achilles** appeared and demanded as his share of the spoils the death of **Polyxena,** whom he had loved in life. The girl was sacrificed and the Greeks set off.

Agamemnon reached home quickly, taking **Cassandra** with him as a captive. It was a fateful homecoming, for his wife, **Clytemnestra,** still smarting over the loss of her daughter **Iphigeneia,** had taken **Aegisthus** as her lover and the two had plotted the murder of **Agamemnon** and his concubine.

For long years **Agamemnon's** daughter **Electra** pined for revenge. In the fullness of time, her brother **Orestes** returned from the exile into which he had been sent and slew **Aegisthus** and his mother. For this act of vengeance he was pursued by the **Furies,** who were eventually persuaded to relent.

Odysseus' return was long delayed and filled with adventure. He got the better of the sorceress **Circe,** who had turned his men into pigs, and remained with her for a year. He also bested the Cyclops **Polyphemus,** blinding him and escaping from his cave, but only after the monster had devoured six of **Odysseus'** men. He escaped the twin menaces of Skylla and Charybdis, encountered earlier by the Argonauts, faced man-eating giants, amorous goddesses and disobedient sailors to finally arrive home alone and find that his wife, Penelope, was being courted by an unmannerly troop of suitors. Aided by some loyal old servants, his

now grown-up son and the goddess **Athena**, he succeeded in recovering his home, his family and his property.

Achilles, according to one tradition, dwelt as an unhappy shade in the Underworld; but according to another, his spirit lived on in bliss, married to **Helen** on the White Island.

The Trojan **Aeneas**, having escaped from the fallen city, made his way to Carthage, where he was hospitably received by its queen, **Dido**. But his destiny forced him to abandon her and continue on to Italy, where his descendants founded Rome.

ANCIENT SOURCES: Homer *Iliad, Odyssey*; Quintus of Smyrna *Posthomerica*; Virgil *Aeneid*, book 2; Aeschylus *Oresteia*; Sophocles *Electra*; Euripides *Electra, Hecuba, The Trojan Women, Iphigeneia in Aulis* and *Iphigeneia in Tauris*; Apollodorus *Library* 3.10.6–3.12.6, *Epitome* 2.15–7.40; Ovid *Metamorphoses*, books 11–14.

Suggestions for Further Reading

This is only a small selection, and of course new books are appearing all the time.

Books with Emphasis on Identifying Images of Myths

Carpenter, T. H. *Art and Myth in Ancient Greece*. London: Thames and Hudson, 1991. A useful reference book, copiously illustrated, offering a brief summary of each myth discussed and information as to when, where, and how often it was represented in Greek art from the 7th through the 4th centuries BC. (356 b&w illustrations)

Henle, Jane. *Greek Myths: A Vase Painter's Notebook*. Bloomington and London: Indiana University Press, 1973. Though restricted to the discussion of myths illustrated by vase painters, subtle ideas about the independence of the graphic tradition, the development of types, the adaptation of formulas, and the influence of tragedy are introduced. Intelligent and often witty, much information is conveyed with a light touch. (176 b&w illustrations, many of them line drawings)

Books with Emphasis on the Relationship of Art to Literature

Friis-Johansen, K. *The Iliad in Early Greek Art*. Copenhagen: Munksgaard, 1967. An investigation of when and where early Greek illustrations can be taken to reflect knowledge of the *Iliad*. (95 b&w illustrations)

Schefold, Karl. *Gods and Heroes in Late Archaic Greek Art*. Cambridge: Cambridge University Press, 1992. Copiously illustrated, often with several

different images of the same myth. Though restricted to a survey of images made mostly in the second half of the 6th century BC, numerous myths are recounted and many images described, analysed and related to literature both extant and lost. (361 b&w illustrations)

Shapiro, H. A. *Myth into Art: Poet and Painter in Classical Greece*. London and New York: Routledge, 1994. Sensitive analysis of the relationship of vase painting and literature in the archaic and classical periods, concentrating on a limited number of myths, providing many translations from Greek literature, and noting the independence of the graphic tradition. (129 b&w illustrations)

Small, Jocelyn Penny. *The Parallel Worlds of Art and Text in Classical Antiquity*. New York: Cambridge University Press, forthcoming. An intelligent, critical analysis of the relationship of art works to texts.

Snodgrass, Anthony. *Homer and the Artists: Text and Picture in Early Greek Art*. Cambridge: Cambridge University Press, 1998. A careful analysis of images (mostly from the 8th and 7th centuries BC), chiefly in order to establish that they were not directly influenced by the Homeric poems. (63 b&w illustrations)

Weitzmann, Kurt. *Illustrations in Roll and Codex: A Study of the Origin and Method of Text Illustration*. Princeton, N.J.: Princeton University Press, 1947. Scholarly study of the relationship of illustrations to texts, with particular emphasis on images in books and continuing beyond antiquity into the Middle Ages. (205 b&w illustrations)

Books Focusing on a Particular Episode, Hero or Mythological Cycle

Anderson, Michael J. *The Fall of Troy in Early Greek Poetry and Art*. Oxford: Oxford University Press, 1997. Scholarly study of the structural, literary and visual links connecting the themes in the legend of the fall of Troy with each other and with other aspects of the Trojan cycle. (21 b&w illustrations)

Carpenter T. H. *Dionysian Imagery in Fifth Century Athens*. Oxford: Oxford University Press, 1997. Scholarly essays on various aspects of images of Dionysus in Athens in the 5th century BC and their relationship (or lack of relationship) to literature and cult. (47 b&w plates)

Hedreen, Guy. *Capturing Troy: The Narrative Functions of Landscape in Archaic and Early Classical Greek Art*. Ann Arbor, Michigan: University of Michigan Press, 2001. A scholarly study of indications of setting (cult statues, city walls, palm trees, etc.) on vase paintings to illustrate the independence of the visual tradition and to explain the narrative significance of such elements. (86 b&w illustrations)

Prag, A. J. N. *The Oresteia*. Oak Park Ill.: Bolchazy-Carducci Publishers, 1985. Scholarly investigation of the mythological and artistic tradition developed before Aeschylus' dramatisation of the theme. (136 b&w illustrations)

Sourvinou-Inwood, Christiane. *Theseus as Son and Step-son*. Institute of Classical Studies Bulletin Supplement no. 40. London: University of London, 1979. Scholarly study of artistic formulas, mythological structures and a mislabelled figure focusing narrowly on the theme of Theseus' relationship to Medea. (7 b&w illustrations)

Woodford, Susan. *The Trojan War in Ancient Art*. London: Duckworth and Ithaca, N.Y.: Cornell University Press, 1993. Survey of the Trojan cycle in Greek and Roman art and literature, with an analysis of artistic types and their dependence on or independence from literature. (113 b&w illustrations)

Miscellaneous

Brilliant, Richard. *Visual Narratives: Story Telling in Etruscan and Roman Art*. Ithaca, N.Y.: Cornell University Press, 1984. Analysis of aspects of historical and mythological narratives in wall painting and relief sculpture in Etruscan and Roman art. (38 b&w illustrations)

Trendall, A. D., and T. B. L. Webster. *Illustrations of Greek Drama*. London: Phaidon, 1971. A compendium of ancient images of Greek dramas, including illustrations of many plays that have not survived. (187 b&w illustrations)

NOTE: All books on Greek art and most on Roman art include some discussion of the myths that are such a prominent part of their production, but few provide more than a passing mention. Although the subject of mythological illustration has been widely explored by authors writing in French and German, regrettably few have been translated. A magnificent compendium of images is collected in the *Lexicon Iconographicum Mythologiae Classicae* LIMC (1981–1999), an international enterprise with articles in English, French, German and Italian. It consists of eight double volumes of text and illustrations devoted to mythological iconography, entries arranged alphabetically, each article covering a mythological character (god, hero or monster).

Picture Credits

Collections are given in the captions accompanying the illustrations. Sources of illustrations not supplied by museums or collections, additional information, and copyright credits are given below.

1. Photo: Museo Nazionale, Naples. Courtesy of the Ministero per i Beni e le Attività Culturali, Soprintendenza Archeologica delle province di Napoli e Caserta.
2. Copyright: The British Museum, London.
3. Copyright: The British Museum, London.
4. After E. Pfuhl, *Malerei und Zeichnung der Griechen* (Munich, 1923).
5. Copyright: The British Museum, London.
6. After A. Furtwängler and K. Reichhold, *Griechische Vasenmalerei* (Munich, 1904–1932).
7. Photo: Schwanke (Deutsches Archäologisches Institut, Rome, neg. no. 80.2908).
8. Louvre, Paris. Copyright R.M.N.
9. After A. Furtwängler and K. Reichhold, *Griechische Vasenmalerei* (Munich, 1904–1932).
10. Photo: Alinari.
11. Copyright: The British Museum, London.
12. After E. Curtius and F. Adler, *Olympia* (Berlin: A. Ascher and Co., 1897). Drawing by M. Kühnert.
13. Photo credit: Foto della Soprintendenza Archeologica per l'Etruria Meridionale, Rome.

14. Photo: Iris & B. Gerald Cantor Center for Visual Arts at Stanford University; Hazel D. Hansen Fund.

15. Photo courtesy of Auction Leu Numismatics 72, 12 May 1998, lot 27.

16. Photo: Singer (Deutsches Archäologisches Institut, Rome neg. no. 72.2416).

17. Copyright: EFA (Ecole Française d'Athènes 26.322), inv. C 149. Photo: Emile Séraf.

18. Antikenmuseum Basel und Sammlung Ludwig (Inv. BS 1404), Basel. Photo: Claire Niggli.

19. Photo: Alinari.

20. Musée des Beaux-Arts et d'Archéologie, Boulogne-sur-Mer. Photo: Devos.

21a. Photo: Lucy Parker. After Susan Woodford, *An Introduction to Greek Art* (London: Duckworth, and Ithaca, N.Y.: Cornell University Press, 1986).

21b. Drawing by Susan Bird. After Susan Woodford, *An Introduction to Greek Art* (London: Duckworth, and Ithaca, N.Y.: Cornell University Press, 1986).

22. Photo: Alison Frantz Collection, American School of Classical Studies at Athens.

23. After K. Weitzmann, *Illustrations in Roll and Codex* (Princeton, N.J.: Princeton University Press, 1947).

24. Drawing after G. Rodenwaldt, *Altdorische Bildwerke in Korfu* (Berlin: Gebr. Mann Verlag, 1938).

25. Photo: Metropolitan Museum of Art, New York (06.1070 Rogers Fund, 1906).

26. After A. Furtwängler and K. Reichhold, *Griechische Vasenmalerei* (Munich, 1904–1932).

27. Photo: Museo Archeologico, Florence. By permission of the Ministero per i Beni e le Attività Culturali, Soprintendenza Archeologica di Firenze.

28. Copyright: The British Museum, London.

29a. Photo: Metropolitan Museum of Art, New York. Rogers Fund, 1911.

29b. Drawing by Susan Bird.

30. Copyright: The British Museum, London.

31. Photo: National Archaeological Museum, Athens.

32. After A. Furtwängler and K. Reichhold, *Griechische Vasenmalerei* (Munich, 1904–1932).

33. Photo: Museo Provinciale Sigismondo Castromediano, Lecce.

34. Photo: Museo Nazionale, Naples. Courtesy of the Ministero per i Beni e le Attività Culturali, Soprintendenza Archeologica delle province di Napoli e Caserta.

Vases in the Metropolitan Museum of Art (New Haven, Conn., 1936).

63. Photo: Badisches Landesmuseum, Karlsruhe.

64. Louvre, Paris. Photo: M. and P. Chuzeville.

65. Drawing by Susan Bird. After Susan Woodford, *An Introduction to Greek Art* (London: Duckworth, and Ithaca, N.Y.: Cornell University Press, 1986).

66. Drawing by Susan Bird. After Susan Woodford, *An Introduction to Greek Art* (London: Duckworth, and Ithaca, N.Y.: Cornell University Press, 1986).

67. Drawing by Susan Bird. After Susan Woodford, *An Introduction to Greek Art* (London: Duckworth, and Ithaca, N.Y.: Cornell University Press, 1986).

68. Copyright: The British Museum, London.

69. Copyright: The British Museum, London.

70. Copyright: The British Museum, London.

71. After E. Curtius and F. Adler, *Olympia* (Berlin: A. Ascher and Co., 1897). Drawing by M. Kühnert.

72. Copyright: The British Museum, London.

73. Photo: Museo Nazionale, Naples. Courtesy of the Ministero per i Beni e le Attività Culturali, Soprintendenza Archeologica delle province di Napoli Caserta.

74. After Eduard Gerhard, *Auserlesene Vasenbilder*, vol. 3 (Berlin, 1847).

75. Photo: Antikensammlung, Staatliche Museen zu Berlin – Preussischer Kulturbesitz, Berlin.

76. Antikensammlung, Staatliche Museen zu Berlin – Preussischer Kulturbesitz, Berlin. Photo: Jutta Tietz-Glagow.

77. Drawing by Susan Bird.

78. Copyright: The British Museum, London.

79. After J. H. W. Tischbein, *Collection of Engravings from Ancient Vases Discovered in the Kingdom of the Two Sicilies between 1789 and 1790* (Naples, 1793–after 1803).

80. Martin von Wagner Museum, Universität Würzburg. Photo: K. Oehrlein.

81. Copyright: The British Museum, London.

82. Drawing by Susan Bird.

83. Photo: Musei Vaticani, Vatican City.

84. Photo: Musei Vaticani, Vatican City.

85. After Eduard Gerhard, *Auserlesene Vasenbilder*, vol. 3 (Berlin, 1847).

86. After E. Pfuhl, *Malerei und Zeichnung der Griechen* (Munich, 1923).

87. Drawing by Susan Bird.

88. Photo: Metropolitan Museum, New York (37.11.9–10, Harris Brisbane Dick Fund, 1937).
89. Photo: Musei Vaticani, Vatican City.
90. Photo: Alison Frantz Collection, American School of Classical Studies at Athens.
91. Copyright: The British Museum, London.
92. Photo: Museo Nazionale, Naples. Courtesy of the Ministero per i Beni e le Attività Culturali, Soprintendenza Archeologica delle province di Napoli e Caserta.
93. Photo: Antikensammlung, Staatliche Museen zu Berlin – Preussischer Kulturbesitz, Berlin.
94. Photo: Antikensammlung, Staatliche Museen zu Berlin – Preussischer Kulturbesitz, Berlin.
95. Copyright: The British Museum, London.
96. Photo: Hirmer Verlag München, Munich.
97. Photo: Museo Nazionale, Naples. Courtesy of the Ministero per i Beni e le Attività Culturali, Soprintendenza Archeologica delle province di Napoli e Caserta.
98. Photo: Metropolitan Museum, New York (20.192.16 Rogers Fund, 1920).
99. After A. Furtwängler and K. Reichhold, *Griechische Vasenmalerei* (Munich, 1904–1932).
100. Photo: The J. Paul Getty Museum, Malibu, California.
101. Photo: Metropolitan Museum, New York (Rogers Fund, 1945).
102. Louvre, Paris. Photo: M. and P. Chuzeville.
103. Photo: Antikensammlung, Staatliche Museen zu Berlin – Preussischer Kulturbesitz, Berlin.
104. After the *Gazette Archéologique* 5 (1879), plate 3.
105. Photo courtesy of the Ministero per i Beni e le Attività Culturali, Soprintendenza Archeologica della Lombardia, Milan.
106. Photo: Louvre, Paris.
107. Photo: Brügner (Deutsches Archäologisches Institut, Rome neg. no. 33.136).
108. Photo: Deutsches Archäologisches Institut, Rome neg. no. 7112.
109. Photo: Felbermeyer (Deutsches Archäologisches Institut, Rome neg. no. 68.5169).
110. Photo: Faraglia (Deutsches Archäologisches Institut, Rome neg. no. 38.1320).
111. Copyright: The British Museum, London.
112. Photo: The Metropolitan Museum of Art, New York.
113. After Brunn Bruckmann *Verlagsanstalt für Kunst und Wissenschaft vormals Bruckmann* (Munich, 1895).
114. Photo: American School of Classical Studies at Athens, Agora Excavations.

115. Copyright: The British Museum, London.
116. Copyright: The British Museum, London.
117. After Eduard Gerhard, *Auserlesene Vasenbilder*, vol. 3 (Berlin, 1847).
118. Photo: Antikensammlung, Staatliche Museen zu Berlin – Preussischer Kulturbesitz, Berlin.
119. Photo: Ashmolean Museum, Oxford.
120. After E. Pfuhl, *Malerei und Zeichnung der Griechen* (Munich, 1923).
121. Copyright: The British Museum, London.
122. After A. Furtwängler and K. Reichhold, *Griechische Vasenmalerei* (Munich, 1904–1932).
123. After A. Furtwängler and K. Reichhold, *Griechische Vasenmalerei* (Munich, 1904–1932).
124. After A. Furtwängler and K. Reichhold, *Griechische Vasenmalerei* (Munich, 1904–1932).
125. Photo: Metropolitan Museum, New York (1972.11.10 Bequest of Joseph H. Durkee, Gift of Darius Ogden Mills, and Gift of C. Ruston Love, by exchange, 1972).
126. After E. Pfuhl, *Malerei und Zeichnung der Griechen* (Munich, 1923).
127. Photo: The Art Museum, Princeton University. Gift of the Committee for the Excavation of Antioch. Photo: Bruce M. White.
128. Antikensammlung, Staatliche Museen zu Berlin – Preussischer Kulturbesitz, Berlin. Photo: Jutta Tietz-Glagow.
129. Copyright: The British Museum, London.
130. Photo: Metropolitan Museum of Art, New York (41.83 Gift of Amelia E. White, 1941).
131. After E. Pfuhl, *Malerei und Zeichnung der Griechen* (Munich, 1923).
132. After E. Pfuhl, *Malerei und Zeichnung der Griechen* (Munich, 1923).
133. After A. Furtwängler and K. Reichhold, *Griechische Vasenmalerei* (Munich, 1904–1932).
134. Photo: Myconos Museum, Myconos.
135. Photo: Museo Nazionale, Naples. Courtesy the Ministero per i Beni e le Attività Culturali, Soprintendenza Archeologica delle province di Napoli e Casuta.
136. Louvre, Paris. Photo: M. and P. Chuzeville.
137. Drawing by Susan Bird.
138. Louvre, Paris. Photo: M. and P. Chuzeville.
139. After A. Furtwängler and K. Reichhold, *Griechische Vasenmalerei* (Munich, 1904–1932).
140. Photo: Musei Vaticani, Vatican City.
141. Photo: Singer (Deutsches Archäologisches Institut, Rome neg. no. 72.593).

142. After A. Furtwängler and K. Reichhold, *Griechische Vasenmalerei* (Munich, 1904–1932).
143. Photo: Hirmer Verlag München, Munich.
144. After P. Baur, *Centaurs in Ancient Art* (Berlin, 1912).
145. Louvre, Paris. Photo: M. and P. Chuzeville.
146. Photo: Museum für Kunst und Gewerbe, Hamburg.
147. Photo: Museo Nazionale, Naples. Courtesy of the Ministero per i Beni e le Attività Culturali, Soprintendenza Archeologica delle province di Napoli e Caserta.
148a. Photo: Singer (Deutsches Archäologisches Institut, Rome neg. no. 71.1474).
148b. Drawing by Susan Bird.
149a. Photo: Brügner (Deutsches Archäologisches Institut, Rome neg. no. 33.150).
149b. Drawing by Susan Bird.
150a. Photo: Singer (Deutsches Archäologisches Institut, Rome neg. no. 72.1327).
150b. Drawing by Susan Bird.
151a. Photo: Sansaini (Deutsches Archäologisches Institut, Rome neg. no. 55.376).
151b. Drawing by Susan Bird.
152. Photo: Hirmer Verlag München, Munich.
153. Photo: Antikensammlung, Staatliche Museen zu Berlin – Preussischer Kulturbesitz, Berlin.
154. Drawing by Susan Bird.
155. Copyright: The British Museum, London.
156. After J. H. W. Tischbein, *Collection of Engravings from Ancient Vases Discovered in the Kingdom of the Two Sicilies between 1789 and 1790* (Naples, 1793–after 1803).
157. After Eduard Gerhard, *Auserlesene Vasenbilder*, vol. 3 (Berlin, 1847).
158. Drawing by Susan Bird.
159. Drawing by Susan Bird.
160. Copyright: The British Museum, London.
161. After A. Furtwängler and K. Reichhold, *Griechische Vasenmalerei* (Munich, 1904–1932).
162. After P. Baur, *Centaurs in Ancient Art* (Berlin, 1912).
163. Photo: National Archaeological Museum, Athens.
164. Photo: Museo Nazionale, Naples. Courtesy of the Ministero per i Beni e le Attività Culturali, Soprintendenza Archeologica delle province di Napoli e Caserta.
165. Photo: Institut für Klassische Archäologie und Antikenmuseum der Universität Leipzig, Leipzig.
166. Louvre, Paris. Photo: M. and P. Chuzeville.

167. Antikensammlung, Staatliche Museen zu Berlin – Preussischer Kulturbesitz, Berlin. Photo: Ingrid Geske.
168. Photo: Musei Vaticani, Vatican City.
169. Photo: Alison Frantz Collection, American School of Classical Studies at Athens.
170. Louvre, Paris: Copyright R.M.N.
171. After Eduard Gerhard, *Auserlesene Vasenbilder*, vol. 3 (Berlin, 1847).
172. Copyright: The British Museum, London.
173. Louvre, Paris. Photo: M. and P. Chuzeville.
174. Copyright: The British Museum, London.
175. Copyright: The British Museum, London.
176. Copyright: The British Museum, London.
177. After A. Furtwängler and K. Reichhold, *Griechische Vasenmalerei* (Munich, 1904–1932).
178. Copyright: The British Museum, London.
179. After A. Furtwängler and K. Reichhold, *Griechische Vasenmalerei* (Munich, 1904–1932).
180. Photo: Private Collection, Miami, Florida.
181. Photo: Alison Frantz Collection, American School of Classical Studies at Athens.
182. After E. Pfuhl, *Malerei und Zeichnung der Griechen* (Munich, 1923).
183. Photo: Susan Woodford. After Susan Woodford, *An Introduction to Greek Art* (London: Duckworth, and Ithaca: N.Y.: Cornell University Press, 1986).
184. Photo: Hirmer Verlag München, Munich.
185. After Susan Woodford, *An Introduction to Greek Art* (London: Duckworth, and Ithaca, N.Y.: Cornell University Press, 1986).
186. Drawing by Susan Bird.
187. Photo: Dieter Widmer, Basel.
188. Copyright: The British Museum, London.
189. Photo: Dieter Widmer, Basel.
190. Copyright: The British Museum, London.
191. Copyright: The British Museum, London.
192. Copyright: The British Museum, London.
193. Copyright: The British Museum, London.
194. Copyright: The British Museum, London.

Index